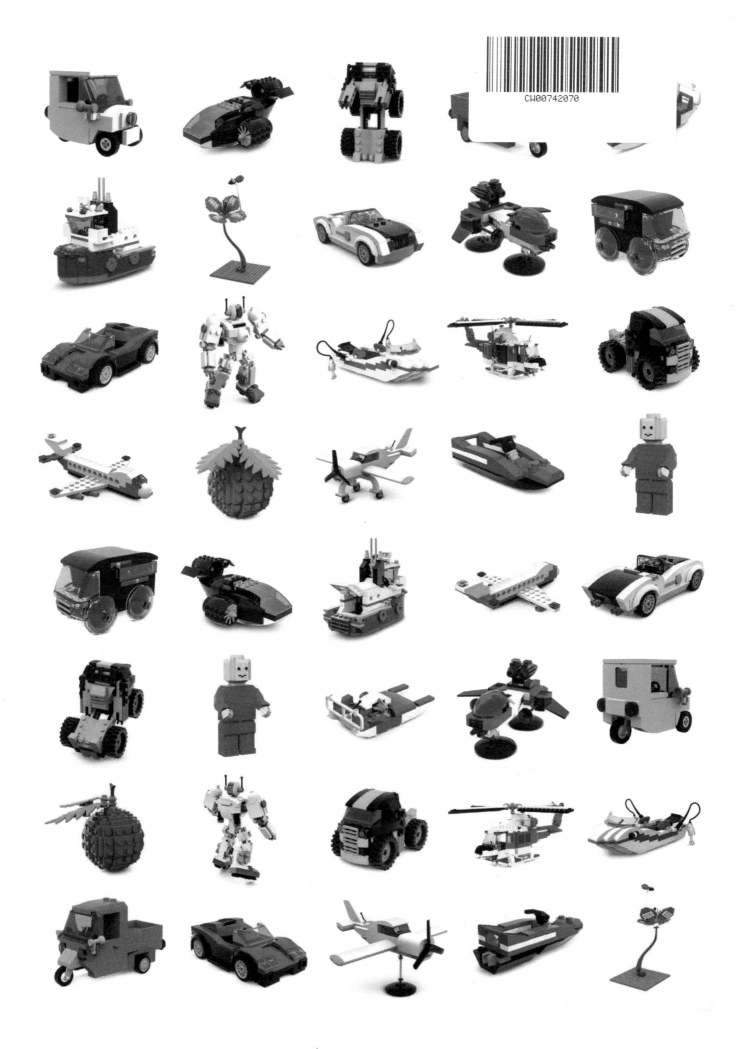

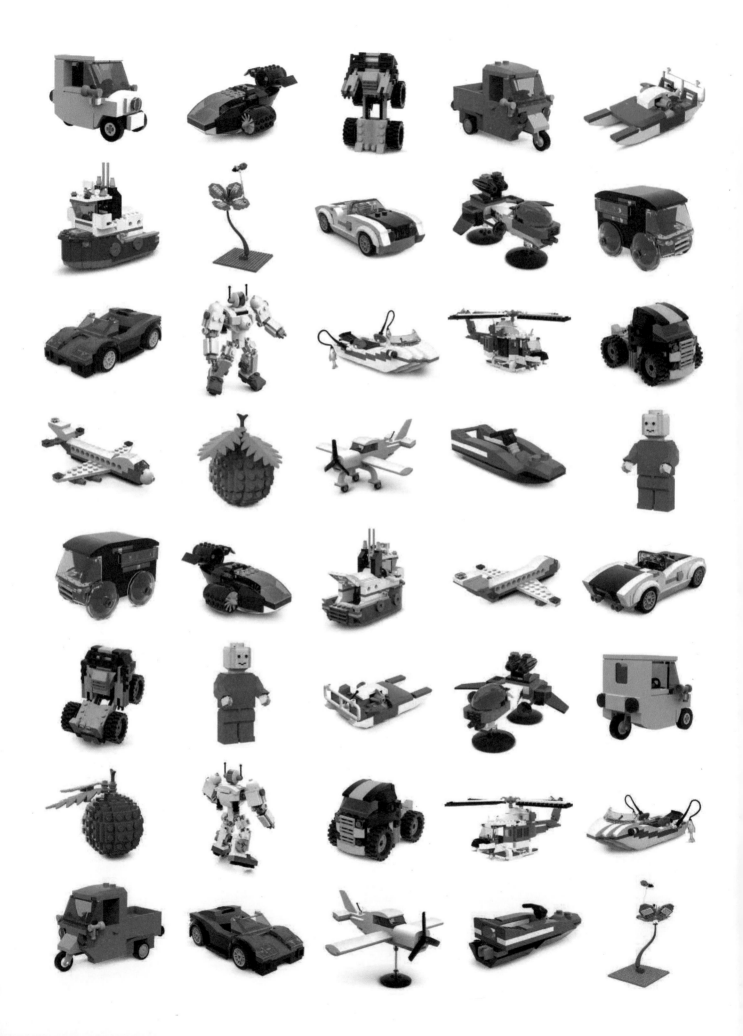

HOW TO BUILD

BUILD

EASY CREATIONS
WITH LEGO® BRICKS

Francesco Frangioja

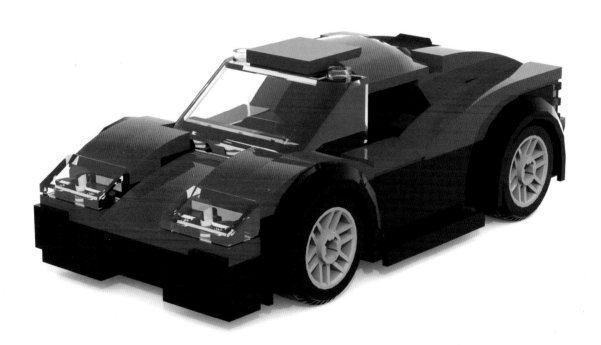

THUNDER BAY
P·R·E·S·S

San Diego, California

FRANCESCO FRANGIOJA

Francesco Frangioja, born in 1971, is a LEGO® enthusiast and builder. He rediscovered his love for LEGO® bricks in 2010, and immediately began an active collaboration with several communities of LEGO® enthusiasts (AFOL—Adult Fans of LEGO®). He's especially interested in the ludic-educational aspects of "playing with LEGO® bricks" concerning children—aspects lying at the heart of the project for this book. In 2016, he decided to "expand" his passion for LEGO® bricks to the professional sphere, obtaining the certification of Facilitator in the LEGO® **SERIOUS**PLAY® Method from the *Association of Master Trainers in the* LEGO® **SERIOUS**PLAY® *Method*. He subsequently started planning and holding workshops at private companies and public corporations. He is also the author of *How to Build Space Explorers with Lego® Bricks*, published by NuiNui.

ACKNOWLEDGMENTS

This book is dedicated to my family.
To my parents, for a fantastic childhood filled with LEGO® sets and bricks, and for the amazing support they've always given me—and continue to give me—in so many aspects of my life.
To my wife Patty, who also let me fill our house with sets and bricks; thank you for your constant support, for being so patient with my passion and for encouraging me to pursue it every day.

My heartfelt thanks goes out to the many people who contributed to the making of this book.
Thanks to the publisher, **NuiNui**, who showed confidence in an absolute amateur and whose staff went above and beyond duty to help me carry out my project.
Thanks to **ItLUG**, the Italian LEGO® Users Group, for all its assistance and support and for putting me in touch with the publisher. And because in the end... it all started (again) with ItLUG.
Thanks to all the "**Master Builders**" who were so generous in "entrusting" me with their models. I've taken the greatest care of them!
Thanks to my **BrianzaLUG** friends for sharing their friendship, advice and endless "LEGO® Knowledge" with me: "EVERYTHING IS AWESOME WHEN YOU'RE PART OF A TEAM!" (from "The LEGO® Movie"). BrianzaLUG is much more than a name and a logo; it's an honor and a privilege to belong to it.

Thanks to the great **Damiano Baldini from AFDL.it** for his friendship and constant encouragement, and for insisting that I be a part of his project from the very start.

I owe special thanks to the wonderful **Nicola Lugato**, one of the builders who kindly "lent" me a model for this book. He's also—first and foremost—the **developer of the two software programs** that allowed me to carry out my project: **Blueprint** to generate the instructions and **Bluerender** to create the digital images you'll find in the book. His assistance was invaluable in configuring my PC correctly, enabling the two software programs to operate in the best possible way; he also helped me configure the software programs themselves, enabling them to produce the instructions and images in the correct format and with the features most suitable to the publisher's requirements.

Thunder Bay Press
An imprint of Printers Row Publishing Group
10350 Barnes Canyon Road, Suite 100
San Diego, CA 92121
www.thunderbaybooks.com

Copyright © 2017 Nuinui, Italy

Thunder Bay Press
Publisher: Peter Norton
Associate Publisher: Ana Parker
Publishing/Editorial Team: April Farr, Kelly Larsen, Kathryn C. Dalby
Editorial Team: JoAnn Padgett, Melinda Allman, Dan Mansfield

Graphic Design: Contextus s.r.l., Pavia
Translation: Contextus s.r.l., Pavia (Daniela Innocenti)

Shutterstock Inc. photo reference:
p. 10: Hans Slegers / p. 14: Samot / p. 33: Mike Pellinni /
p. 43: 1000 Words / pp. 56-57: Jahanzaib Naiyyer /
p. 58: Dmitry Polonskiy / p. 63: Zoran Temelkov /
p. 67: Maks Narodenko / pp. 80-81: KKulikov /
p. 82: Serg64 / p. 103: Media Union / pp. 128-129: Kusska /
p. 130 and p. 133: Aphelleon / p. 139: Romolo Tavani /
p. 151: Giovanni Benintende / pp. 170-171: TaYa294 /
p. 189: Vadim Sadovski / p. 190: Alexey Stiop

ISBN: 978-1-68412-540-1
Printed in China
22 21 20 19 18 1 2 3 4 5

The publisher would like to thank ItLUG - Italian LEGO® Users Group for its valuable collaboration.
http://itlug.org

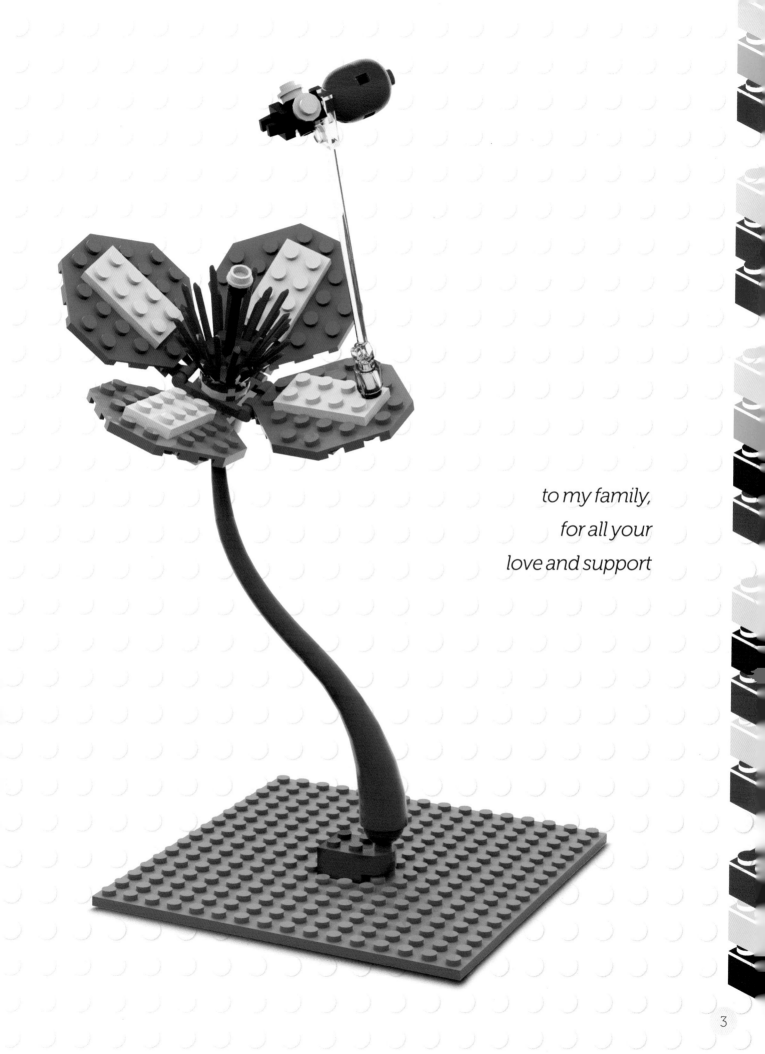

to my family,
for all your
love and support

3

PREFACE

The book you're about to read is the result of a joint effort and participation, rather than the work of just one author. My job consisted in looking for and selecting a series of models—both fun to build and play with—and collecting them in a single book.

Therefore, none of this would have been possible or even feasible without the invaluable contribution of the many incredible builders all over the world who agreed to join me in this venture!

Some of them modified their models to make them easier to build; others replaced certain parts so that their "babies" wouldn't contain rare or expensive elements. The helpfulness, enthusiasm and straightforwardness with which they all placed their models at my disposal describe the "strength" of the AFOL community (Adult Fans of LEGO®, as we call ourselves), far better than any words. Their approach to my project, not to mention the way they participated in and collaborated with it, has once again proven the "stuff" our community is made of. A community featuring individual elements and people, sure; yet all of us are united by the same wish for self-improvement. A community based on mutual respect and support rather than on competition and rivalry. This is what makes our community so special. This is what allowed me to create this book. You can find the names and a short biography of each builder in the paragraph on their respective models.

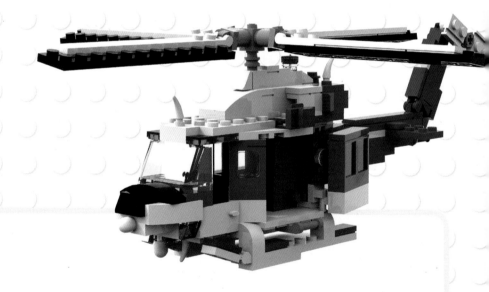

ABOUT THE BOOK

The book includes step-by-step instructions to build each model, with the aim of helping readers learn the techniques, tricks and methods needed to build any object with LEGO® bricks. So get ready to let your imagination and creativity run wild as you start building… anything you want!

The book also contains the list of LEGO® parts and components you'll need to build each model. Furthermore, a link or QR code lets you download a folder containing the following onto your PC/Mac/Tablet: the file (.LXF) of the LDD (LEGO® Digital Designer) project for each model; the "Wanted List" in XML format to upload directly to the http://www.bricklink.com marketplace for purchasing the LEGO® elements you'll need to build the various models detailed in the book; a video of the finished model rotating at 360°.

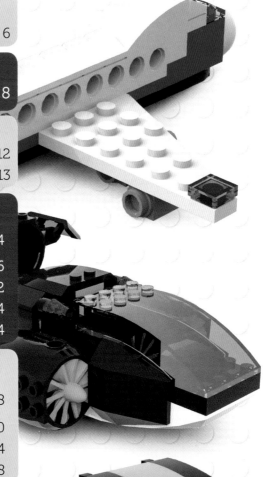

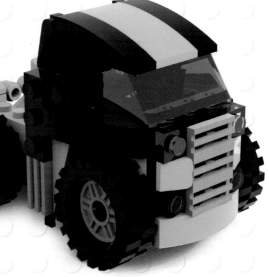
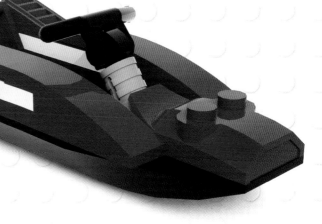
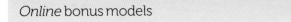

THE HISTORY
of LEGO® System A/S

The LEGO® Group was founded **in 1932** by Ole Kirk Kristiansen. The company has passed from father to son and is now owned by Kjeld Kirk Kristiansen, the founder's grandson. A master carpenter and woodworker, Ole Kirk Kristiansen opened his first workshop in what was then the village of Billund, in Denmark. He started by designing and building small indoor staircases, ironing boards, stools and toys, all made of wood. His son, Godtfred Kirk Kristiansen, became an apprentice in his father's workshop when he was only 12 years old!

In 1934, the company changed its name to LEGO®, made up of the Danish words "LEG" ("play") and "Godt" ("well"). Ole Kirk Kristiansen wouldn't realize until later on that LEGO means "put together—build" in Latin. The workshop had 6 employees by then.
The company produced its first "set" **in 1935**: a cute wooden duck that was "replicated" out of bricks **in 2011** with a special set made exclusively for Group employees.
In 1936, Godtfred Kirk Kristiansen "carved" his father's motto, "Only the best is good enough", out of wood, hanging it up in the workshop.
In 1937, at the age of 17, Godtfred Kirk Kristiansen also began creating models and toys.
By 1939, the workshop had 10 employees, a number which had grown to 40 **by 1943**!
In 1947, The Group purchased the first plastic-injection molding machine (produced by Windsor SH Plastic) in the history of Denmark, for a price equivalent to a fifteenth of its 1946 revenue!
In 1949, the company produced over 200 different wood and plastic toy models, including the first made with "interlocking bricks"—though these versions were still missing the inner "tubes".
The word LEGO was officially registered as a trademark in Denmark on May 1st **1954**. On the ferry to England, Godtfred Kirk Kristiansen met a toy salesman and the two men began talking. The salesman expounded the following theory: that the toys of the period were affected by the lack of a concept of "system". This conversation was the "spark" that gave Godtfred the idea that would soon become the company emblem: the LEGO® System!
The patent for the brick in its present form—that is, with the "stud-and-tube" system—was filed in **1958**. This new interlocking system led to sturdier and more solid constructions. Meanwhile, the employee count had reached 140 and the company branches increased to 3: in Billund, Germany and Switzerland. There would be 7 by the following year, with branches opening in France, England, Belgium and Sweden, and 9 two years later (as Finland and the Netherlands opened branches on their national territory).
In 1961, LEGO® established a branch in Italy and, simultaneously, a trade agreement with Samsonite Corp touched off sales in the United States and Canada.

In 1963, Godtfred Kirk Kristiansen established the guiding principles the company would follow in designing and creating future sets:

- they must have unlimited play potential
- they must be suitable for girls and boys alike
- they must be fun for all ages
- they must be suitable for year-round play
- they must be safe and allow peaceful, "quiet" play
- they must guarantee long hours of play
- they must stimulate and develop the players' creativity
- they must guarantee top quality, from all points of view.

LEGOLAND® Billund opened **in 1968**: 3,000 visitors crossed the threshold on the first day, numbering a total of 625,000 by the end of the season! It would only take 5 years for the five-millionth ticket to be sold!

A new range of products for younger builders was launched on the market **in 1969**: DUPLO® was born!

Representing the third generation of the Kristiansen family, Kjeld Kirk Kristiansen entered The LEGO® Group's top management team **in 1977**. The new LEGO® Technic "theme" came out the same year!

1985 saw the start of a collaboration with Professor Seymour Papert and the Massachusetts Institute of Technology (MIT); four years later, Professor Papert was named LEGO® Professor of Learning Research.

Renowned Professor Xavier Gilbert was appointed to the LEGO® Chair of Business Dynamics **in 1990**, as part of a collaboration with the IMD Business School in Lausanne, Switzerland.

The website www.lego.com was launched **in 1996**!

The LEGO® Shop @ Home—the fantastic online LEGO® Shop—was launched **in 1999**.

The LEGO® SERIOUSPLAY® program and method was officially introduced on the market **in 2001.**

A history-making agreement between LEGO® and Ferrari® was signed **in 2004**.

The LEGO® Ambassador Program was launched **in 2005** with the aim of creating closer ties between The LEGO® Group and its many fans and enthusiasts all over the world.

To properly mark its 80th anniversary **in 2014**, the Group "treated itself" to the worldwide phenomenon of "The LEGO® Movie"—a hugely successful film!

The company has come a long way since it was established—changing (at times radically) from a small carpenter's workshop to a large and modern global enterprise, from wood to plastic, innovating and transforming itself and above all (though not without "difficulty") adapting to a constantly-evolving market in order to become the first worldwide toy producer in 2015.

DICTIONARY
of most-used parts

Did you know that every LEGO® part and component has its own name?

To build with LEGO® bricks, you don't have to know the names of the parts and components you're using, but it can prove helpful.

For example, if you want to ask a friend to make an exchange, or if you need to buy some parts online, how would you look for the brick you need without knowing its name?

Although the word "bricks" is generally used to refer to the parts as a whole, only a specific type of piece can actually be called a **brick**. Each "family" of LEGO® parts and components is identified by its own name.

Let's see the main "families" of LEGO® components and discover their names.

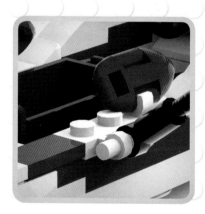

BRICKS

Any element with a height corresponding to that of the basic 1x1 piece is called a **Brick**.

To establish the "size" of a brick, simply count the number of STUDS per side. In the example in **Figure 1**, we find the following Bricks (clockwise): a 2x6 (blue); 2x4 (red); 1x4 (yellow); 1x1 (purple); 2x2 (green).

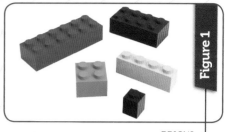

BRICKS

MODIFIED BRICKS

Any brick (see previous paragraph) that has been "modified" or altered in any way (e.g., with STUDS placed on one or more sides, various types of connectors, etc.) is called a **Modified Brick**. See **Figure 2**.

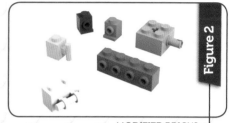

MODIFIED BRICKS

ROUND BRICKS

Any component with a height corresponding to that of a normal **Brick** but with a round/curved shape (and therefore surface) is called a **Round Brick**. In **Figure 3**, clockwise: a Round 2x2 (red); Round 4x4 (green); Round 1x1 (blue); Brick Round Corner Macaroni 2x2 (yellow).

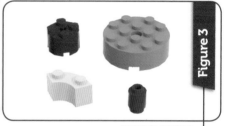

ROUND BRICKS

PLATES (PLATES ROUND & WEDGE)

Any element with a height corresponding to 1/3 (one-third) of the basic 1x1 element. "Superficial" sizes are the same as for Bricks, and here too are calculated by counting the STUDS on top. For example, in **Figure 4** we find the following (clockwise): a Plate 4x6 (yellow); Plate 2x4 (red); Plate 4x4 (blue); Plate, Round 4x4 (blue); Plate, Round 1x1 (fuchsia); Wedge 4x3 (blue). In the center, a Plate, Round 2x2 (brown) and a Plate 1x2 (green).

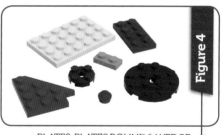

PLATES, PLATES ROUND & WEDGE

Depending on its shape and type, a **Plate** component is classified as:

- a **Wedge** (due to its angular shape), when a **Plate** component is triangular in shape. In some cases, for example with Wedges used as "wings", the components also present a left or right bent (**Figure 4**—4x3 blue),

- a **Round Plate** when the component is circular in shape (**Figure 4**—4x4 purple; 1x1 pink and 2x2 brown).

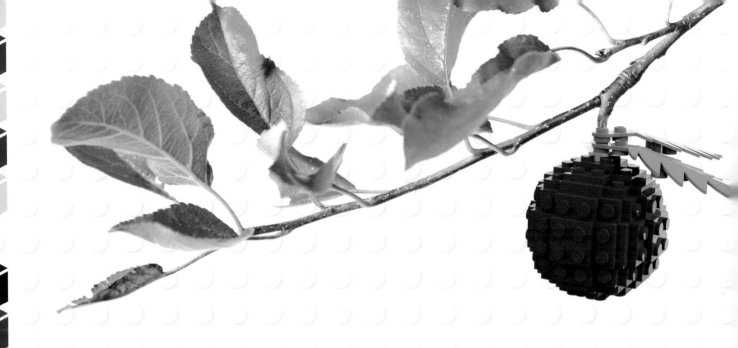

MODIFIED PLATES

Any **Plate** (see previous paragraph) that has been modified or altered in any way (e.g., with various types of connectors or hinges) is called a **Modified Plate**. See **Figure 5**.

Figure 5

MODIFIED PLATES

SLOPE

Any component where one or more sides incline or slope from top to bottom. You can find this type of component (see **Figure 6**) with a certain range of slants, from a minimum of 18° to a maximum of 75°, but the most common are those with an angle of 33° or 45°. They are produced in *Standard* and *Inverted* versions; the latter presents a slope from bottom to top (e.g., the light blue part in **Figure 6**).

Figure 6

SLOPE

BRACKETS

Any component, generally derived from the **Plate** type, that can be used to build laterally.

Figure 7

BRACKETS

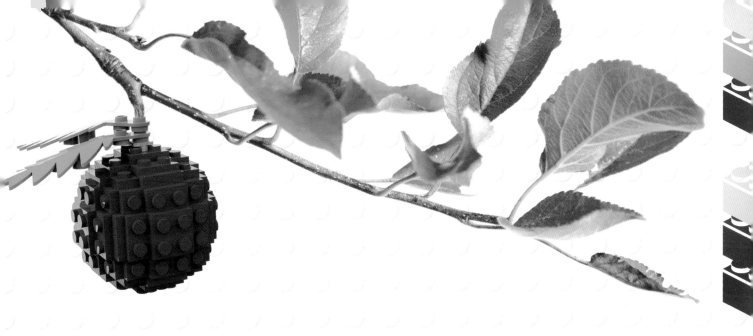

CONES & DOMES

Any component conical or semispherical in shape is called a **Cone** (or **Dome**).

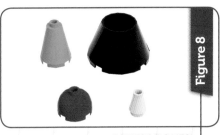

CONES & DOMES

TILES & PANELS

Any component identical to a **Plate** but with a smooth surface (that is, devoid of STUDS) is called a **Tile**. Components that look like they're made out of several Tiles linked at various angles to form a sort of wall are called **Panels**. You can find them in different sizes, with or without STUDS on the surface (e.g., the green "L-shaped" part, the white "L-shaped" part and the light blue "corner" part in **Figure 9**).

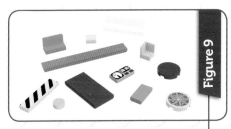

TILES & PANELS

TECHNIC BRICKS & ELEMENTS

Any component initially designed for LEGO® Technic sets, but also used for other sets, is called a **Technic Brick**. The red parts, the yellow part similar to a 1x2 brick and the orange part in **Figure 10** are Technic Bricks; the blue and yellow "L-shaped" parts are **Liftarms**; the two gray pieces are **Axles**, given their "X shape".

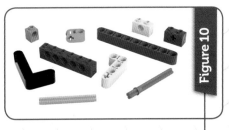

TECHNIC BRICKS & ELEMENTS

WHERE TO BUY
assorted loose parts

Though LEGO® sets are undoubtedly the company's most recognizable product, sooner or later every building enthusiast wants to create something without instructions (or maybe following the ones in this book!). Thus the time comes to stock up on what's known as "loose parts" in jargon: bricks, wheels, windows, doors and everything you need for your constructions.

There are several ways to obtain the necessary parts and components for freestyle creation.

For example, you can buy LEGO® sets from the "**Classic**" line (https://shop.lego.com/en-US/Classic-Sets)—boxes of parts and components that, when combined, make up a sort of "construction warehouse" to draw from. However, these parts and elements are very generic.

Designs like the ones in this book, or the ones you might find online, feature a wide range of parts and components, so buying the sets described above just may not be enough…

So, what to do? Easy! Just access **BrickLink**®: the most popular online platform among brick enthusiasts (AFOL—Adult Fan of LEGO® and TFOL—Teenage Fan of LEGO®).

Why is **BrickLink**® the best option?
1. Easy to use
2. Secure (as to both creating your order and payment method)
3. You can "upload" a design created with LEGO® DIGITAL DESIGNER onto a "shopping list" ("Wanted List" on **BrickLink**®) without having to make a previous list of the parts needed to build your model.

Use the following link or QR code to access a video explaining how to order off **BrickLink**®.

www.nuinui.ch/video/it/s05/lego-creations/bricklink-tutorial

TECHNIQUES AND "TRICKS"
to couple bricks

Like any other object, LEGO® bricks come in their own sizes as to length and height. However, unlike normal objects, you don't measure them in inches but in:

- **STUD**, the "buttons" we find on the surface on a brick

- **BRICK**, the height of the individual "classic" brick

- **PLATE**, the height of the individual "flat" brick

Equivalences between the different types of bricks are based on the "STUD measurement" system. For example:

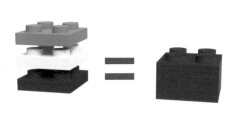

OR

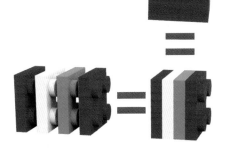

3 2x2 PLATES (STUD) horizontally wedged one on top of the other correspond to 1 2X2 BRICK (STUD) in height

4 2x2 PLATES wedged vertically correspond to 1 2x2 BRICK (STUD) in width

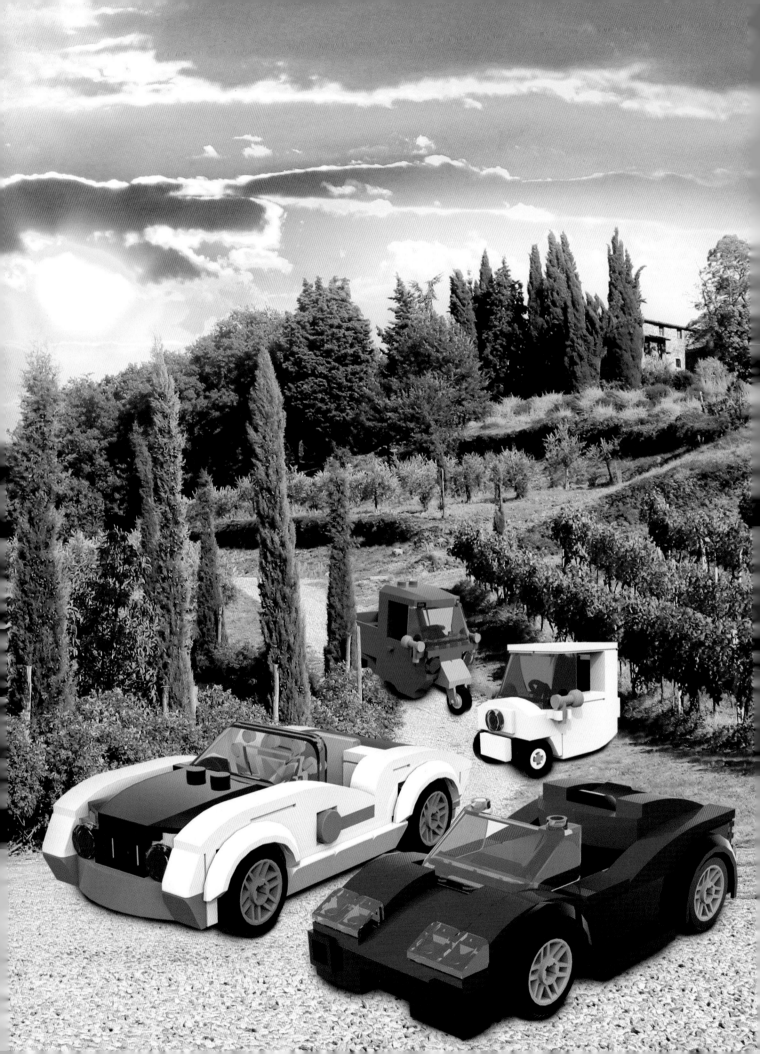

CARS AND TRUCKS

TIME TO HIT THE ROAD!

Let's start imagining the kind of trip we want to take with our creation.

Do we want to go into town or to the mountains?

Are we thinking about a recreational vehicle (like a sedan, sports car, SUV, etc.) or a work vehicle (like a van, truck, tow-truck, etc.)?

Be creative with your bricks!

It doesn't matter what kind of vehicle we're thinking of; the main thing is to be creative in imagining how to use our bricks.

Remember—even the plainest bricks can be used lots of different ways!

For example, take bricks like these (**A**): though plain, they can be used to create exhaust pipes (**B**) or to create the grille "logo" (**C**), or even to make a visible shock absorber (**D**).

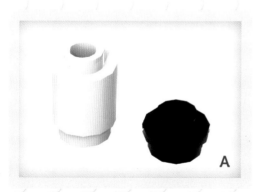

A

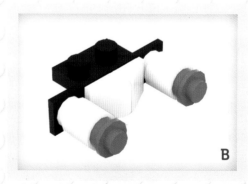

B

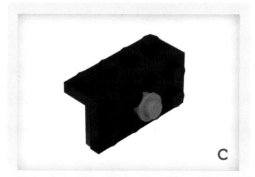

C

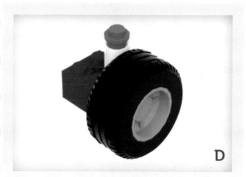

D

LEGO® brick version

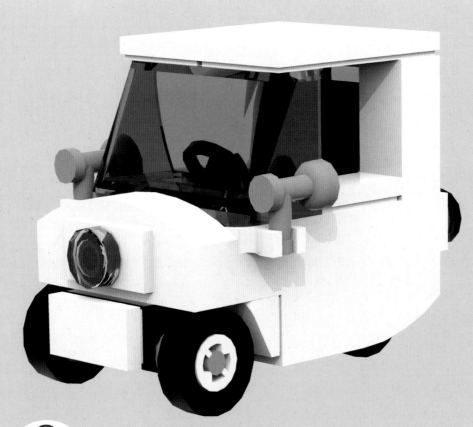

MODEL N.1

PEEL ENGINEERING P50

AUTHOR/DESIGNER: TOM NETHERTON

An automobile produced by the **Peel Engineering Company**, a car manufacturer located on the Isle of Man, the **Peel® P50** is regularly type-approved for road circulation, and considered the smallest, lightest vehicle in the world. It's 4.4 ft long and 3.3 ft wide, with a height of 4 ft. It weighs 130 lbs and has three wheels: a rear-wheel drive and two front wheels.

The engine, measuring 3 cubic inches, allows it to reach the astounding maximum speed of 38 mph! Among the vehicle's main features: **it lacks a reverse gear!**

TOM NETHERTON

An active soldier with the United States Army, Tom is studying Mechanical Engineering while he serves. He's been a brick enthusiast ever since he was 4 years old. Upon completing his term of service, he dreams of working for one of the main American car manufacturers as an engineer.

Features

- can fit (the torso of) a Minifigure in the driver's seat
- has 3 wheels, just like the original
- a special vehicle that will fit in no matter what "city" you've built!

List of bricks needed to build our Peel® P50

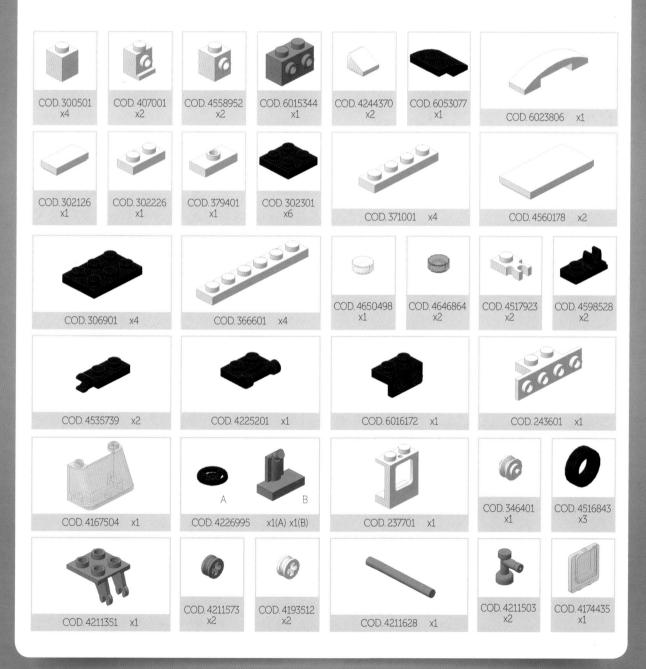

COD. 300501 x4

COD. 407001 x2

COD. 4558952 x2

COD. 6015344 x1

COD. 4244370 x2

COD. 6053077 x1

COD. 6023806 x1

COD. 302126 x1

COD. 302226 x1

COD. 379401 x1

COD. 302301 x6

COD. 371001 x4

COD. 4560178 x2

COD. 306901 x4

COD. 366601 x4

COD. 4650498 x1

COD. 4646864 x2

COD. 4517923 x2

COD. 4598528 x2

COD. 4535739 x2

COD. 4225201 x1

COD. 6016172 x1

COD. 243601 x1

COD. 4167504 x1

COD. 4226995 x1(A) x1(B)

COD. 237701 x1

COD. 346401 x1

COD. 4516843 x3

COD. 4211351 x1

COD. 4211573 x2

COD. 4193512 x2

COD. 4211628 x1

COD. 4211503 x2

COD. 4174435 x1

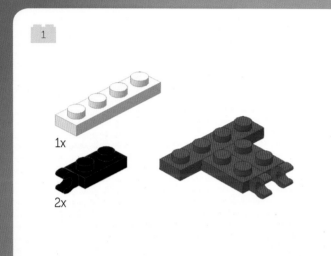

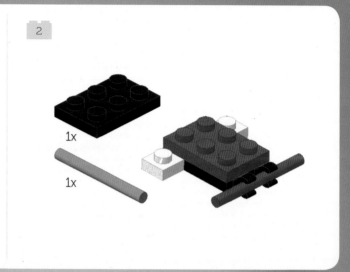

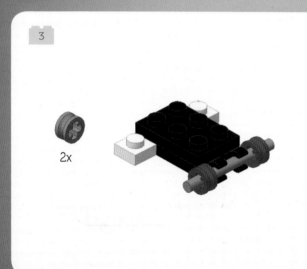

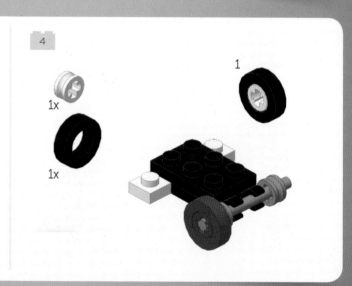

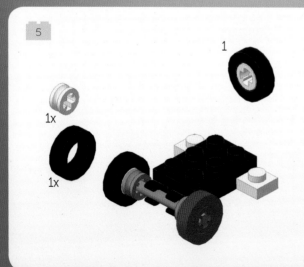

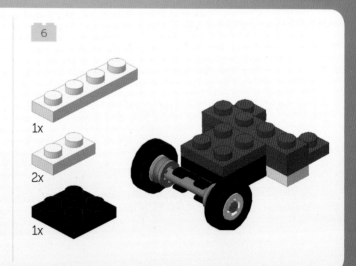

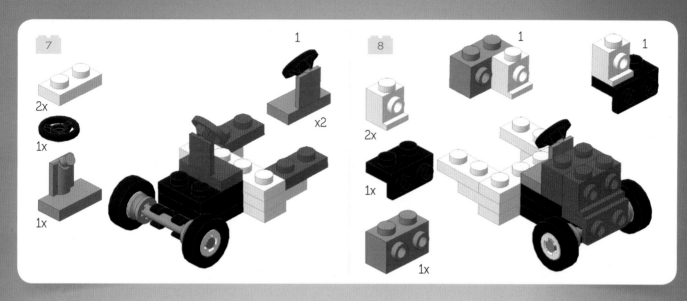

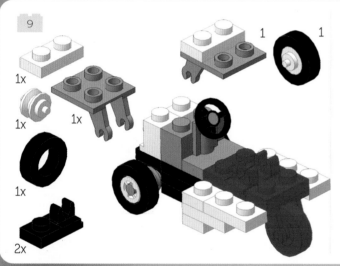

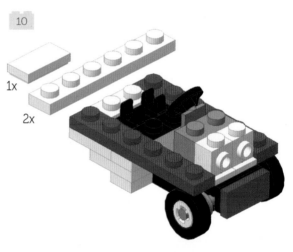

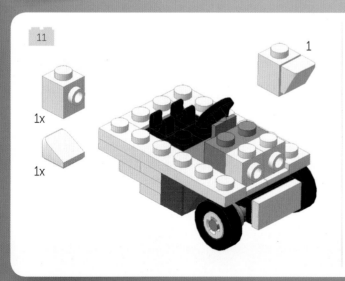

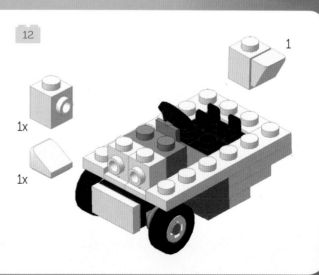

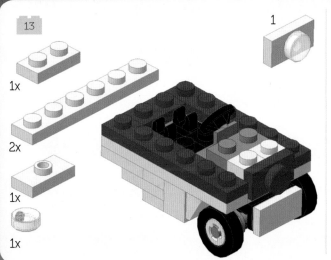

13

1x
2x
1x
1x

1

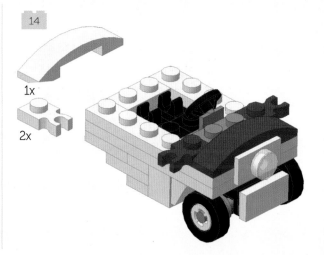

14

1x
2x

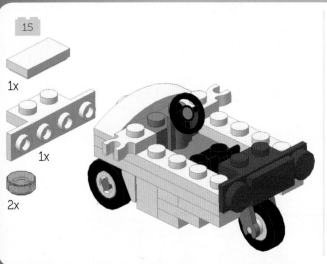

15

1x
1x
2x

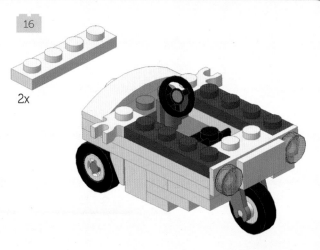

16

2x

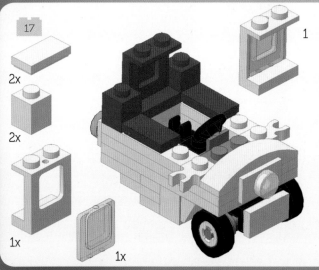

17

2x
2x
1x
1x

1

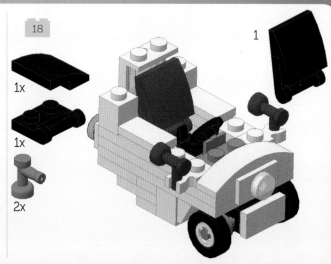

18

1x
1x
2x

1

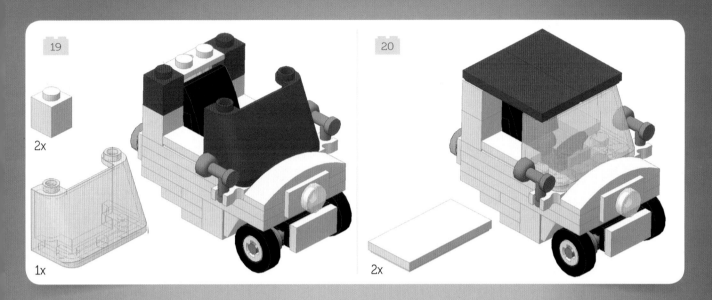

19

2x

1x

20

2x

21

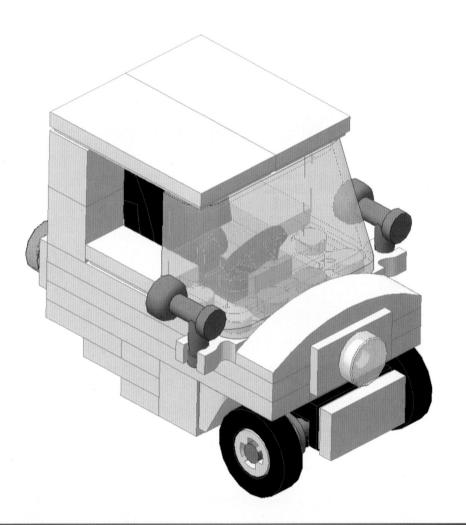

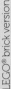

LEGO® brick version

www.nuinui.ch/upload/legocreations-p22.zip

MODEL N.2

PIAGGIO® "APE"

AUTHOR/DESIGNER: KAMAL MUFTIE YAFI

This "three-wheel" vehicle, a true icon of Italian design, was launched in 1948, when Italy still bore the ravages of World War II. There was an obvious shortage of means of transportation, but few could afford the "luxury" of a four-wheel vehicle.

Thus Piaggio® came up with the idea of building a commercial three-wheel vehicle: a three-wheel delivery van derived from a scooter. The earliest model was built based on a Vespa®.

KAMAL MUFTIE YAFI

Kamal is a 14-year-old boy who lives in Jakarta, Indonesia, where he currently attends high school. He's always been a brick enthusiast, but began creating his own models only recently.

Features

- doors that really open
- can fit a Minifigure in the driver's seat
- possibility of loading "goods" in the cargo bed

List of bricks needed to build our Piaggio® "APE"

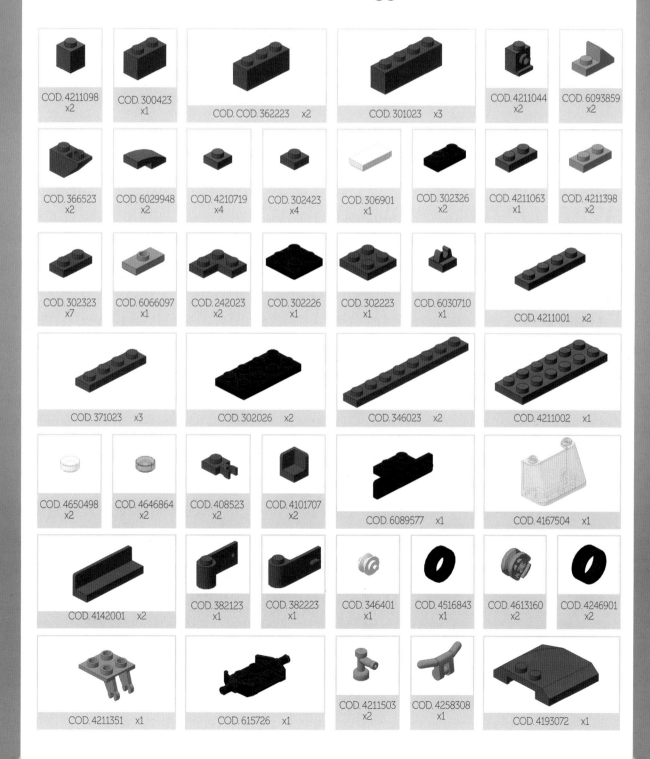

COD. 4211098 x2	COD. 300423 x1

COD. COD. 362223 x2

COD. 301023 x3

COD. 4211044 x2

COD. 6093859 x2

COD. 366523 x2

COD. 6029948 x2

COD. 4210719 x4

COD. 302423 x4

COD. 306901 x1

COD. 302326 x2

COD. 4211063 x1

COD. 4211398 x2

COD. 302323 x7

COD. 6066097 x1

COD. 242023 x2

COD. 302226 x1

COD. 302223 x1

COD. 6030710 x1

COD. 4211001 x2

COD. 371023 x3

COD. 302026 x2

COD. 346023 x2

COD. 4211002 x1

COD. 4650498 x2

COD. 4646864 x2

COD. 408523 x2

COD. 4101707 x2

COD. 6089577 x1

COD. 4167504 x1

COD. 4142001 x2

COD. 382123 x1

COD. 382223 x1

COD. 346401 x1

COD. 4516843 x1

COD. 4613160 x2

COD. 4246901 x2

COD. 4211351 x1

COD. 615726 x1

COD. 4211503 x2

COD. 4258308 x1

COD. 4193072 x1

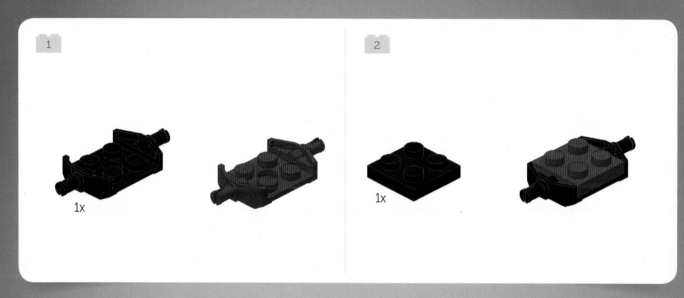

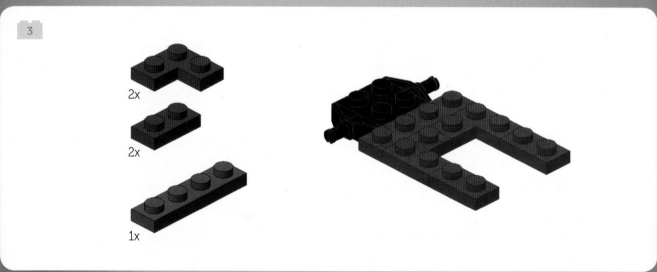

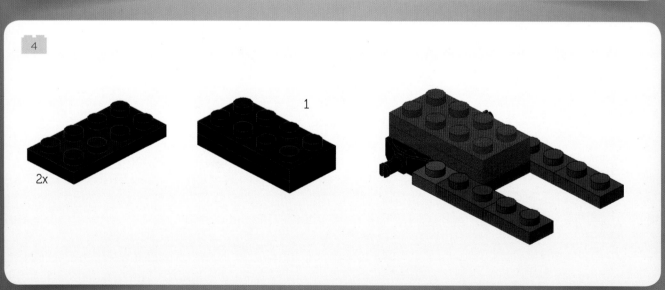

5

1x

1

x2

1x

2x

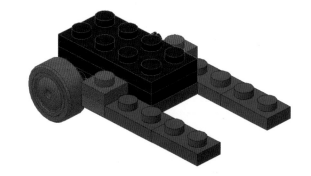

6

1x

1

1x

7

1x

1x

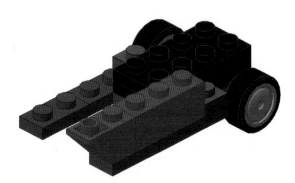

8

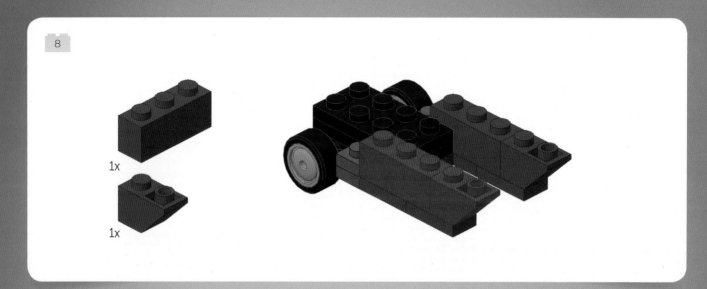

1x

1x

9

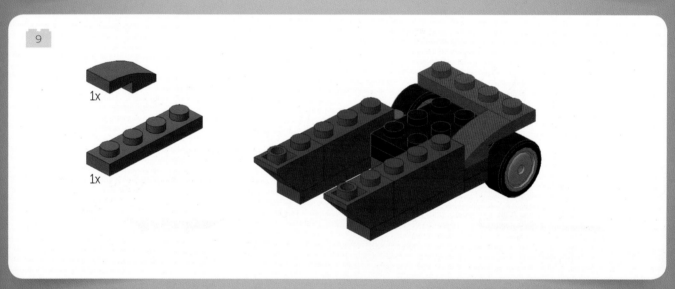

1x

1x

10

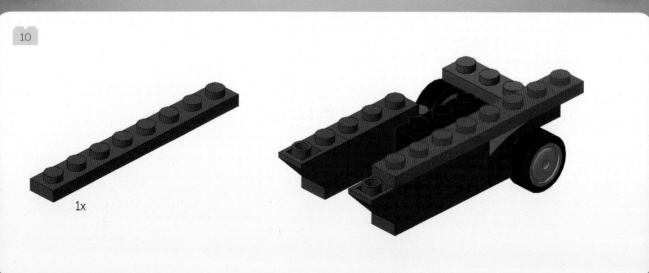

1x

11

1x

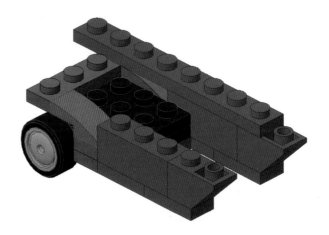

12

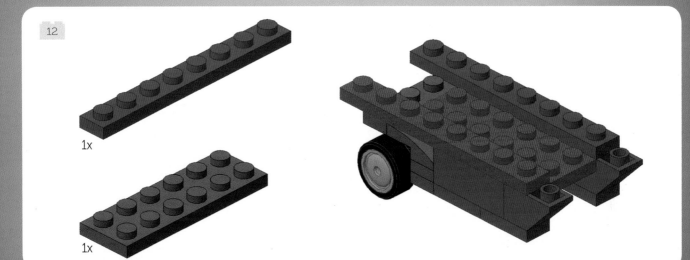

1x

1x

13

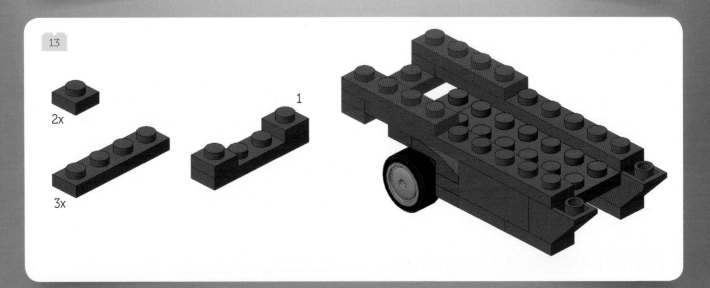

2x

3x

1

14

1x

1x

2x

1

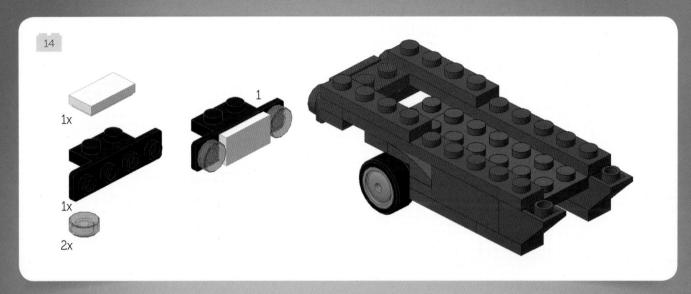

15

1x

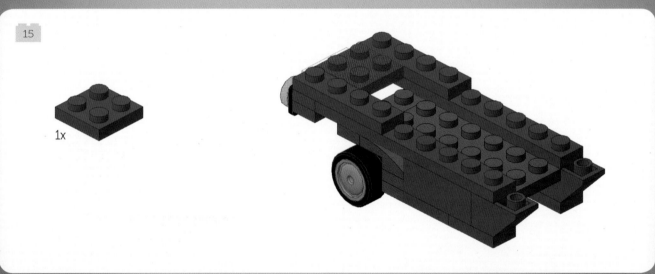

16

2x

1

1x

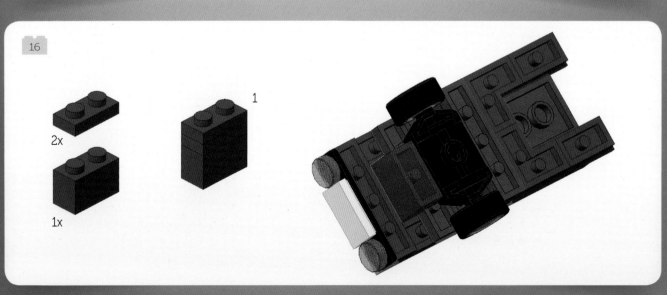

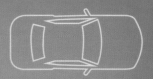

17

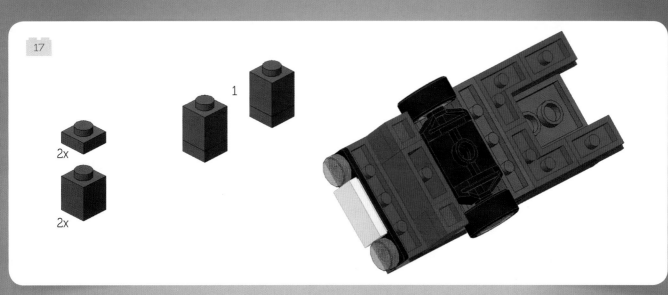

2x

2x

1

18

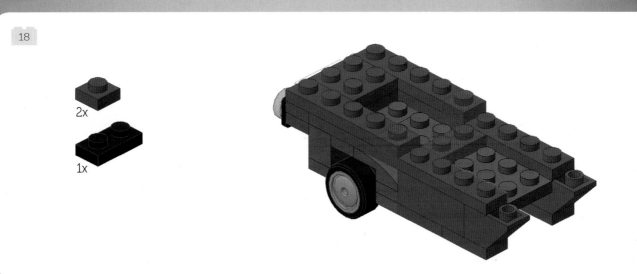

2x

1x

19

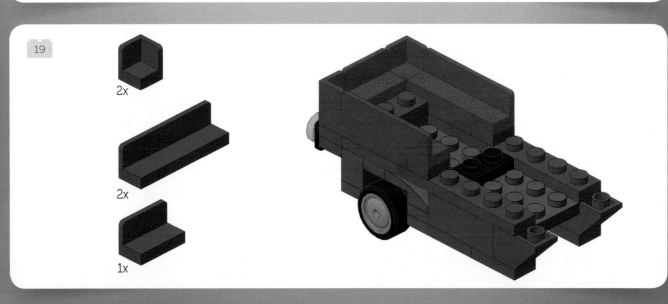

2x

2x

1x

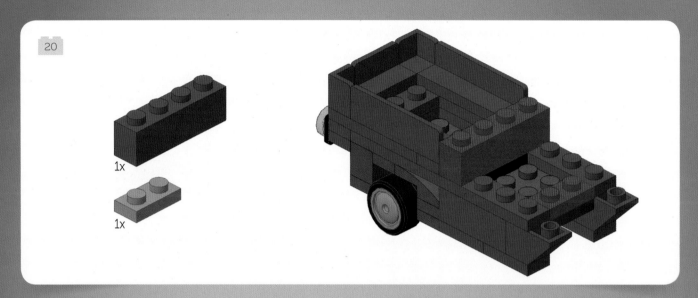

20

1x

1x

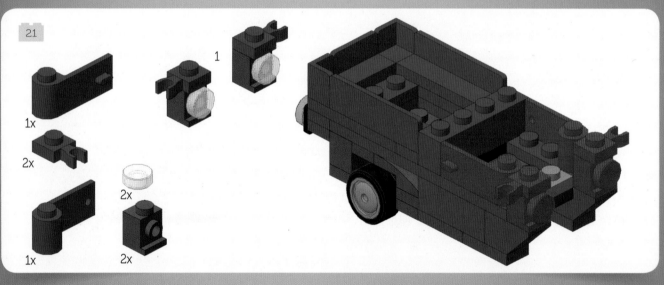

21

1x

2x

1

2x

1x

2x

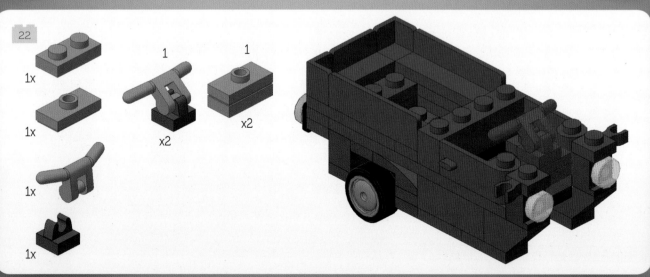

22

1x

1x

1

1

x2

x2

1x

1x

23

1x

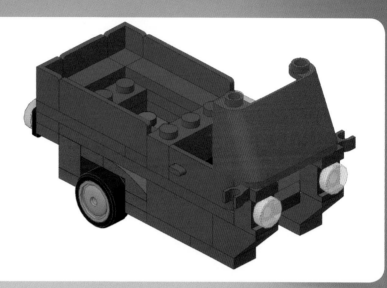

24

2x

2x

1x

1x

1x

1

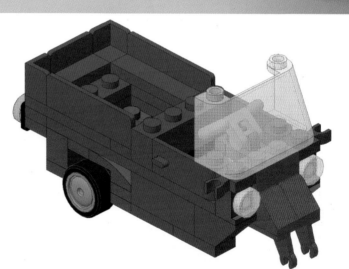

25

1x

1x

1

x2

2x

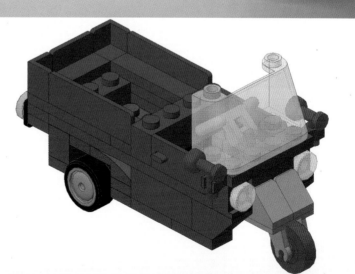

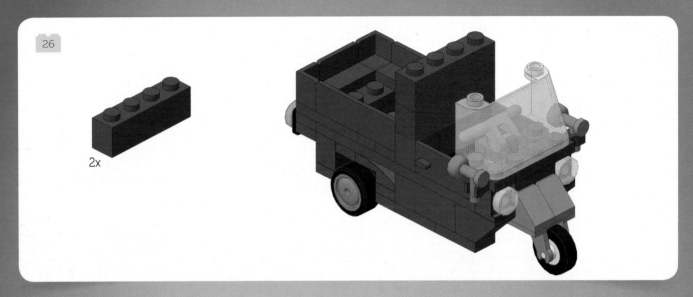

26

2x

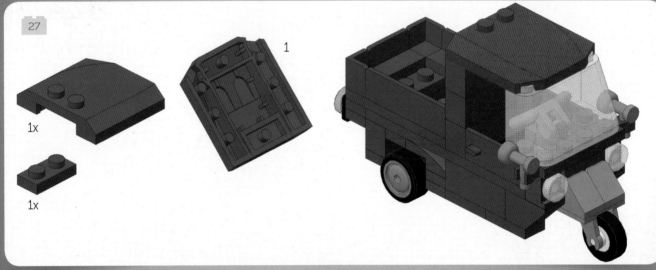

27

1x

1x

1

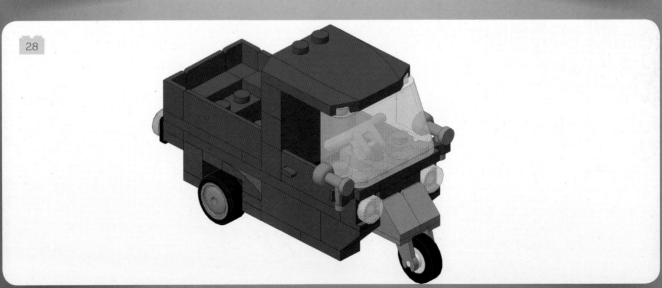

28

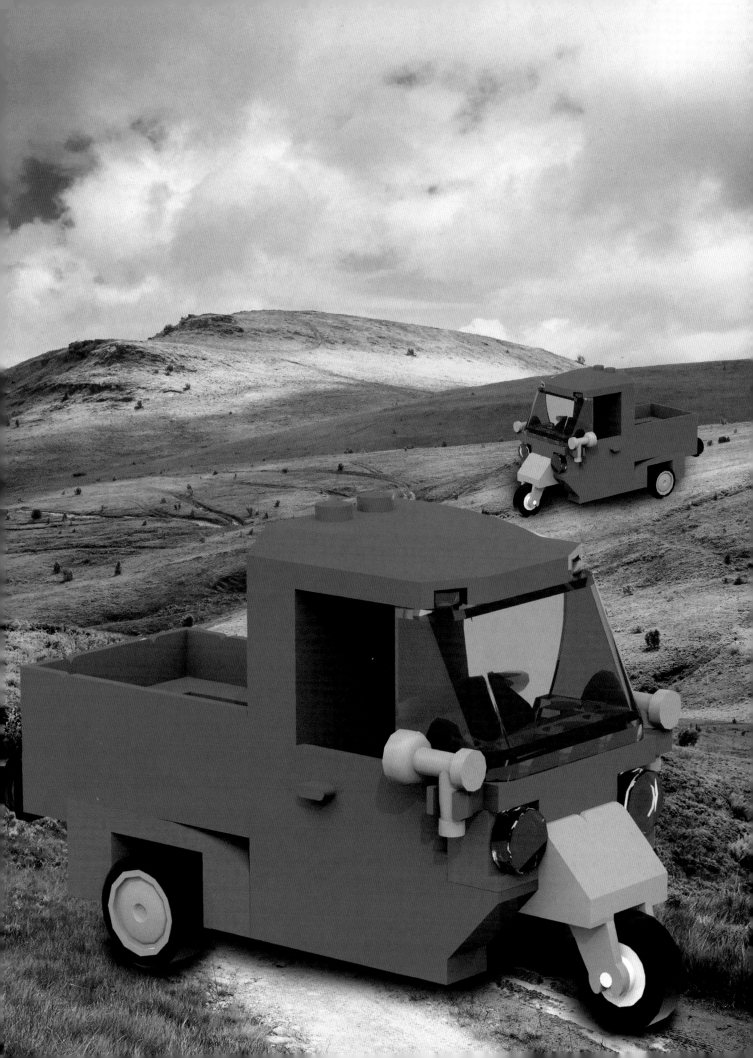

LEGO® brick version

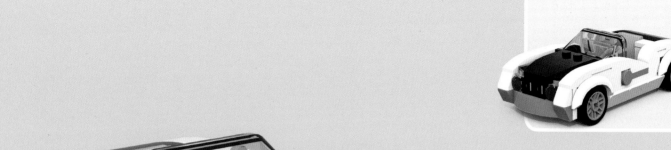

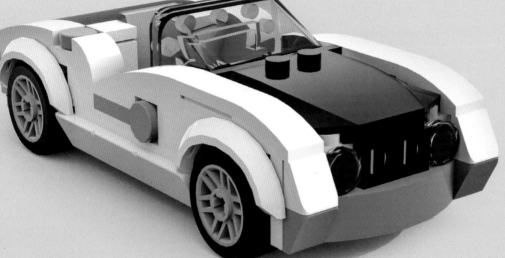

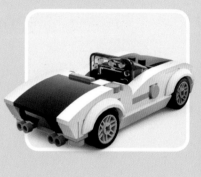

www.nuinui.ch/upload/legocreations-p34.zip

MODEL N.3

A "VINTAGE" ROADSTER

AUTHOR/DESIGNER: IVAN POPOV

Originally, the term *roadster* referred to an open-top, two-seater vehicle which, unlike a *convertible*, didn't have roll-down side windows. Basically, and in spite of the sliding roof, passengers were still exposed to the weather. Nowadays, the term *roadster* is used to indicate lightweight sports vehicles (still two-seaters), equipped with a "soft-top" (a folding fabric roofing) or a "hard-top" (metal or plastic roofing). Today they do have side windows, though with no pillars.

IVAN POPOV
A native of Kiev, Ukraine, Ivan is 26 years old and lives in Moscow, Russia. Just like Tom, Ivan began playing with bricks at the age of 4, and all he did was... "play" with them until 8 years ago, when he started building his own models—mostly brick and "City" scale "replicas" of famous cars.

Features

- classic "vintage" British roadster look
- can fit a Minifigure in the driver's seat

List of bricks needed to build our "vintage" Roadster

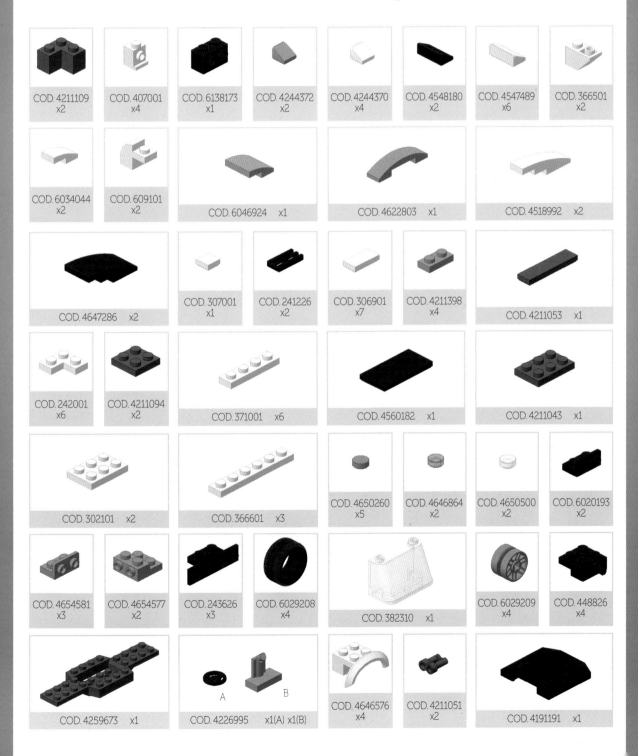

COD. 4211109 x2

COD. 407001 x4

COD. 6138173 x1

COD. 4244372 x2

COD. 4244370 x4

COD. 4548180 x2

COD. 4547489 x6

COD. 366501 x2

COD. 6034044 x2

COD. 609101 x2

COD. 6046924 x1

COD. 4622803 x1

COD. 4518992 x2

COD. 4647286 x2

COD. 307001 x1

COD. 241226 x2

COD. 306901 x7

COD. 4211398 x4

COD. 4211053 x1

COD. 242001 x6

COD. 4211094 x2

COD. 371001 x6

COD. 4560182 x1

COD. 4211043 x1

COD. 302101 x2

COD. 366601 x3

COD. 4650260 x5

COD. 4646864 x2

COD. 4650500 x2

COD. 6020193 x2

COD. 4654581 x3

COD. 4654577 x2

COD. 243626 x3

COD. 6029208 x4

COD. 382310 x1

COD. 6029209 x4

COD. 448826 x4

COD. 4259673 x1

COD. 4226995 x1(A) x1(B)

COD. 4646576 x4

COD. 4211051 x2

COD. 4191191 x1

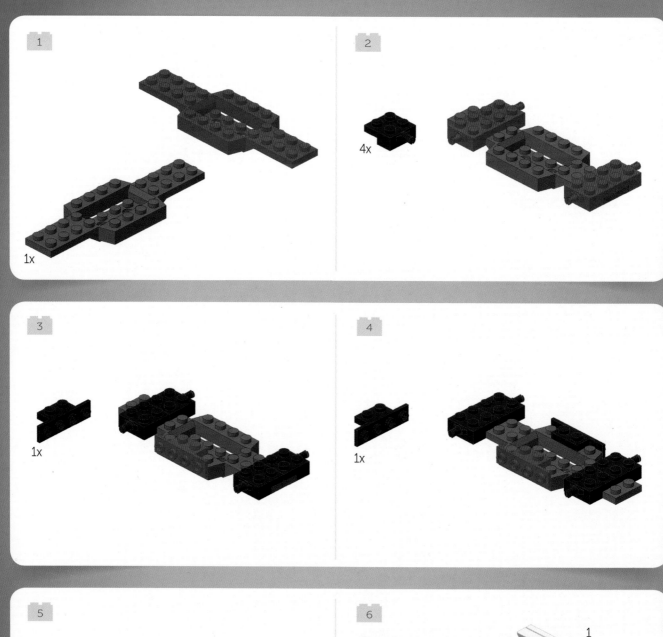

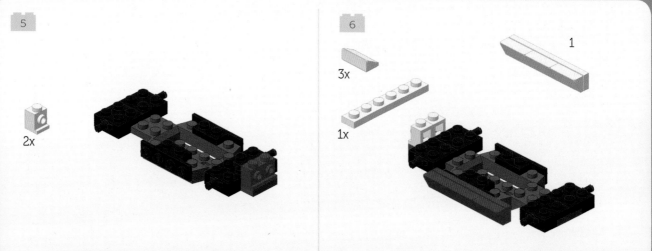

7

3x

1x

1

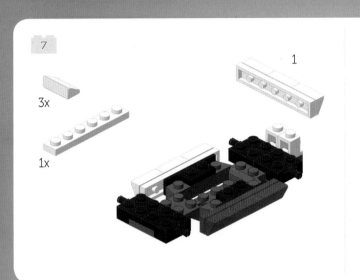

8

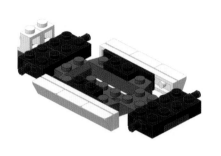

9

2x

2x

1x

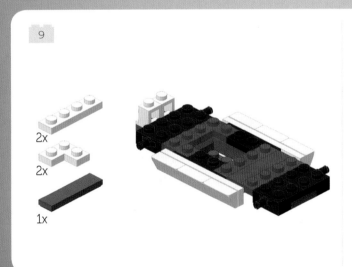

10

1x

1x

1

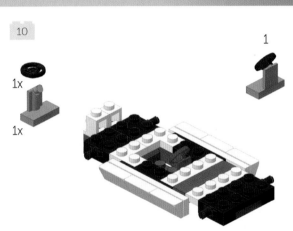

11

2x

2x

1

x2

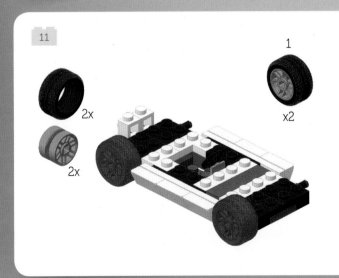

12

2x

2x

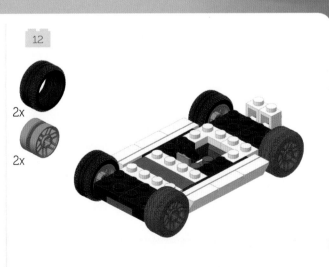

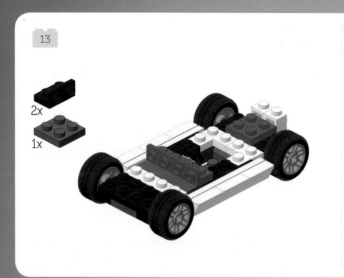

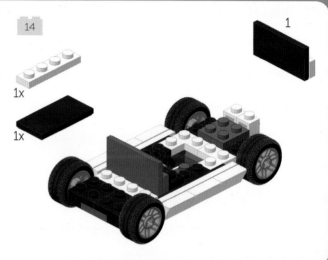

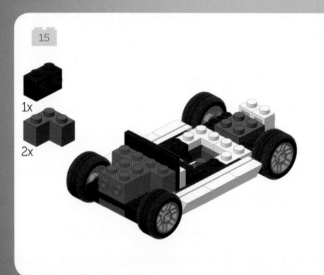

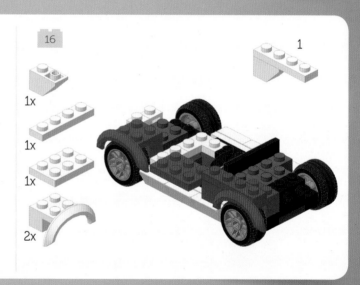

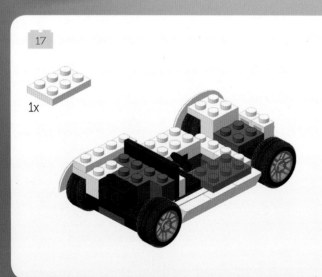

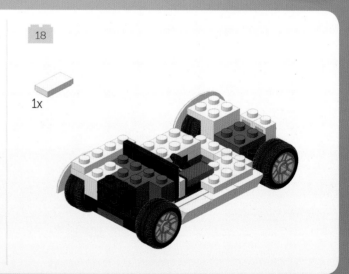

19

1x
1x
1x
1

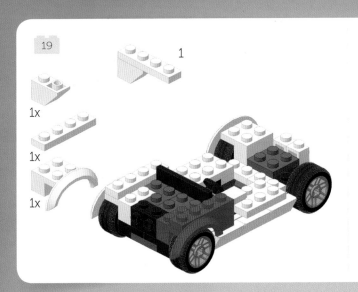

20

1x

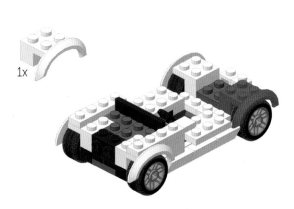

21

1x
1x
1x
1x
1

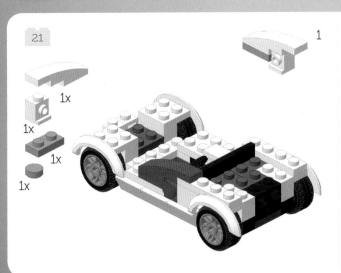

22

1x
1x
1x
1x
1

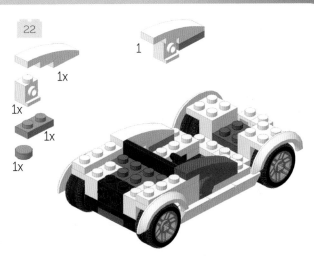

23

1x
2x
2x
2x
2x
1
1
x3

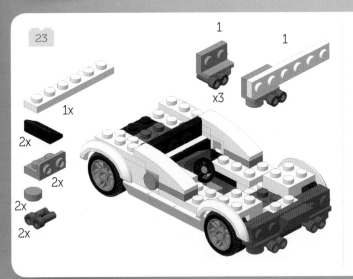

24

2x
2x

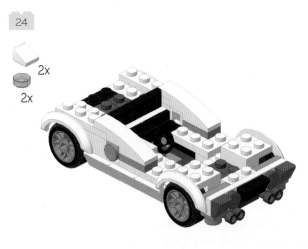

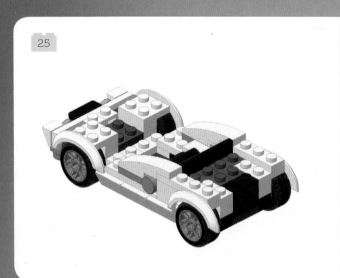

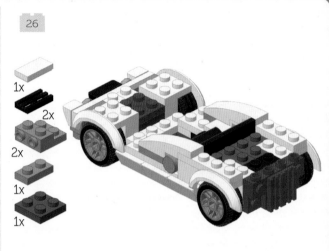

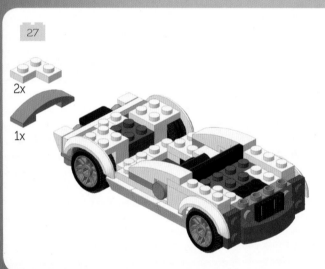

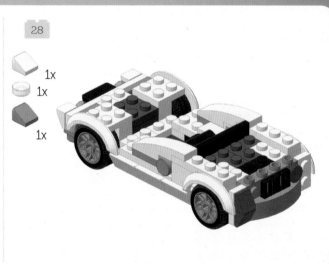

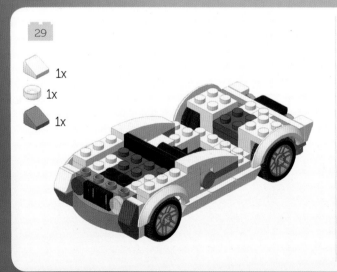

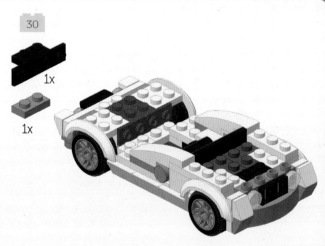

31

1x

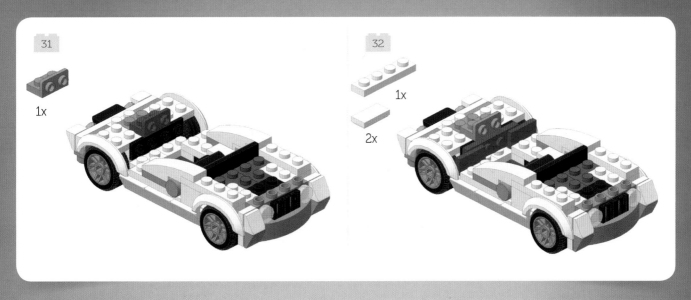

32

1x

2x

33

1x

1x

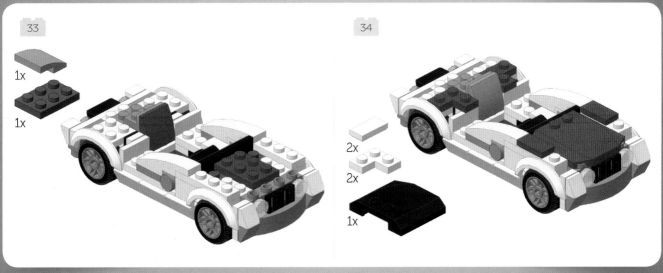

34

2x

2x

1x

35

2x

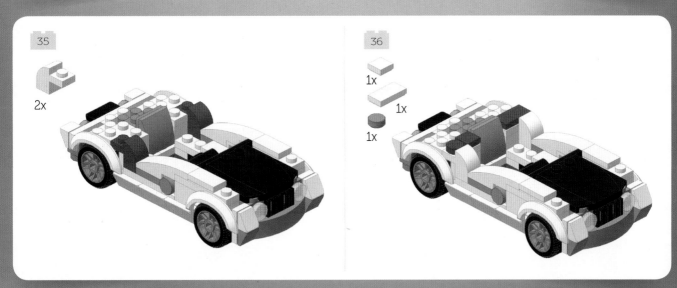

36

1x

1x

1x

37

2x

2x

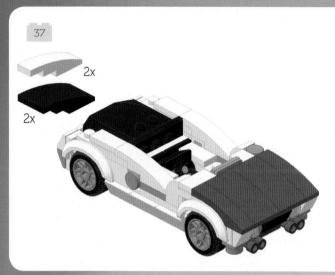

38

1x

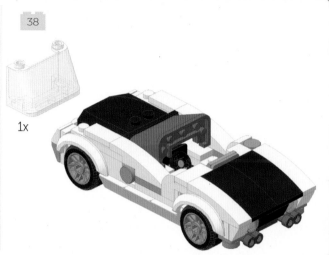

39

2x

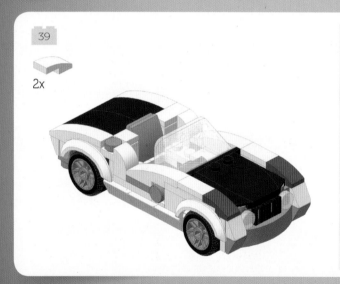

40

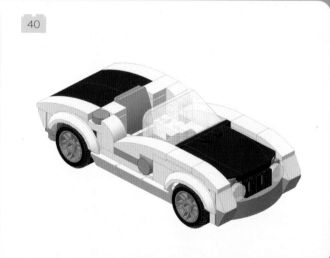

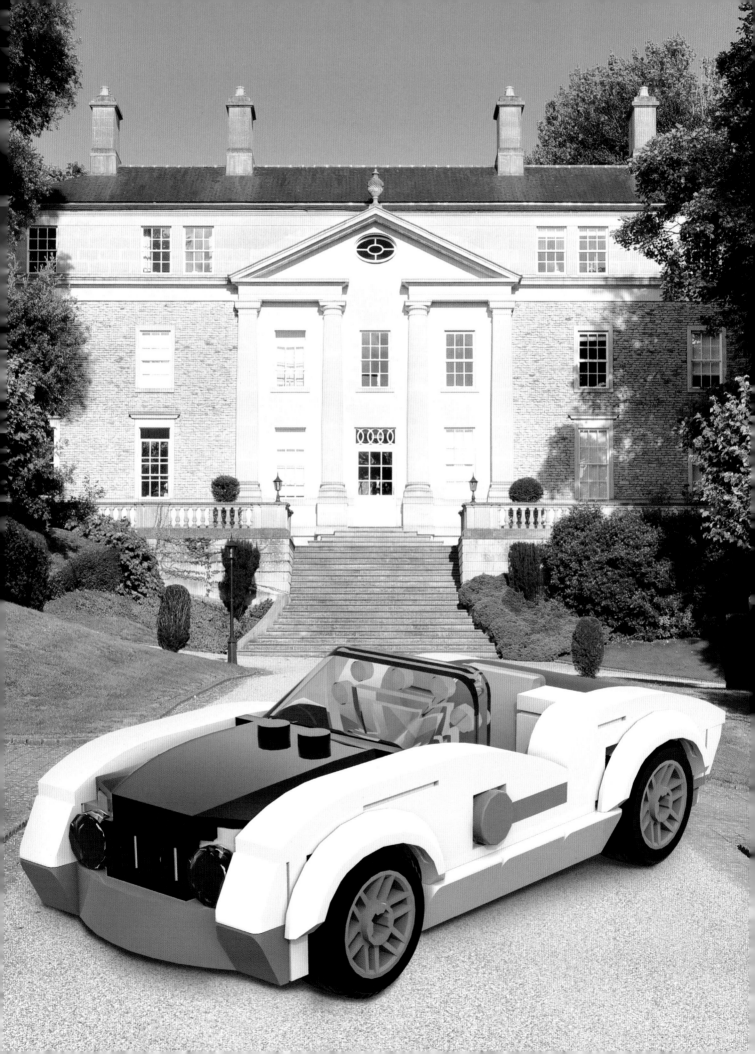

LEGO® brick version

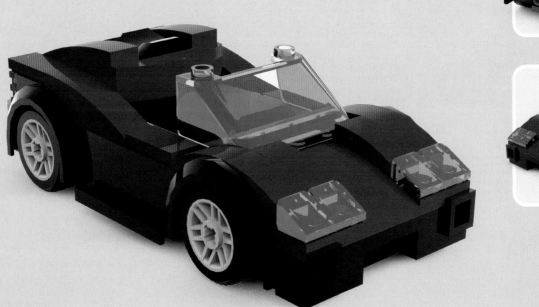

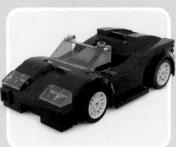

www.nuinui.ch/upload/legocreations-p44.zip

MODEL N.4

MCLAREN® MP4-12C

AUTHOR/DESIGNER: IVAN POPOV

The McLaren® MP4-12C is a "Grand Tourer" built by the British car manufacturer of the same name. The vehicle is propelled by a "V-shaped" cylinder engine created based on a Nissan® engine designed for endurance racing and used in competitions like the 24 Hours of Le Mans. The maximum speed declared is 205 mph; it goes from 0 to 62 mph in 3.3 seconds and from 0 to 124 mph in 8.9 seconds!

Features

- classic "Supercar" look
- can fit a Minifigure in the driver's seat
- presented here in the *roadster* (convertible) version

List of bricks needed to build our McLaren® MP4-12C

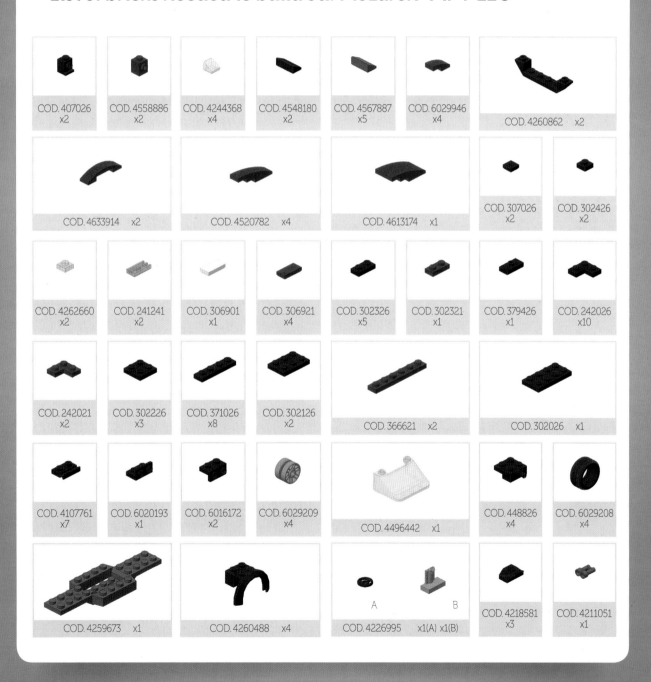

COD. 407026 x2	COD. 4558886 x2	COD. 4244368 x4	COD. 4548180 x2	COD. 4567887 x5	COD. 6029946 x4	COD. 4260862 x2	
COD. 4633914 x2		COD. 4520782 x4		COD. 4613174 x1	COD. 307026 x2	COD. 302426 x2	
COD. 4262660 x2	COD. 241241 x2	COD. 306901 x1	COD. 306921 x4	COD. 302326 x5	COD. 302321 x1	COD. 379426 x1	COD. 242026 x10
COD. 242021 x2	COD. 302226 x3	COD. 371026 x8	COD. 302126 x2	COD. 366621 x2		COD. 302026 x1	
COD. 4107761 x7	COD. 6020193 x1	COD. 6016172 x2	COD. 6029209 x4	COD. 4496442 x1	COD. 448826 x4	COD. 6029208 x4	
COD. 4259673 x1	COD. 4260488 x4	COD. 4226995 x1(A) x1(B)		COD. 4218581 x3	COD. 4211051 x1		

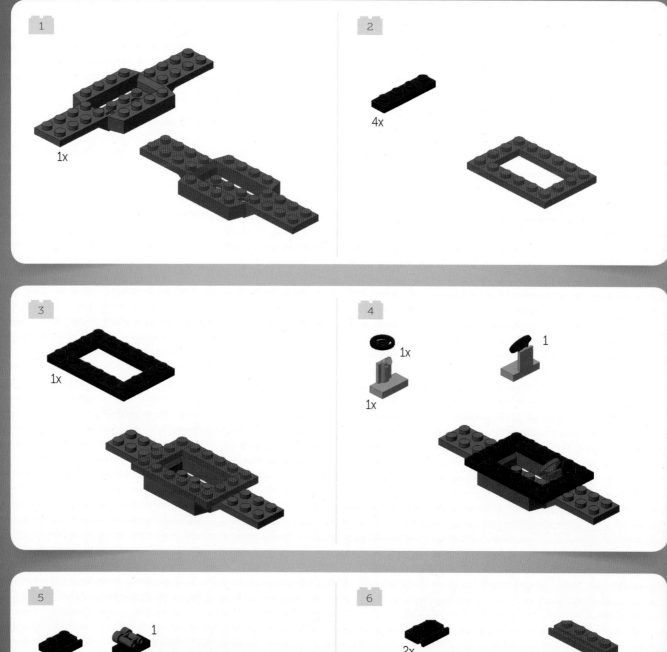

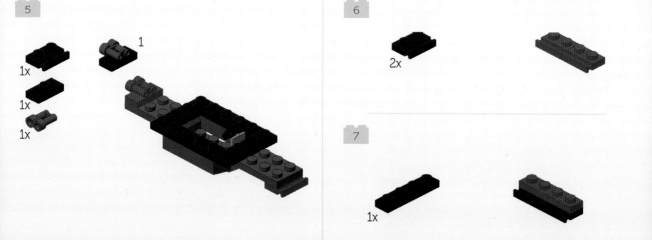

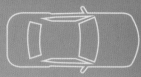

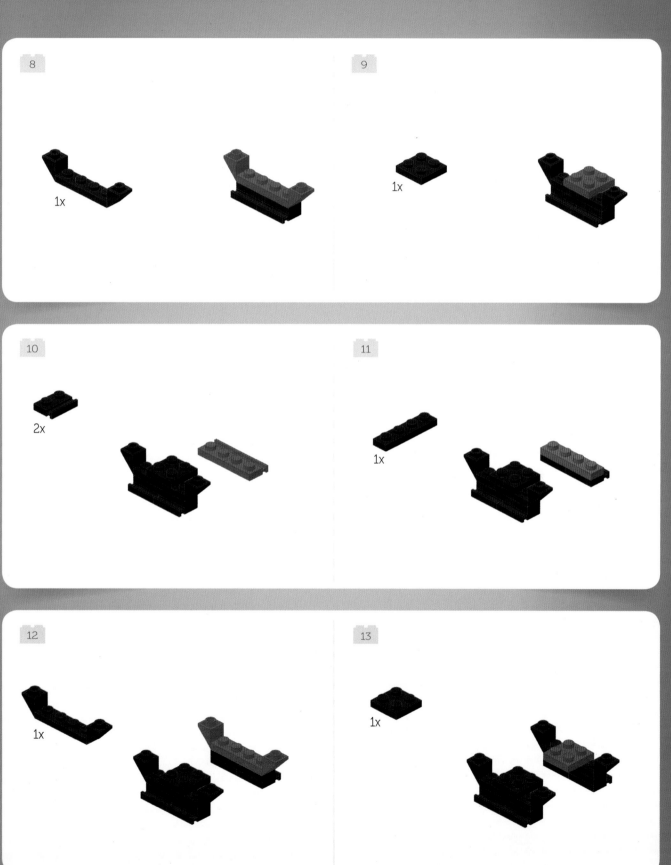

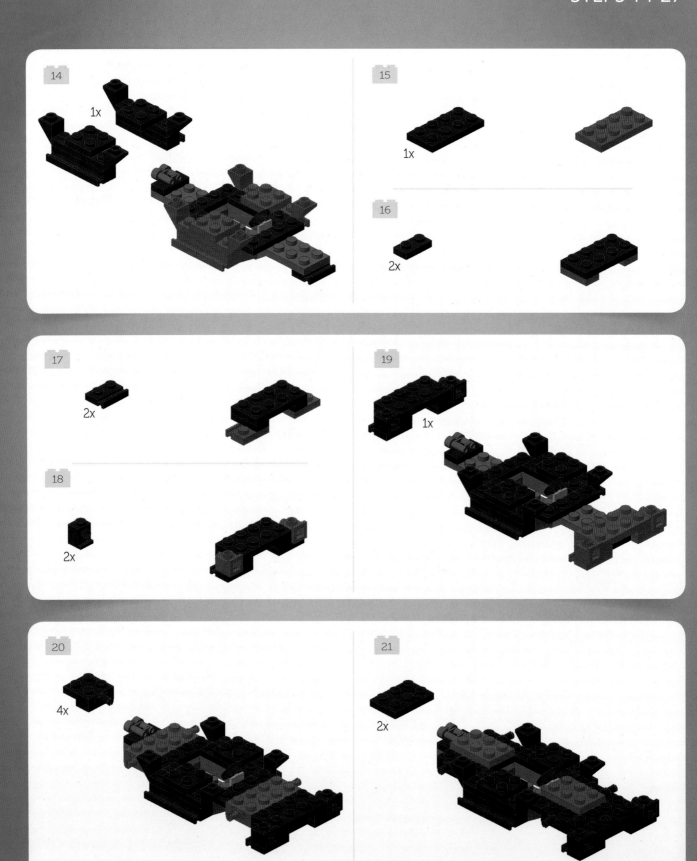

14 1x

15 1x

16 2x

17 2x

18 2x

19 1x

20 4x

21 2x

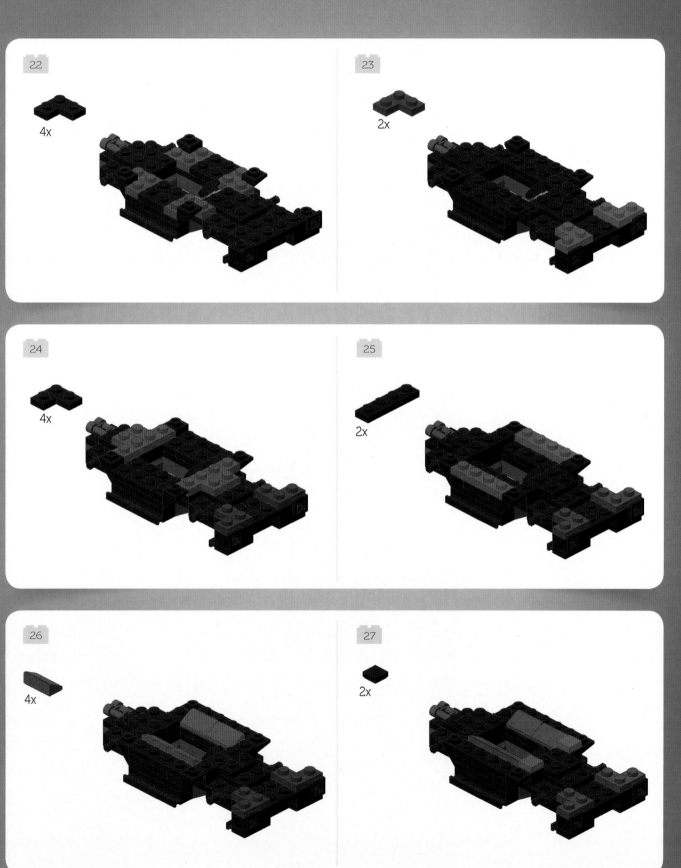

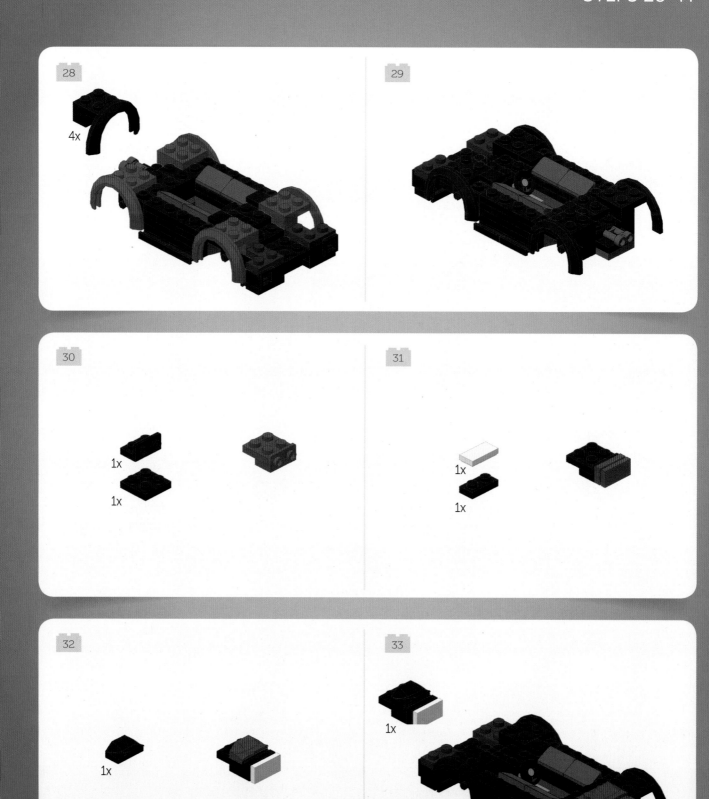

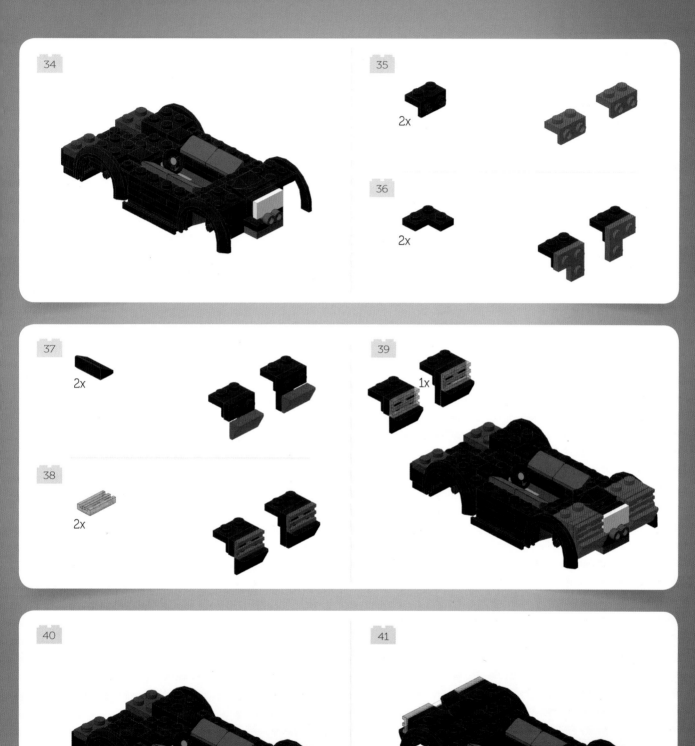

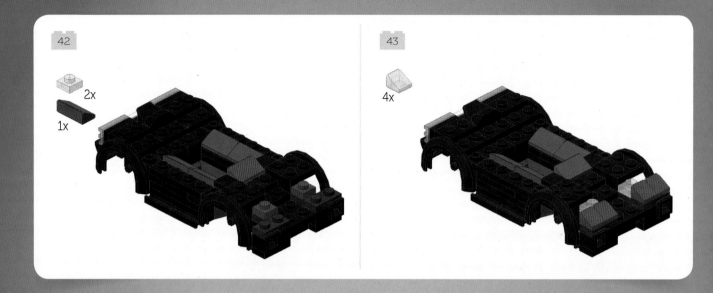

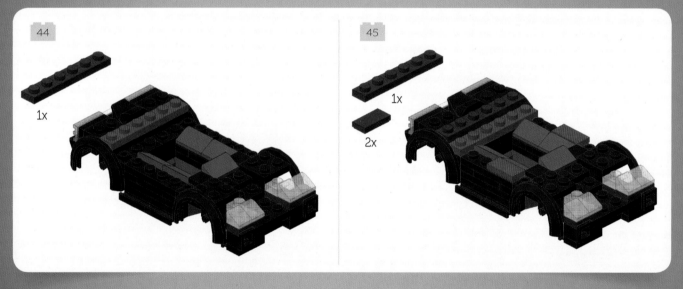

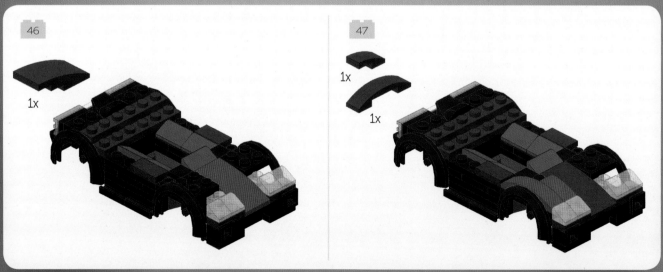

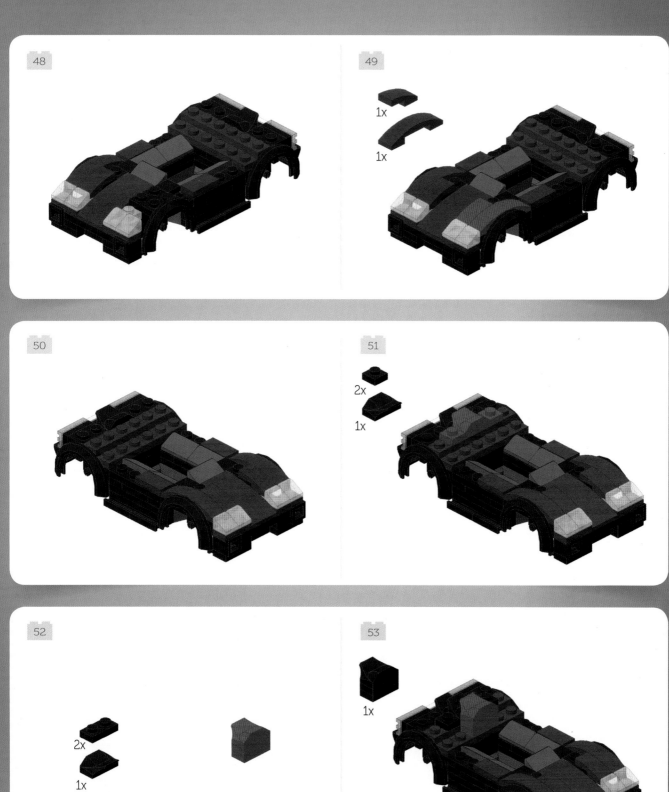

54

2x

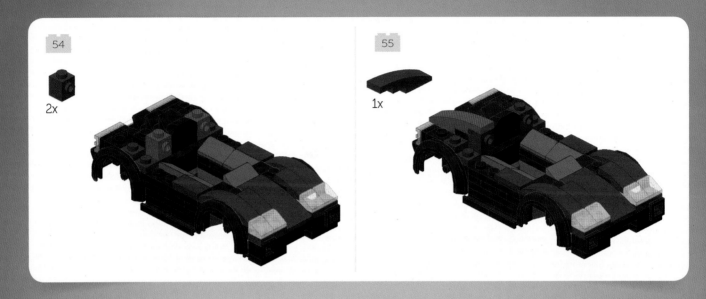

55

1x

56

1x

1x

57

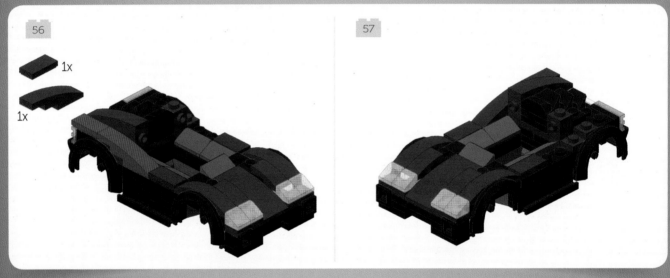

58

1x

59

1x

1x

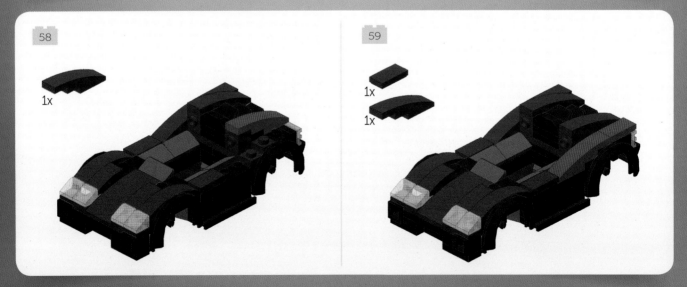

60

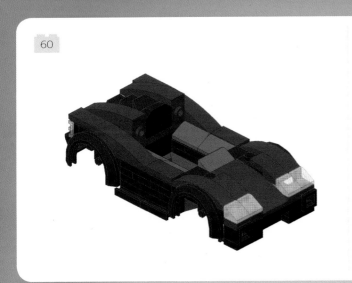

61

1

4x

x4

4x

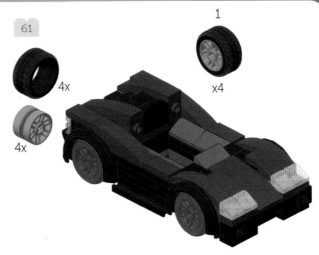

62

1x

63

1x

64

1x

65

1x

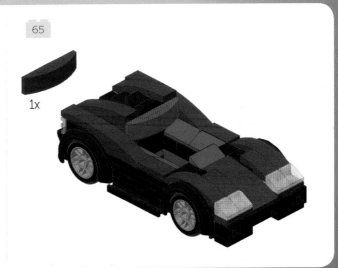

66

1x

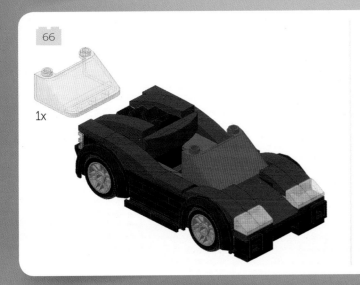

67

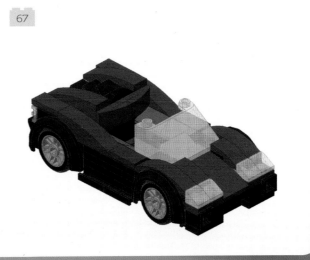

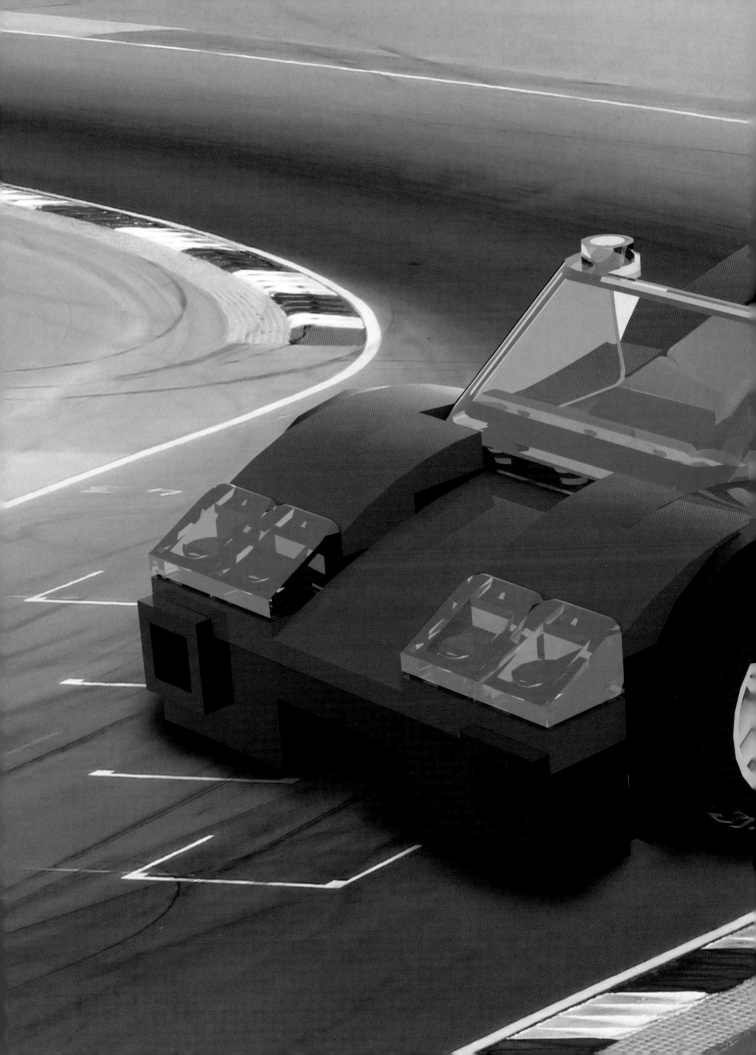

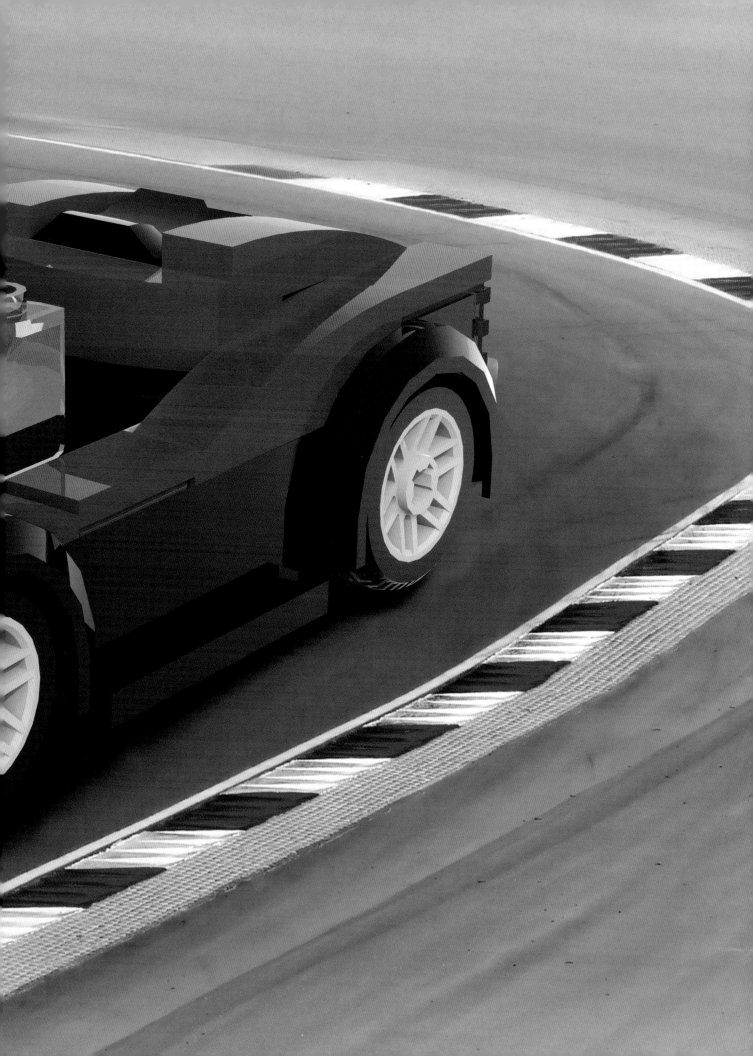

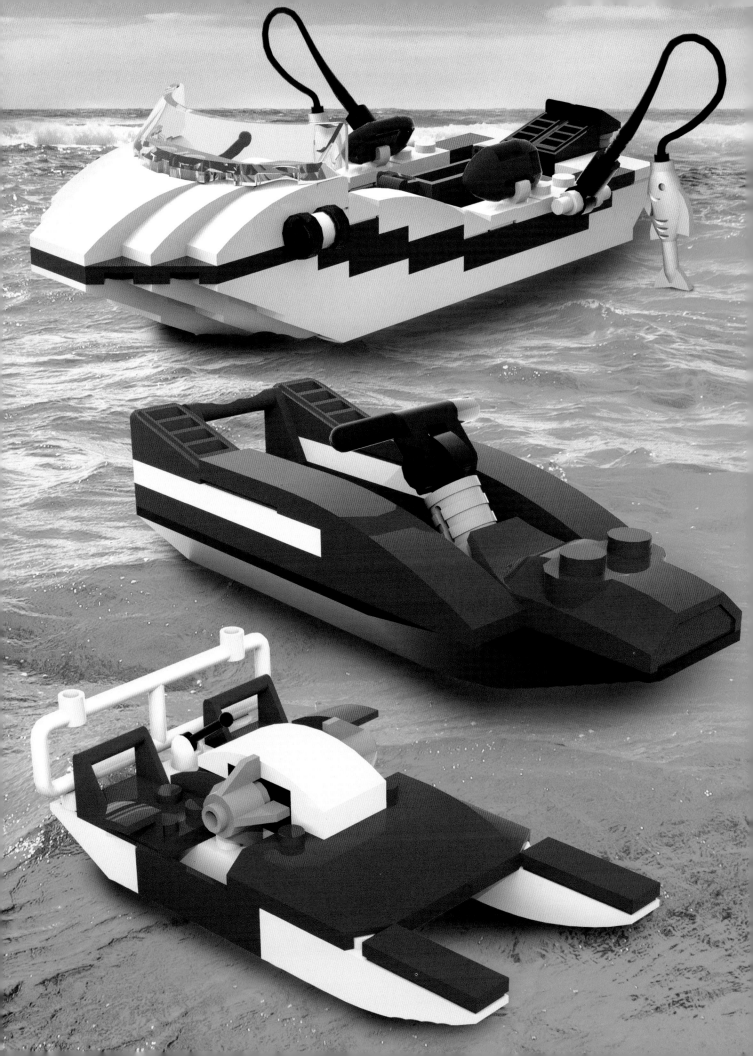

BOATS AND SHIPS

SEA? HERE WE COME!

Like we've already seen with wheeled vehicles, certain bricks are especially suitable to build "floating" vehicles—ships, boats and anything that's meant to go on the water.

Take bricks like this (**A**), for example: they're perfect to create bows, sterns and hulls!

And don't forget rudders and the inevitable propellers (**B**).

Happy "seas" and... let's start building!

A

B

LEGO® brick version

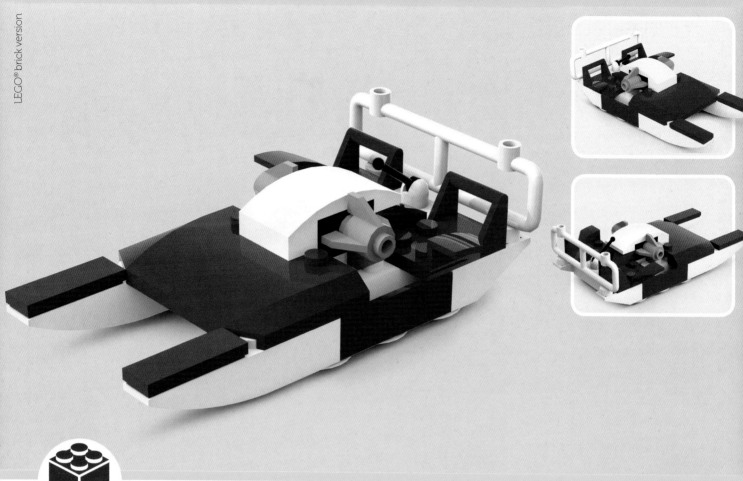

www.nuinui.ch/upload/legocreations-p60.zip

MODEL N.5

THE CLASSIC "PEDAL BOAT"

MODEL: TIM JOHNSON
CREATION: FRANCESCO FRANGIOJA

Who's never taken a ride on a pedal boat during a seaside vacation? This type of watercraft, a familiar sight in any seaside resort, is a sort of small paddleboat, propelled by the action of pedals "maneuvered" by the passengers themselves. The faster you pedal, the faster you'll go!

TIM JOHNSON

A producer of digital content in real life, Tim Johnson has collected over 120,000 LEGO® bricks over the years. He still keeps the empty boxes from each and every set he buys, just like when he was a kid. He specializes in micro-scale "Architecture" constructions (the LEGO® theme that honors great architectural works from all over the world). He draws inspiration from the internet and his own imagination to build his models.

Features

- summer livery in classic colors (red and white)
- can fit two Minifigures
- doesn't float if you put it in water

List of bricks needed to build our Pedal Boat

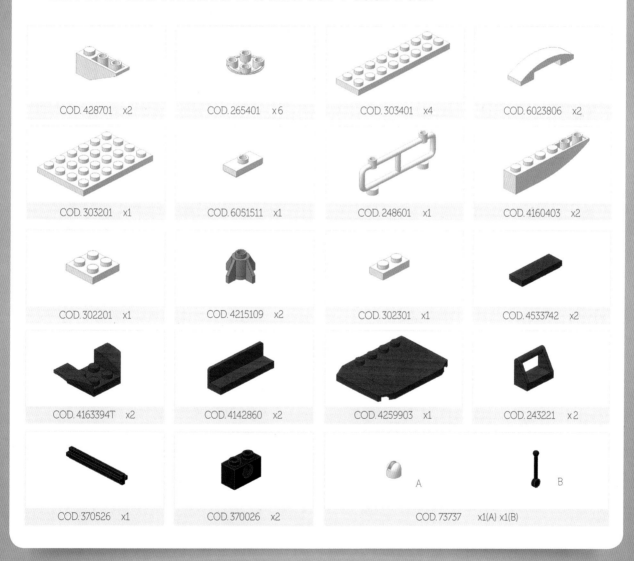

COD. 428701 x2	COD. 265401 x6	COD. 303401 x4	COD. 6023806 x2
COD. 303201 x1	COD. 6051511 x1	COD. 248601 x1	COD. 4160403 x2
COD. 302201 x1	COD. 4215109 x2	COD. 302301 x1	COD. 4533742 x2
COD. 4163394T x2	COD. 4142860 x2	COD. 4259903 x1	COD. 243221 x2
COD. 370526 x1	COD. 370026 x2	COD. 73737 x1(A) x1(B)	

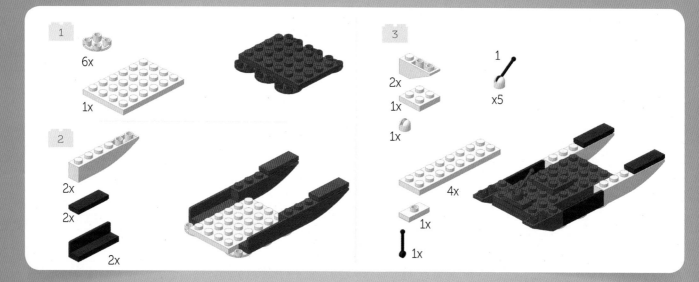

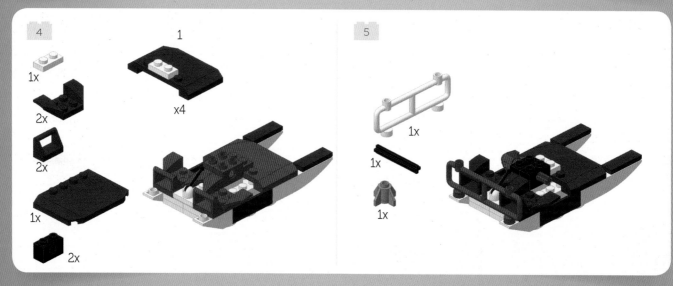

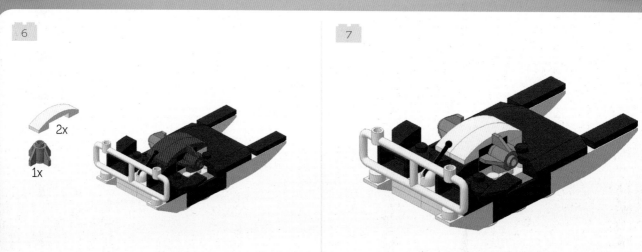

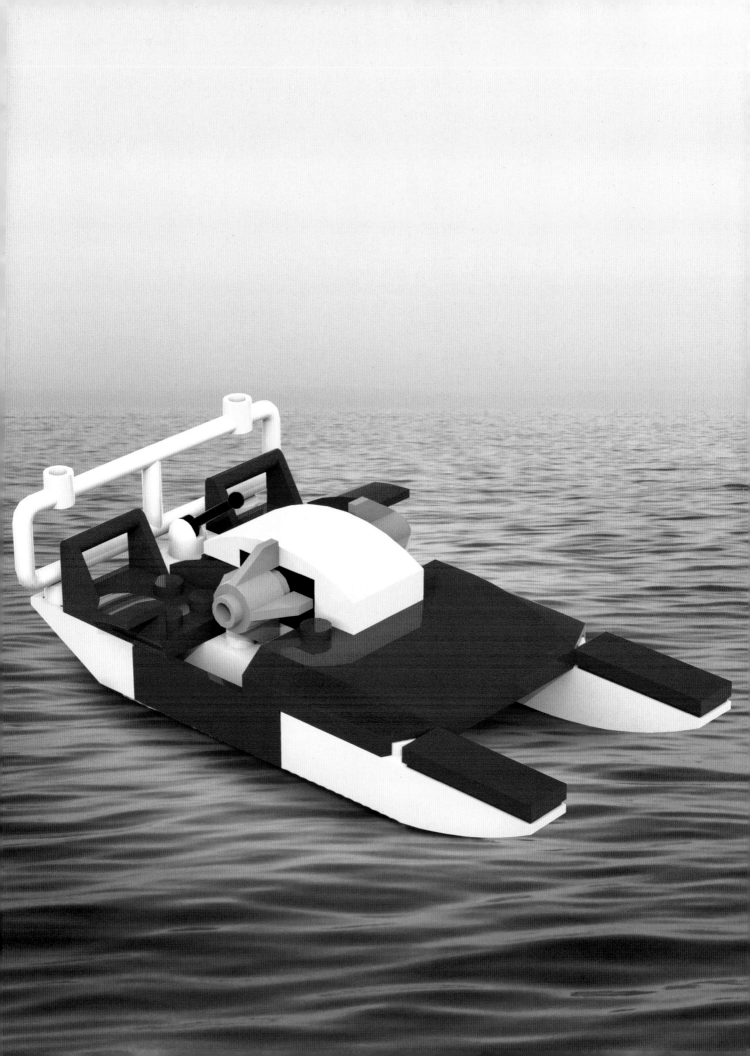

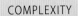
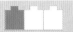
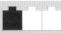

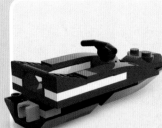

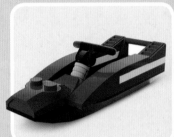

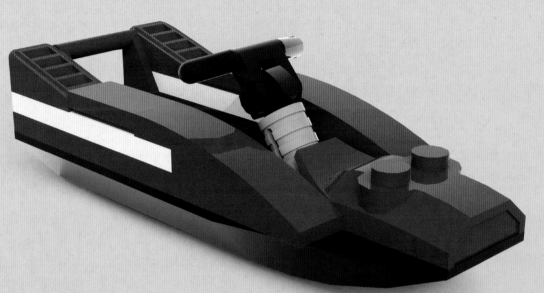

www.nuinui.ch/upload/legocreations-p64.zip

MODEL N.6

A FAST JET SKI

MODEL: TIM JOHNSON
CREATION: FRANCESCO FRANGIOJA

There's nothing better than a water bike (or Jet Ski) for sea and speed lovers!
A "keel", a practical handlebar to maneuver it, a "seat" for our Minifigure and we're ready for an exciting race through the waves!

Features

- sporty look
- can host a Minifigure
- doesn't float if you put it in water

List of bricks needed to build our Jet Ski

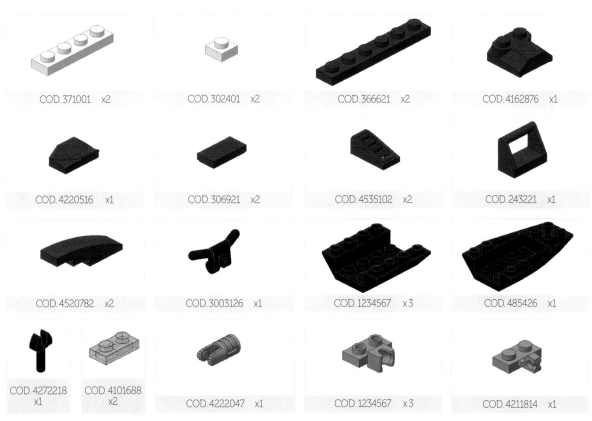

COD. 371001 x2	COD. 302401 x2	COD. 366621 x2	COD. 4162876 x1
COD. 4220516 x1	COD. 306921 x2	COD. 4535102 x2	COD. 243221 x1
COD. 4520782 x2	COD. 3003126 x1	COD. 1234567 x3	COD. 485426 x1
COD. 4272218 x1	COD. 4101688 x2	COD. 4222047 x1	COD. 1234567 x3 / COD. 4211814 x1

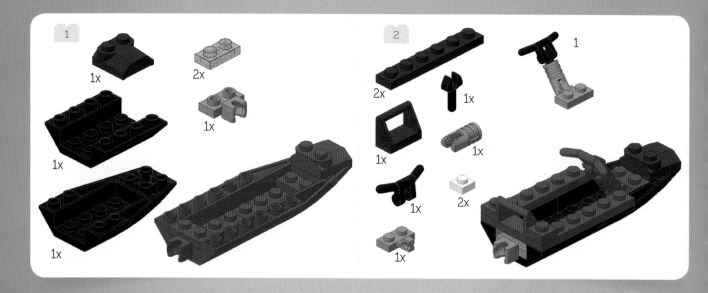

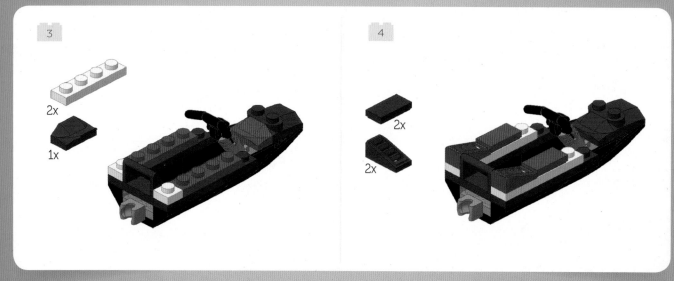

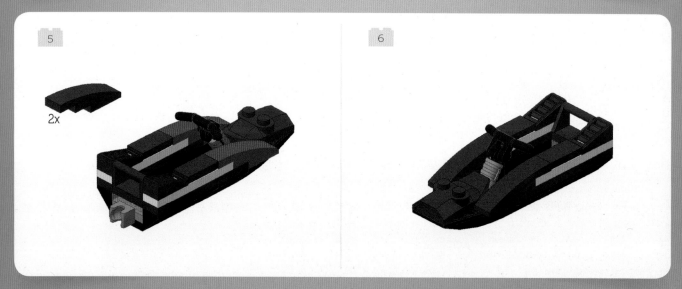

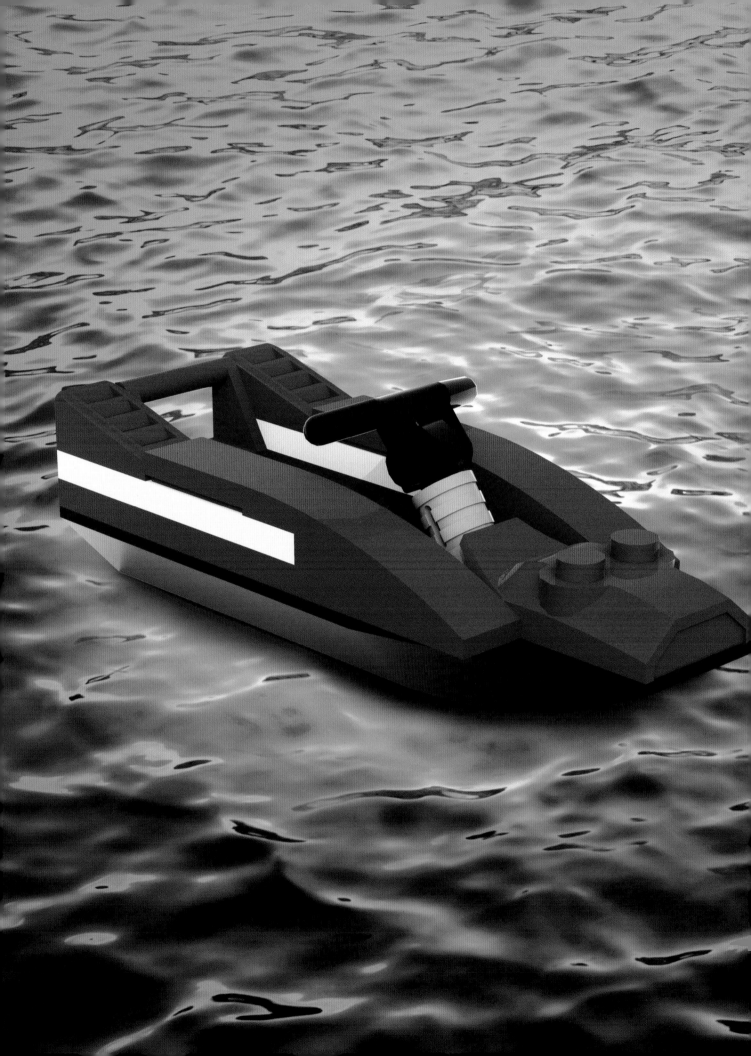

LEGO® brick version

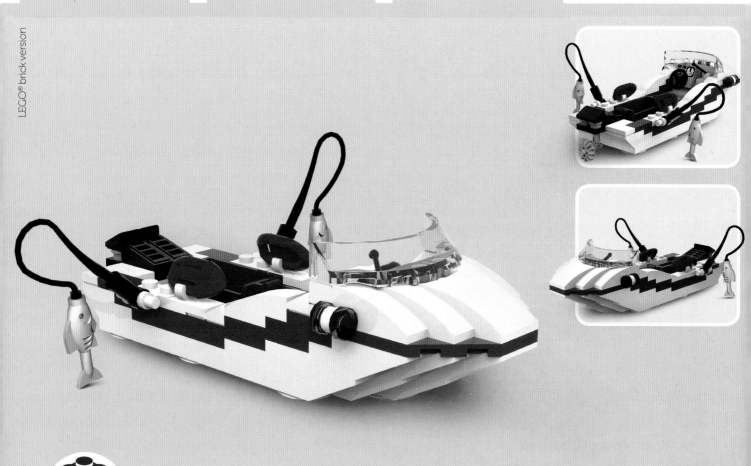

www.nuinui.ch/upload/legocreations-p68.zip

MODEL N. 7

FISHING BOAT

MODEL: BARNEY MAIN
CREATION: FRANCESCO FRANGIOJA

Why not treat ourselves to a day of sun, sea and fishing? All we need is the right vehicle!
How about a fast, streamlined motor-boat to spend our day fishing on the water?

BARNEY MAIN
Barney Main studies Engineering Design at the University of Bristol. Aside from creating and building things with LEGO® bricks, he's also a fan of rugby and robotics. He specializes in creating "doll-scale" characters to stage funny or ironic scenes (using nothing but LEGO® bricks, of course).

Features

- sporty livery
- can host two Minifigures
- includes complete fishing gear
- includes 2 life vests and a box for the "catch"
- doesn't float if you put it in water

List of bricks needed to build our Fishing Boat

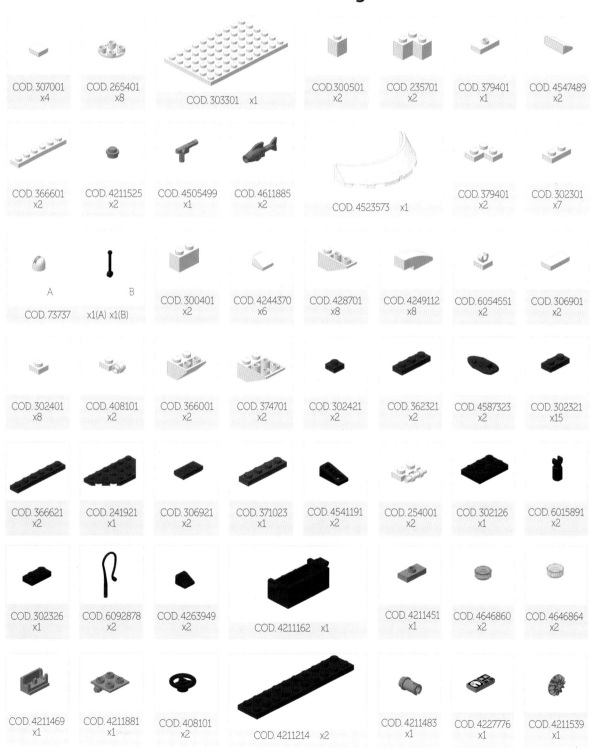

COD. 307001 x4	COD. 265401 x8	COD. 303301 x1	COD.300501 x2	COD. 235701 x2	COD. 379401 x1	COD. 4547489 x2
COD. 366601 x2	COD. 4211525 x2	COD. 4505499 x1	COD. 4611885 x2	COD. 4523573 x1	COD. 379401 x2	COD. 302301 x7
COD. 73737 x1(A) x1(B)		COD. 300401 x2	COD. 4244370 x6	COD. 428701 x8	COD. 4249112 x8	COD. 6054551 x2 / COD. 306901 x2
COD. 302401 x8	COD. 408101 x2	COD. 366001 x2	COD. 374701 x2	COD. 302421 x2	COD. 362321 x2	COD. 4587323 x2 / COD. 302321 x15
COD. 366621 x2	COD. 241921 x1	COD. 306921 x2	COD. 371023 x1	COD. 4541191 x2	COD. 254001 x2	COD. 302126 x1 / COD. 6015891 x2
COD. 302326 x1	COD. 6092878 x2	COD. 4263949 x2	COD. 4211162 x1	COD. 4211451 x1	COD. 4646860 x2	COD. 4646864 x2
COD. 4211469 x1	COD. 4211881 x1	COD. 408101 x2	COD. 4211214 x2	COD. 4211483 x1	COD. 4227776 x1	COD. 4211539 x1

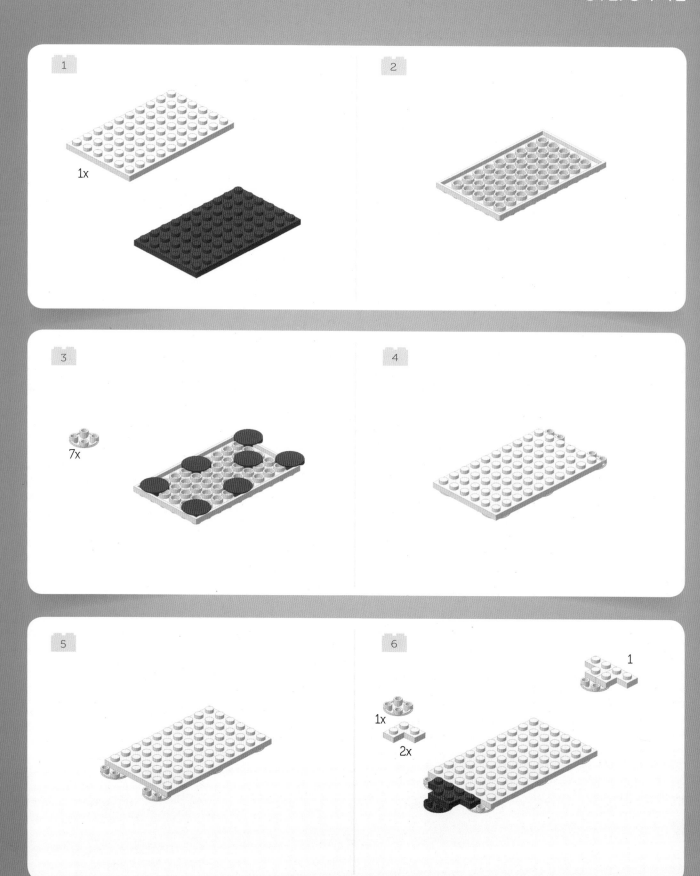

7

1x

8

2x

1x

9

10

11

2x

2x

1

12

2x

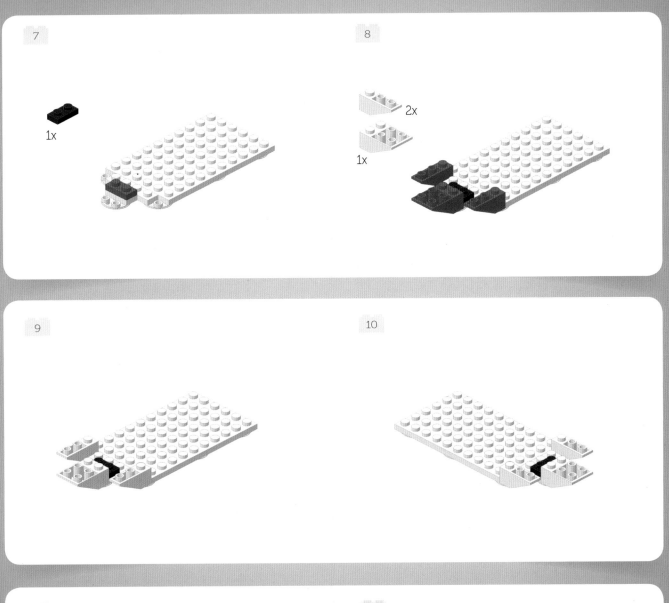

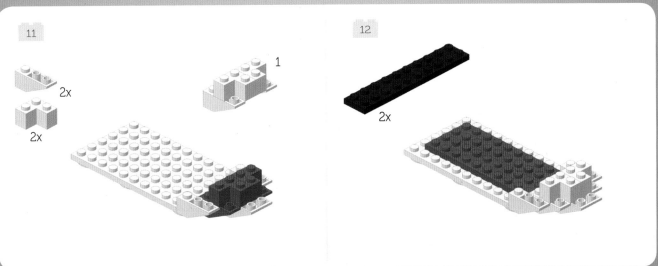

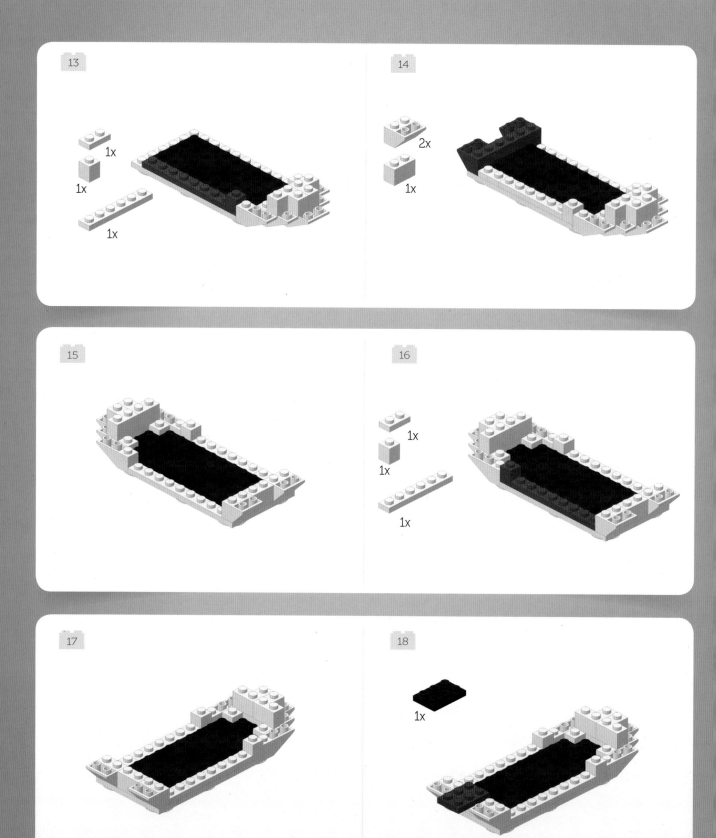

19

1x

1x

1x

20

1

2x

2x

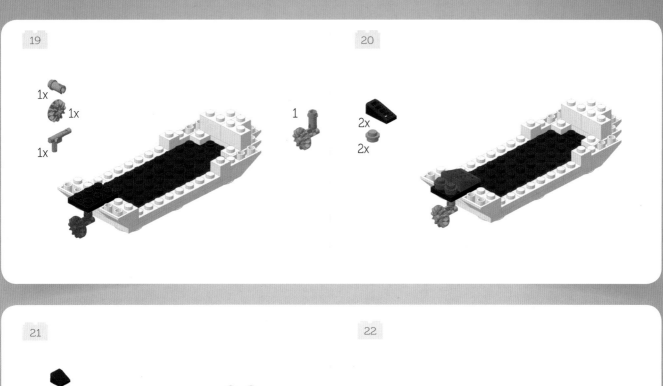

21

2x

22

2x

3x

2x

4x

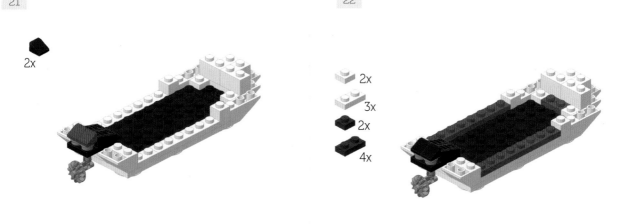

23

2x

2x

24

2x

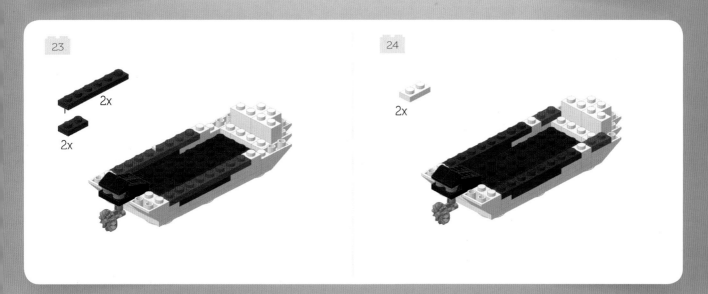

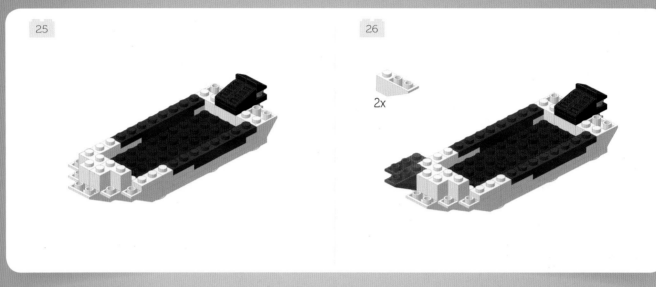

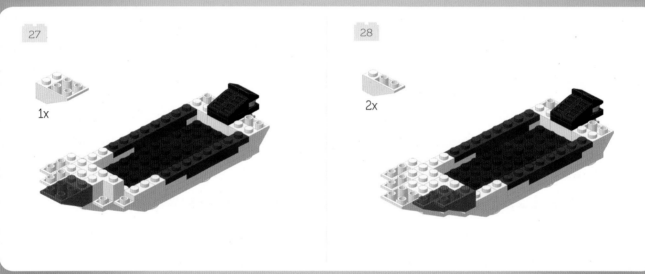

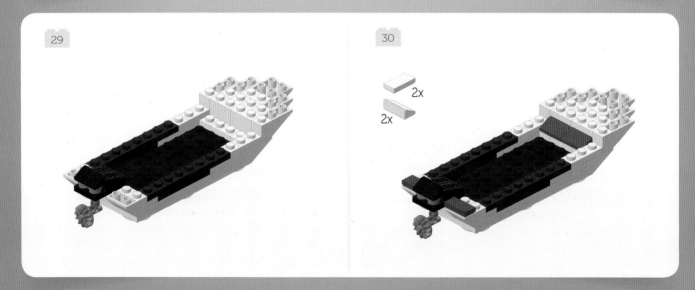

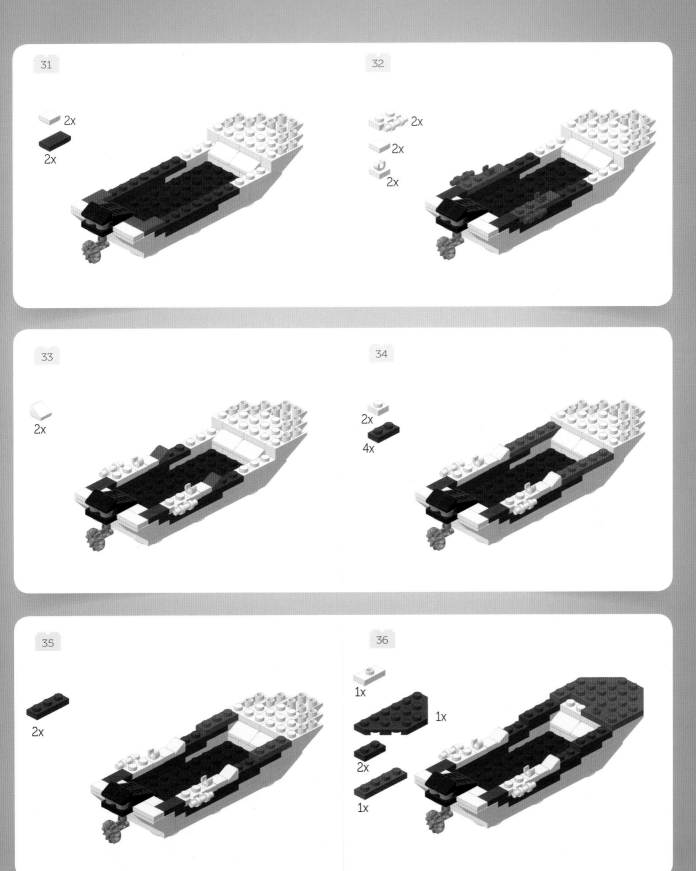

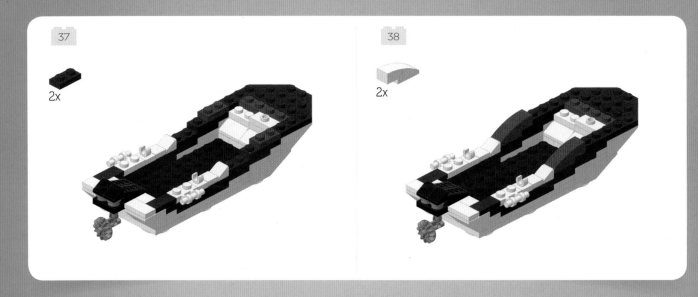

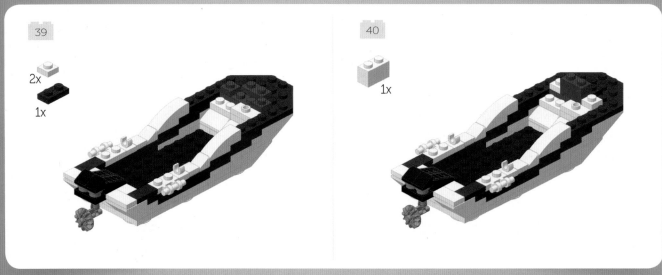

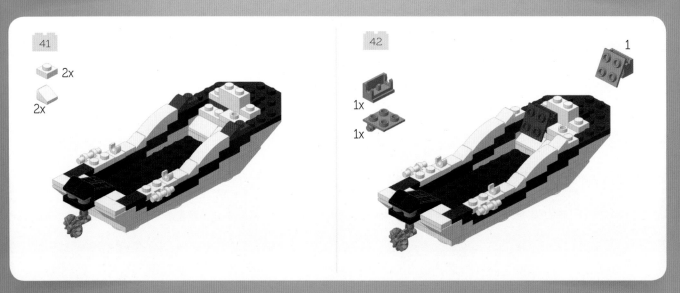

43

1x

1x

44

1x

1x

1

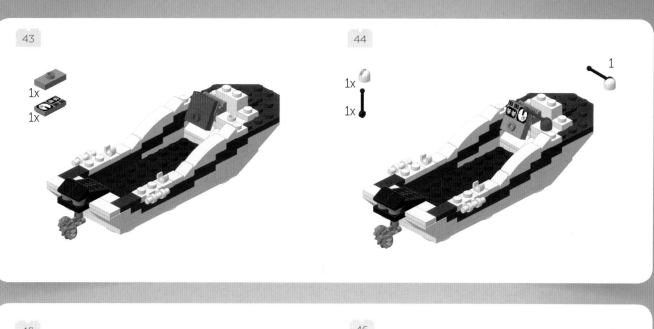

45

1x

46

1x

2x

1

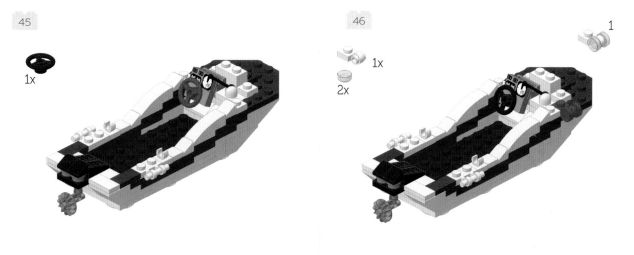

47

2x

48

1x

2x

1

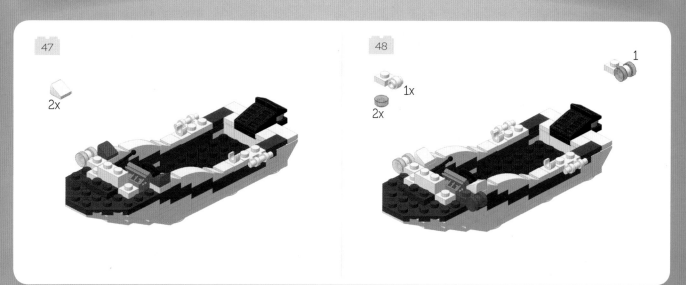

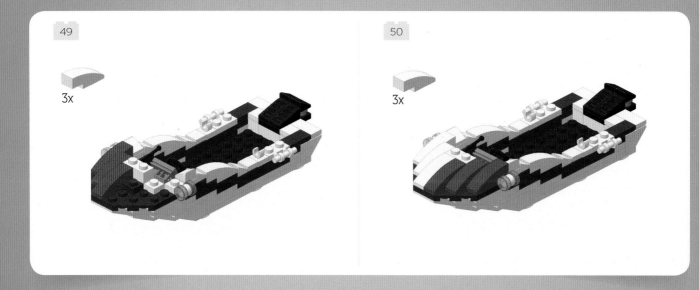

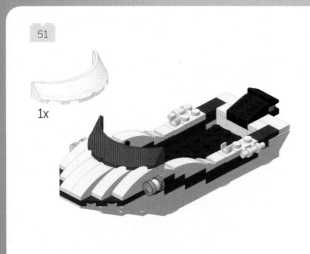

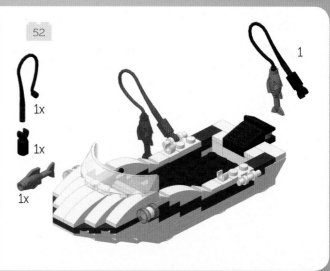

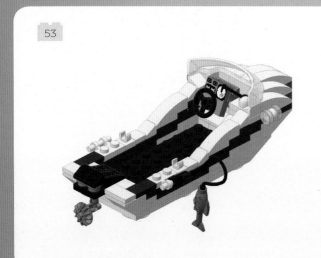

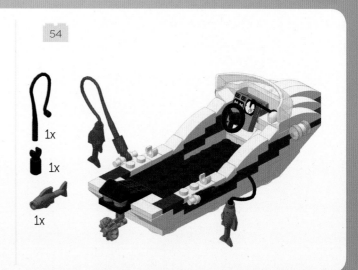

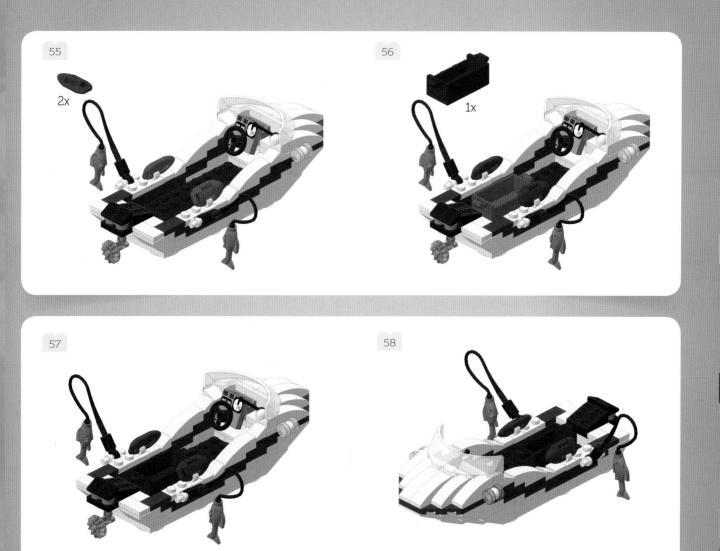

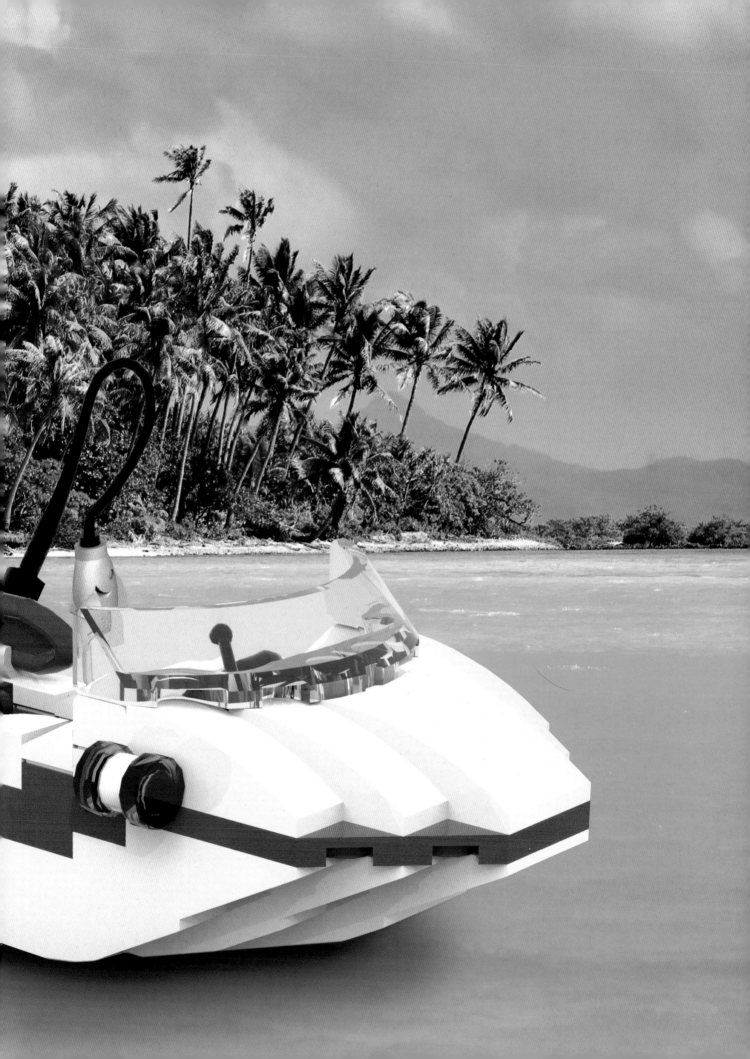

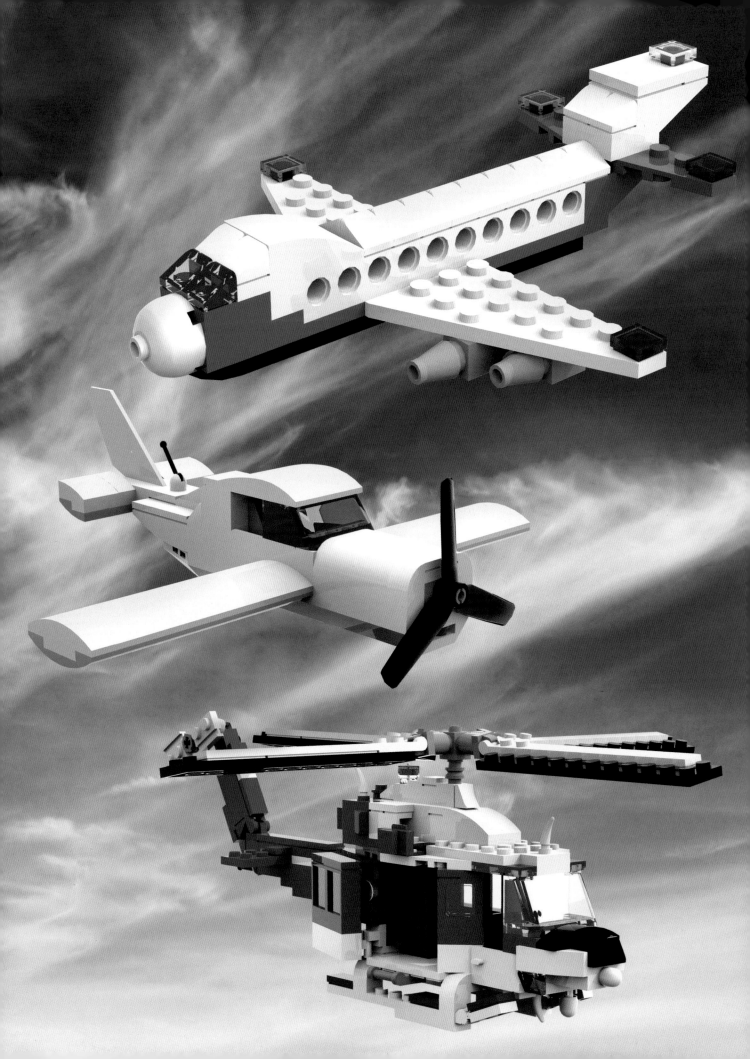

AIRPLANES AND HELICOPTERS

TIME TO FLY!

Had enough fun among the waves? Then it's time to gaze up at the stars, devoting ourselves to the "flying machines" that have made our dreams of flying come true ever since they were first invented!

As with the wheeled and "navigation" vehicles we've already seen, some bricks are especially suitable to build modern and period airplanes, helicopters and anything that can fly!

For example, bricks like these (**A**) are suitable for engines and noses, while we can use others (**B**) to make any kind of wing we like!

Just don't forget that all aircraft must have two important features: a fine, powerful engine and a rudder at the rear (**C**)!

Happy "flying" and... let's start building!

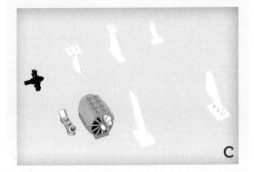

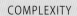
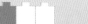
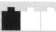
LEGO® brick version

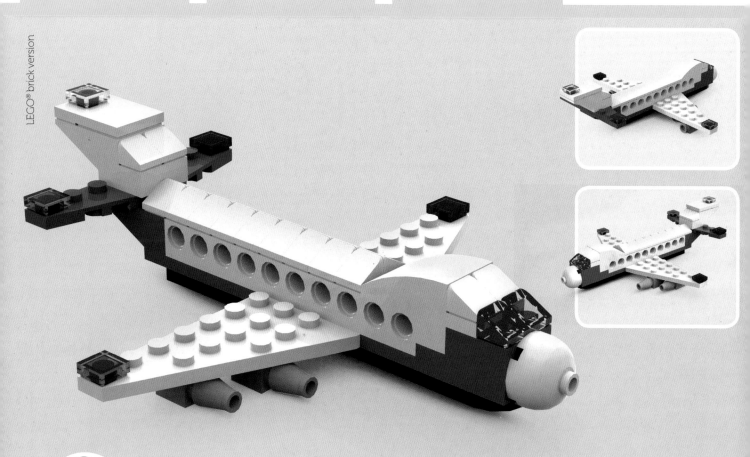

www.nuinui.ch/upload/legocreations-p84.zip

MODEL N.8

"MICRO"-SCALE AIRLINER

MODEL: BARNEY MAIN
CREATION: FRANCESCO FRANGIOJA

How about starting our sky adventures by building a lovely airliner?
I'm sure you're thinking: "But it's too big!!!"
And indeed, the "size issue" is what led several members of the fan community to start building on a "micro" scale!

Features

- easy to build, with a blue-and-white livery recalling the famous Air Force One
- correctly-placed "navigation" lights
- very "swooshable" model

List of bricks needed to build our "Micro"-Scale Airliner

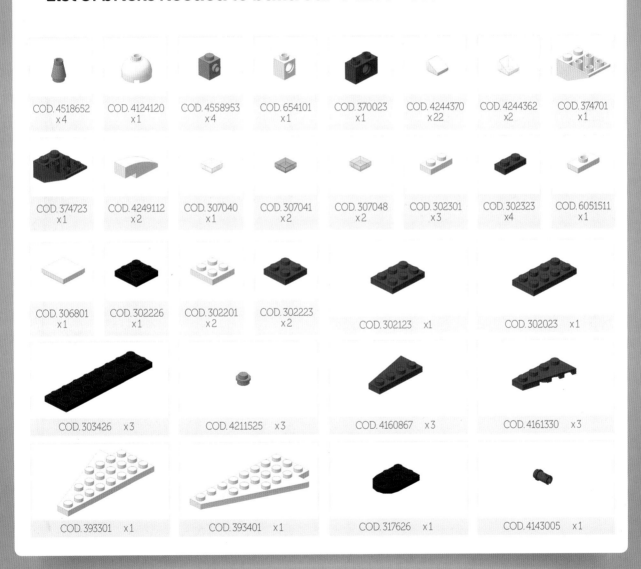

| COD. 4518652 x4 | COD. 4124120 x1 | COD. 4558953 x4 | COD. 654101 x1 | COD. 370023 x1 | COD. 4244370 x22 | COD. 4244362 x2 | COD. 374701 x1 |

| COD. 374723 x1 | COD. 4249112 x2 | COD. 307040 x1 | COD. 307041 x2 | COD. 307048 x2 | COD. 302301 x3 | COD. 302323 x4 | COD. 6051511 x1 |

| COD. 306801 x1 | COD. 302226 x1 | COD. 302201 x2 | COD. 302223 x2 | COD. 302123 x1 | COD. 302023 x1 |

| COD. 303426 x3 | COD. 4211525 x3 | COD. 4160867 x3 | COD. 4161330 x3 |

| COD. 393301 x1 | COD. 393401 x1 | COD. 317626 x1 | COD. 4143005 x1 |

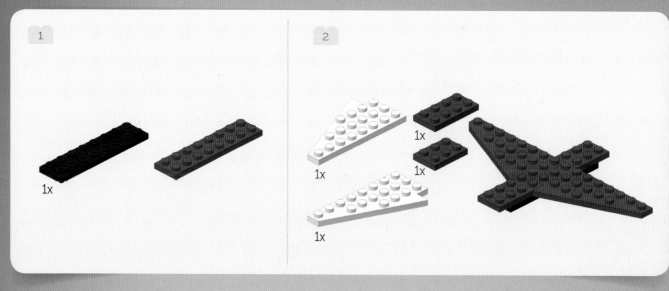

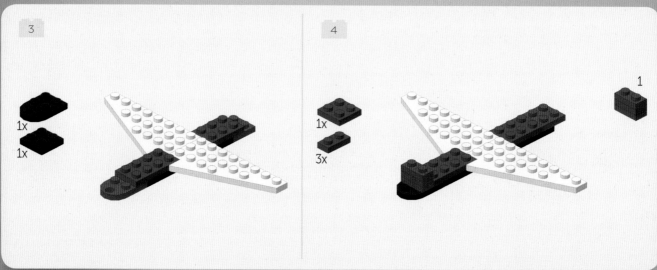

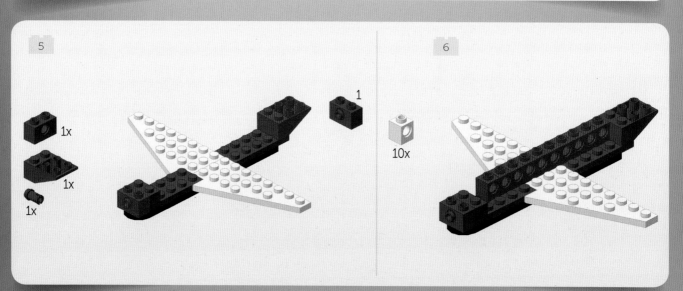

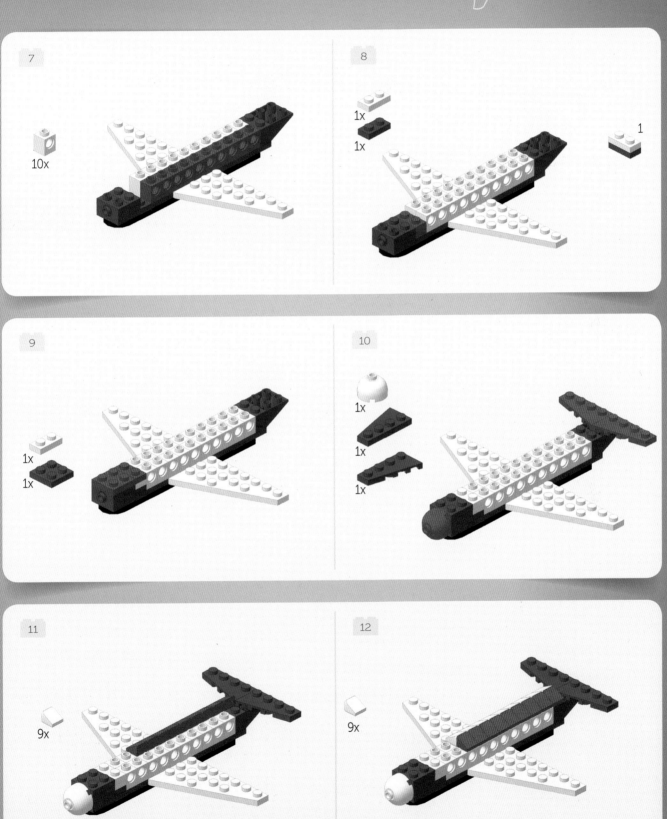

13

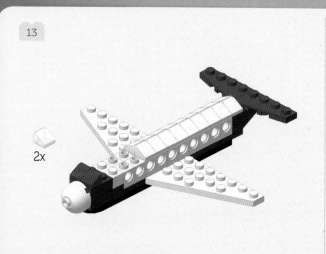

2x

14

2x

1x

1

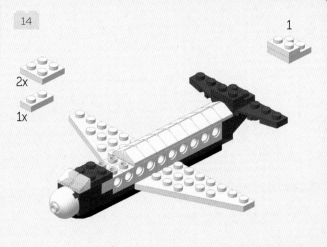

15

2x

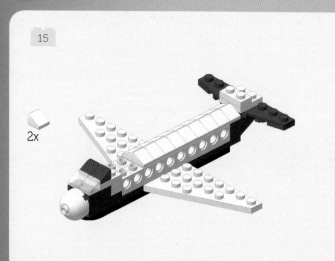

16

2x

1x

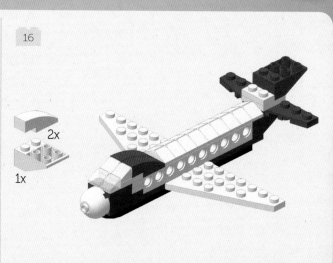

17

2x

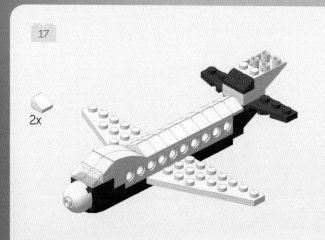

18

1x

1x

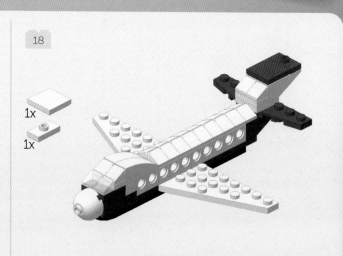

19

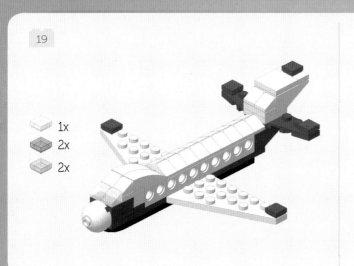

1x
2x
2x

20

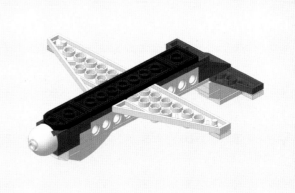

21

4x
4x

4x

1 1

1 1

22

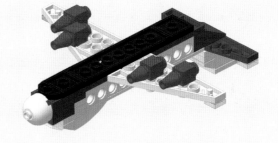

LEGO® brick version

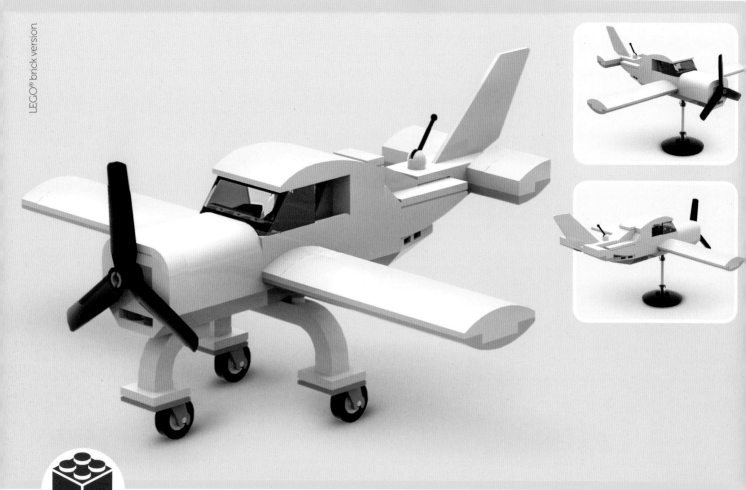

MODEL N.9

LIGHTWEIGHT AIRCRAFT

AUTHOR/DESIGNER: CUSTOMBRICKSET (YOUTUBE® CHANNEL)

Going back to the normal "Minifigure scale", the model reproduces the typical lightweight aircraft we use when learning to fly, the first step of the journey to become a real pilot.
This model, specifically, is inspired by a small lightweight aircraft designed by the French company Daher-Socata® and known as the "TB20".

CUSTOMBRICKSET

CustomBrickset is a YouTube® channel where users upload video tutorials with step-by-step instructions detailing how to build original creations or alternate versions of official sets.
All the video content available is free.

Features

- all-white livery
- can fit a Minifigure at the controls
- extremely "swooshable" model
- the instructions and list of components include everything you need to build a "flight"-simulating support and the normal landing gear. It's up to the readers to choose the version they want to build!

List of bricks needed to build our Lightweight Aircraft

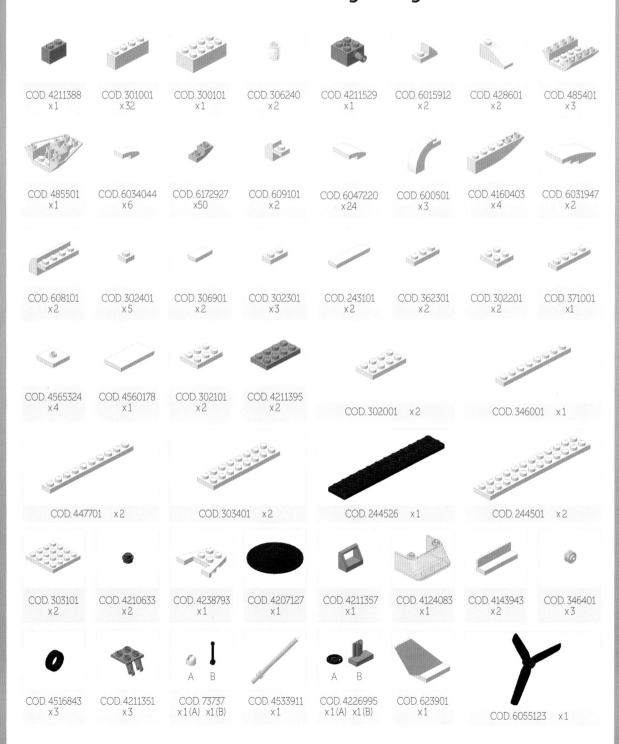

COD. 4211388 x1	COD. 301001 x32	COD. 300101 x1	COD. 306240 x2	COD. 4211529 x1	COD. 6015912 x2	COD. 428601 x2	COD. 485401 x3
COD. 485501 x1	COD. 6034044 x6	COD. 6172927 x50	COD. 609101 x2	COD. 6047220 x24	COD. 600501 x3	COD. 4160403 x4	COD. 6031947 x2
COD. 608101 x2	COD. 302401 x5	COD. 306901 x2	COD. 302301 x3	COD. 243101 x2	COD. 362301 x2	COD. 302201 x2	COD. 371001 x1
COD. 4565324 x4	COD. 4560178 x1	COD. 302101 x2	COD. 4211395 x2	COD. 302001 x2		COD. 346001 x1	
COD. 447701 x2		COD. 303401 x2		COD. 244526 x1		COD. 244501 x2	
COD. 303101 x2	COD. 4210633 x2	COD. 4238793 x1	COD. 4207127 x1	COD. 4211357 x1	COD. 4124083 x1	COD. 4143943 x2	COD. 346401 x3
COD. 4516843 x3	COD. 4211351 x3	COD. 73737 x1 (A) x1 (B)	COD. 4533911 x1	COD. 4226995 x1 (A) x1 (B)	COD. 623901 x1	COD. 6055123 x1	

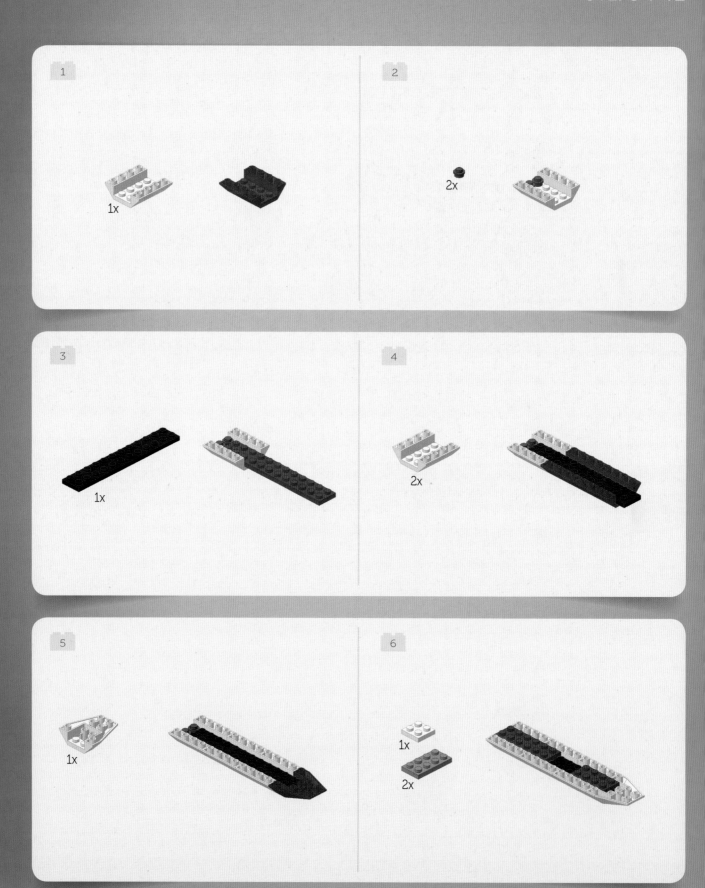

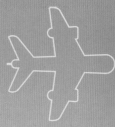

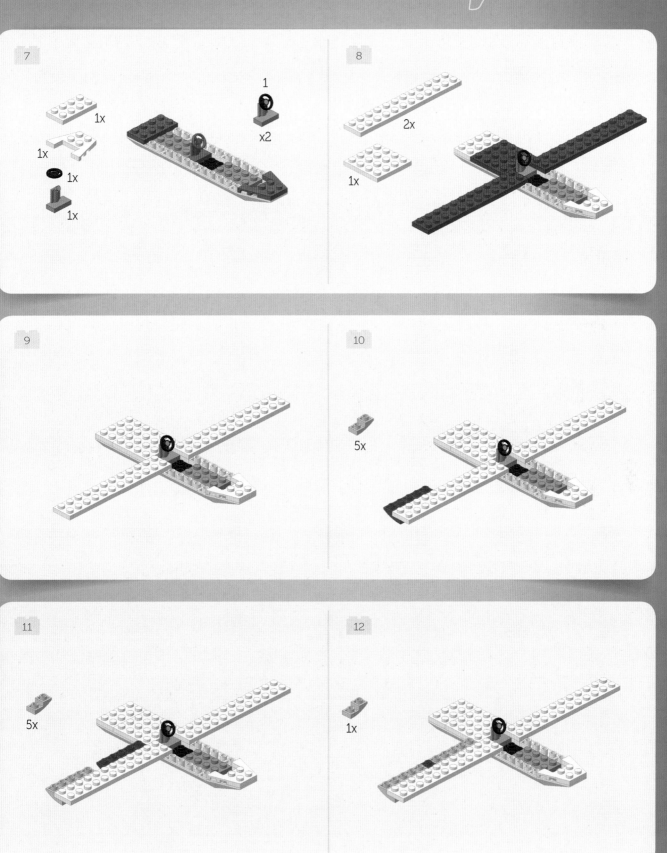

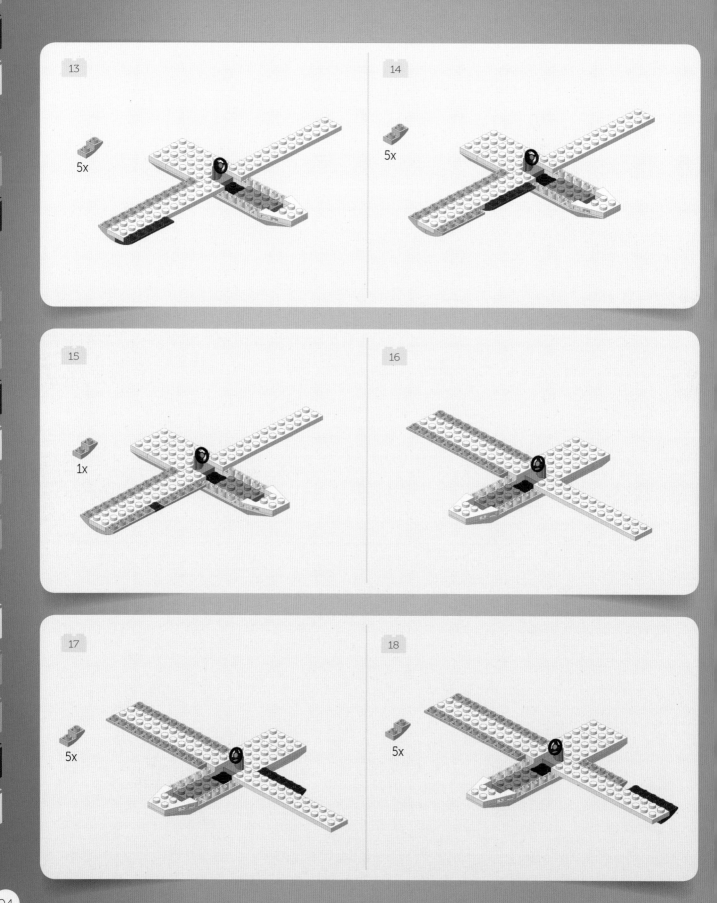

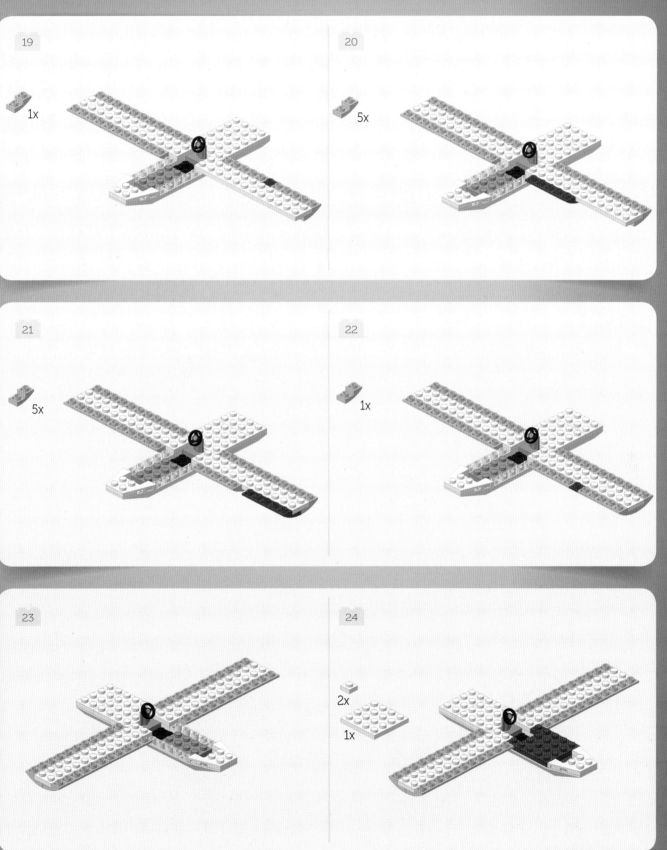

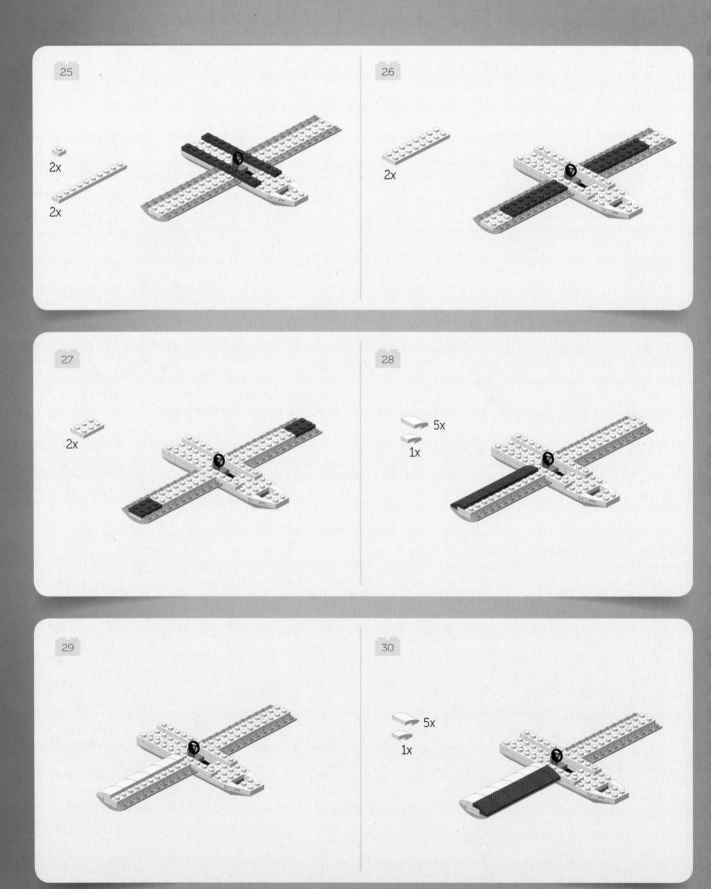

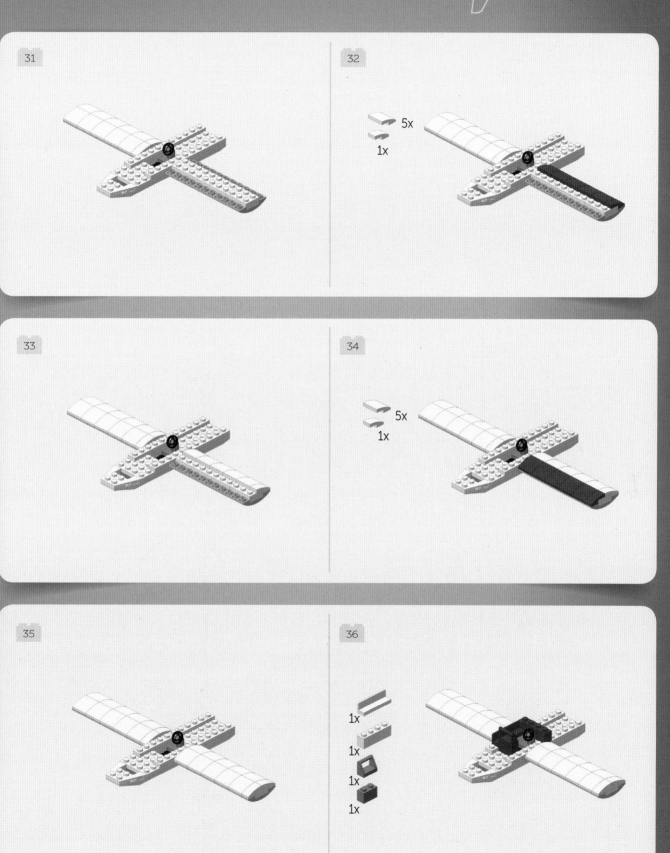

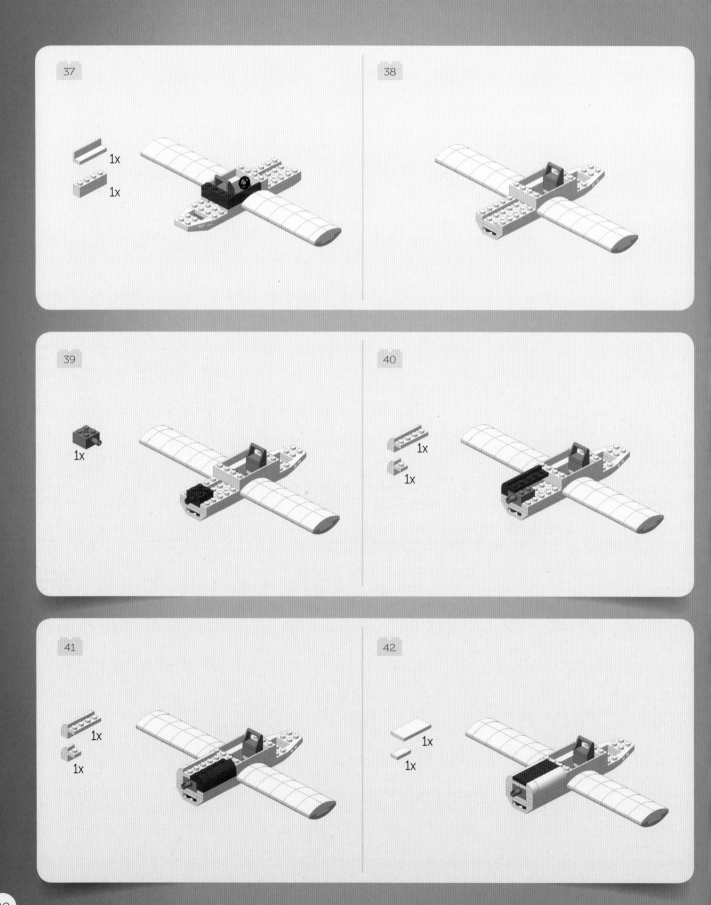

43

1x

1x

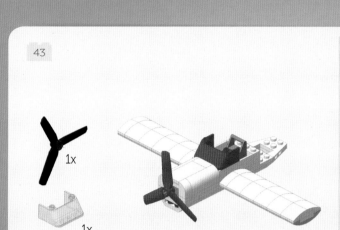

44

2x

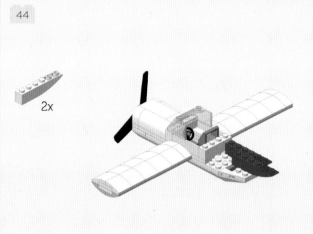

45

2x

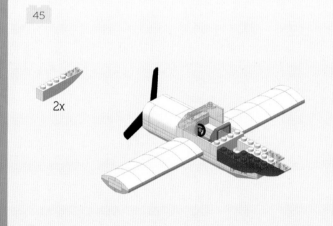

46

1x

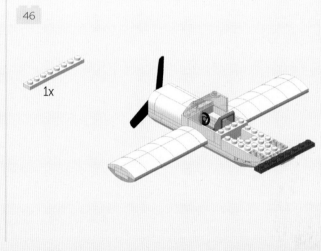

47

1x

1x

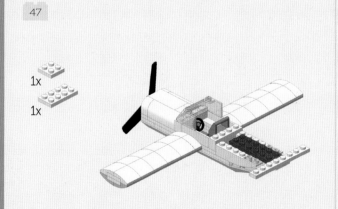

48

2x

2x

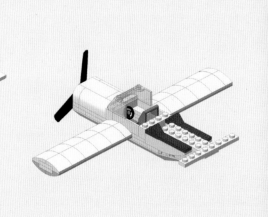

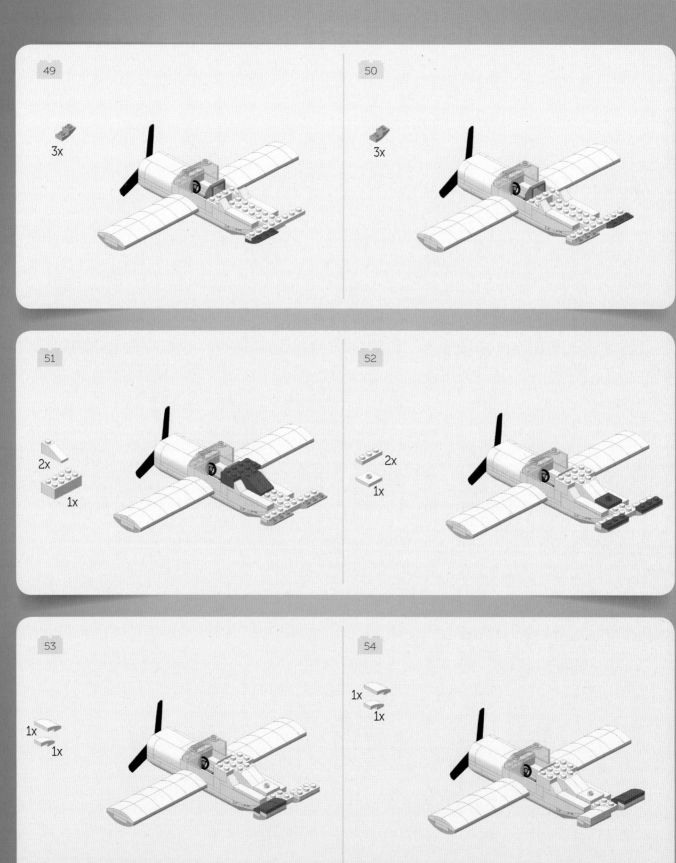

49
3x

50
3x

51
2x
1x

52
2x
1x

53
1x
1x

54
1x
1x

55

2x
2x
2x

1 1

x2 x2

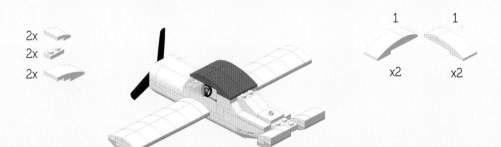

56

1x
1x
1x
1x

1

x2

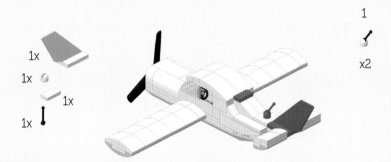

57

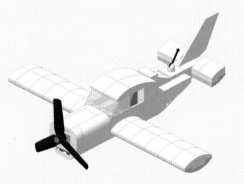

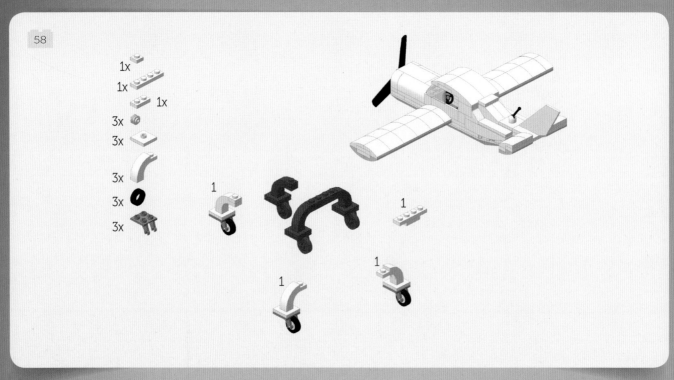

58

1x
1x
1x
3x
3x
3x
3x
3x
1
1
1
1

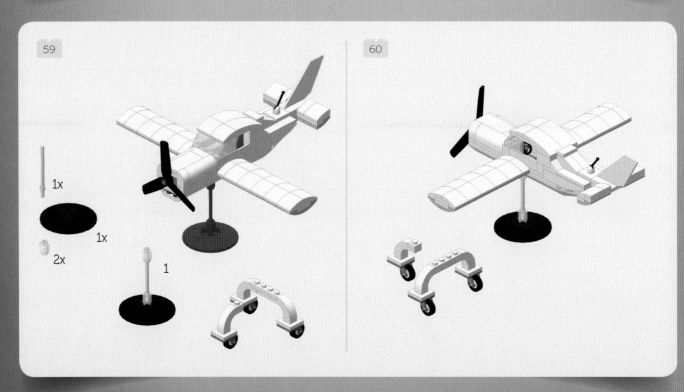

59

1x
1x
2x
1

60

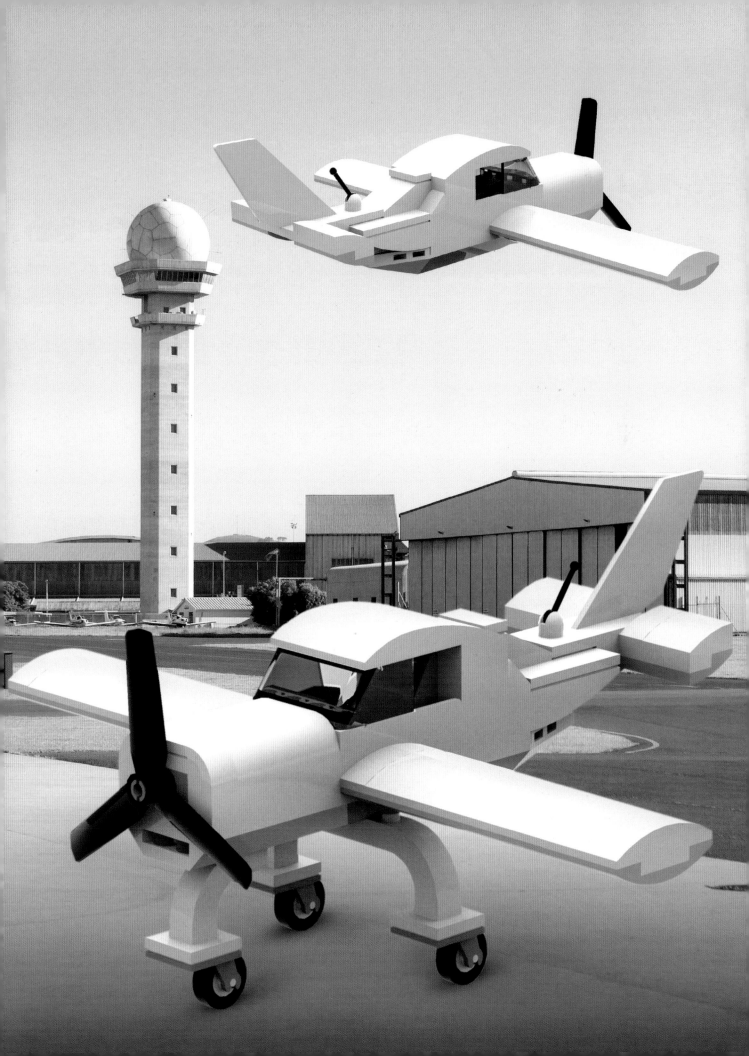

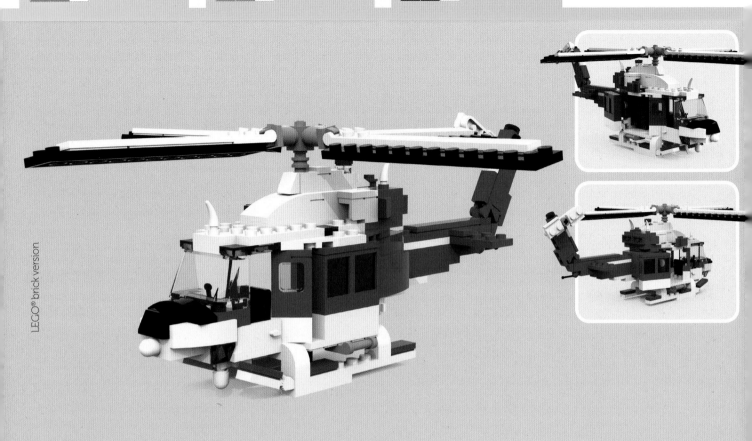

LEGO® brick version

www.nuinui.ch/upload/legocreations-p104.zip

MODEL N.10

"NYPD BELL 412" HELICOPTER

AUTHOR/DESIGNER: CRAIG PERRIN (NICKNAME: CRIGA88)

Let's leave the world of fixed-wing aircraft behind for a moment and turn to a rotorcraft, one of the most famous helicopter models in the world: the "NYPD Bell 412" used by the New York Police Department!

CRAIG PERRIN
Craig, 28 years old, lives in Sydney (Australia) and has served in his country's Air Force for the past 5 years.
His work keeps him far from home for months at a time, so he spends a lot of his free time building "virtually" with LDD, since he obviously can't take physical bricks with him.

Features

- livery like the original helicopter used by the NYPD
- can fit a Minifigure at the controls and a couple in the cargo bay
- side doors that really open
- the main and rear rotors really "rotate"
- correctly-placed "navigation" lights
- extremely "swooshable" model

List of bricks needed to build our "NYPD Bell 412"

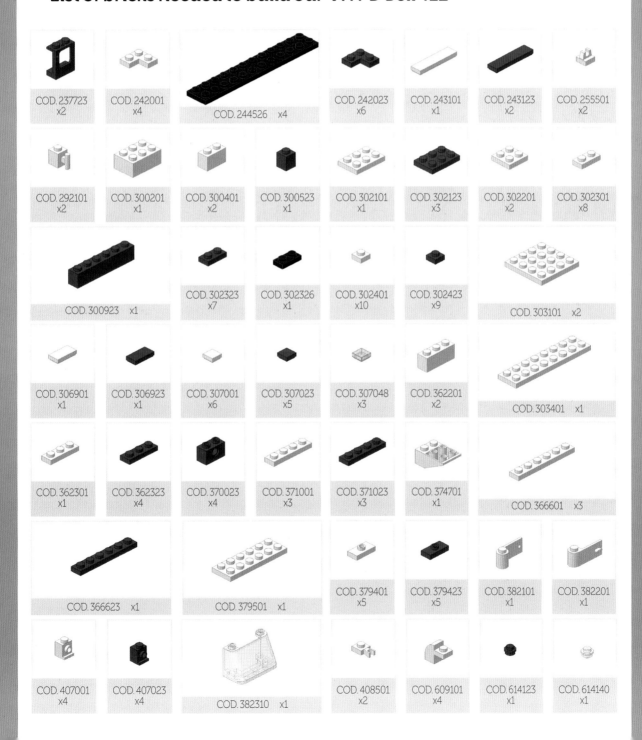

COD. 237723 x2	COD. 242001 x4	COD. 244526 x4	COD. 242023 x6	COD. 243101 x1	COD. 243123 x2	COD. 255501 x2	
COD. 292101 x2	COD. 300201 x1	COD. 300401 x2	COD. 300523 x1	COD. 302101 x1	COD. 302123 x3	COD. 302201 x2	COD. 302301 x8
COD. 300923 x1	COD. 302323 x7	COD. 302326 x1	COD. 302401 x10	COD. 302423 x9	COD. 303101 x2		
COD. 306901 x1	COD. 306923 x1	COD. 307001 x6	COD. 307023 x5	COD. 307048 x3	COD. 362201 x2	COD. 303401 x1	
COD. 362301 x1	COD. 362323 x4	COD. 370023 x4	COD. 371001 x3	COD. 371023 x3	COD. 374701 x1	COD. 366601 x3	
COD. 366623 x1	COD. 379501 x1	COD. 379401 x5	COD. 379423 x5	COD. 382101 x1	COD. 382201 x1		
COD. 407001 x4	COD. 407023 x4	COD. 382310 x1	COD. 408501 x2	COD. 609101 x4	COD. 614123 x1	COD. 614140 x1	

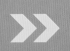

COD. 623101
x2

COD. 654101
x1

COD. 4112535
x1

COD. 4118620
x1

COD. 4119014
x3

COD. 4121715
x1

COD. 4169203
x1

COD. 4170253
x2

COD. 4108153 x1

COD. 4101691
x2

COD. 4174748
x1

COD. 302401
x10

COD. 4210639
x2

COD. 663601 x9

COD. 4179874
x1

COD. 4179875
x1

COD. 4180505
x1

COD. 4180534
x1

COD. 4183035
x2

COD. 4183048
x2

COD. 4211085
x1

COD. 4211065
x2

COD. 4210469
x1

COD. 4210635
x2

COD. 4210636
x1

COD. 4211052
x6

COD. 4211060
x1

COD. 4211063
x4

COD. 6016172
x1

COD. 6073890
x1

COD. 4211088
x1

COD. 4211094
x2

COD. 4211119
x2

COD. 4211387
x1

COD. 4211069
x1

COD. 4211412
x4

COD. 4211483
x2

COD. 4211511
x1

COD. 4211573
x2

COD. 4211807
x2

COD. 4222196
x2

COD. 4244362
x2

COD. 4527839
x1

COD. 4538760
x1

A B
COD. 4221775 x1(A) x1(B)

COD. 4244627
x2

COD. 4249112
x4

COD. 4277780
x4

COD. 4515364
x4

COD. 4521209
x4

COD. 4244370
x4

COD. 4613153
x1

COD. 6058177
x2

COD. 4540048
x5

COD. 4543998
x1

COD. 4548180
x1

COD. 4558168
x4

COD. 4558954
x4

COD. 4568387
x4

COD. 4585702
x2

COD. 4587840
x1

COD. 4597605
x1

COD. 4623199
x1

COD. 4626882
x1

COD. 4646864
x2

COD. 4654522
x1

COD. 4655241
x1

COD. 6030711
x4

COD. 6070698

1

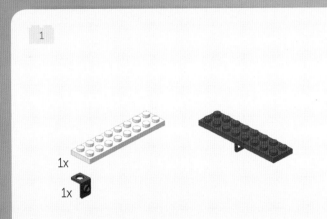

1x

1x

2

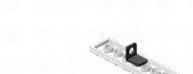

3

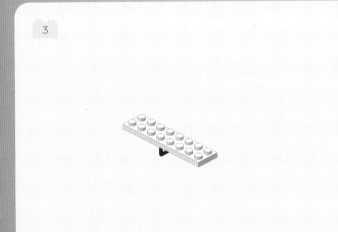

4

2x

5

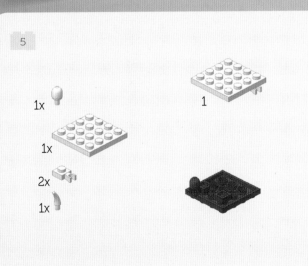

1x

1

1x

2x

1x

6

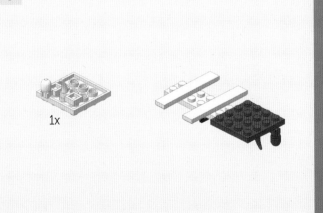

1x

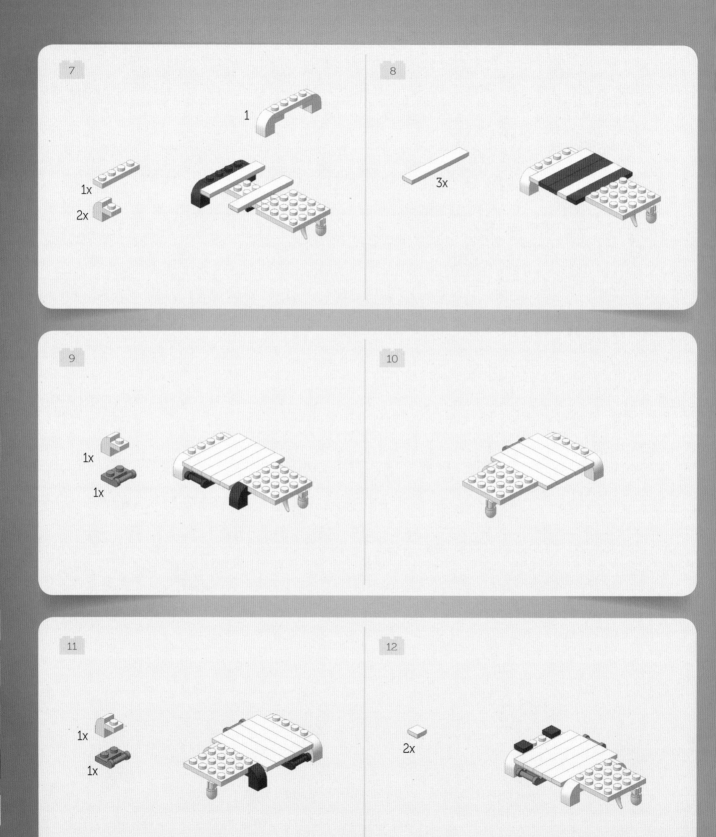

13

1x
2x
2x
1x
1x

1 1 1
x7

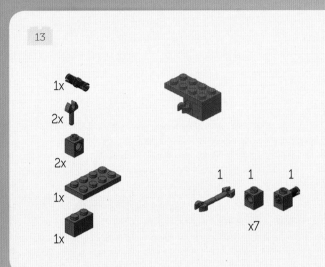

14

1x
1x

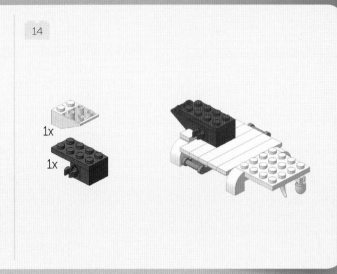

15

1x

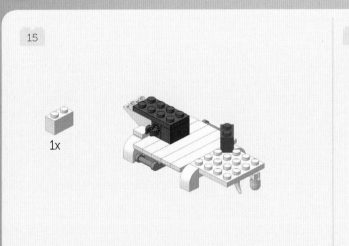

16

1x
1x

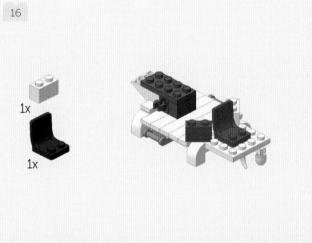

17

1x
1x

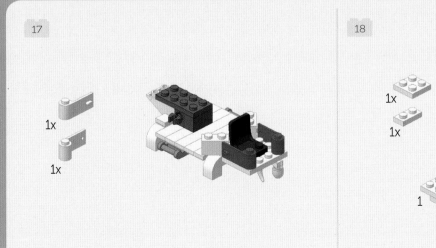

18

1x
1x

1

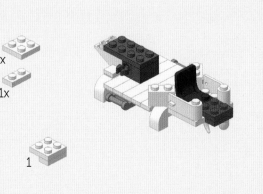

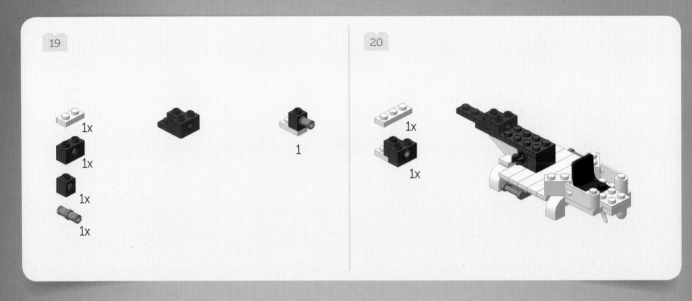

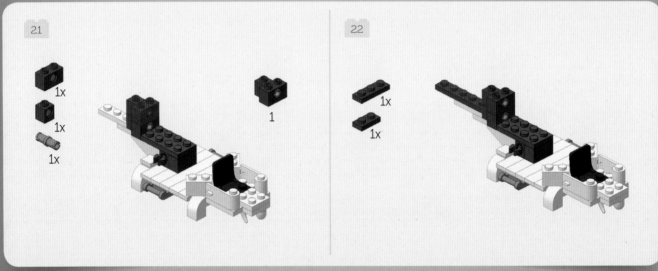

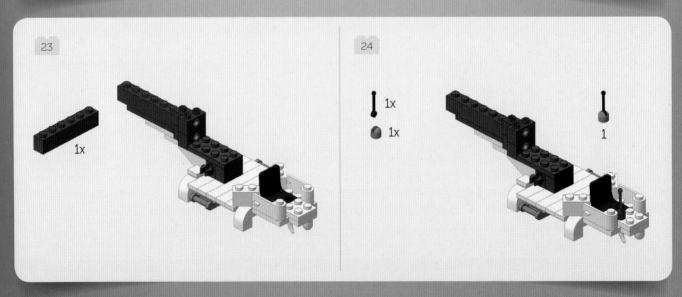

25

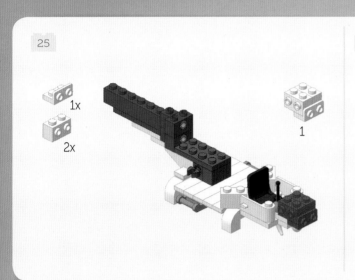

1x
2x

1

26

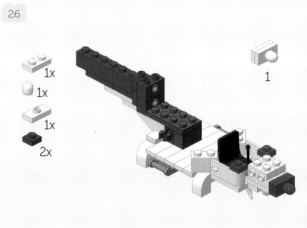

1x
1x
1x
2x

1

27

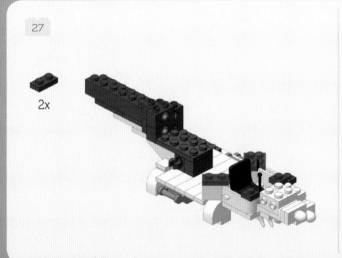

2x

28

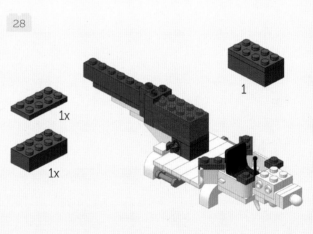

1x
1x

1

29

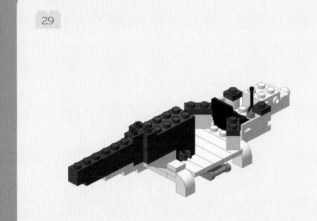

30

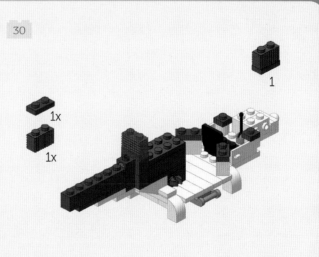

1x
1x

1

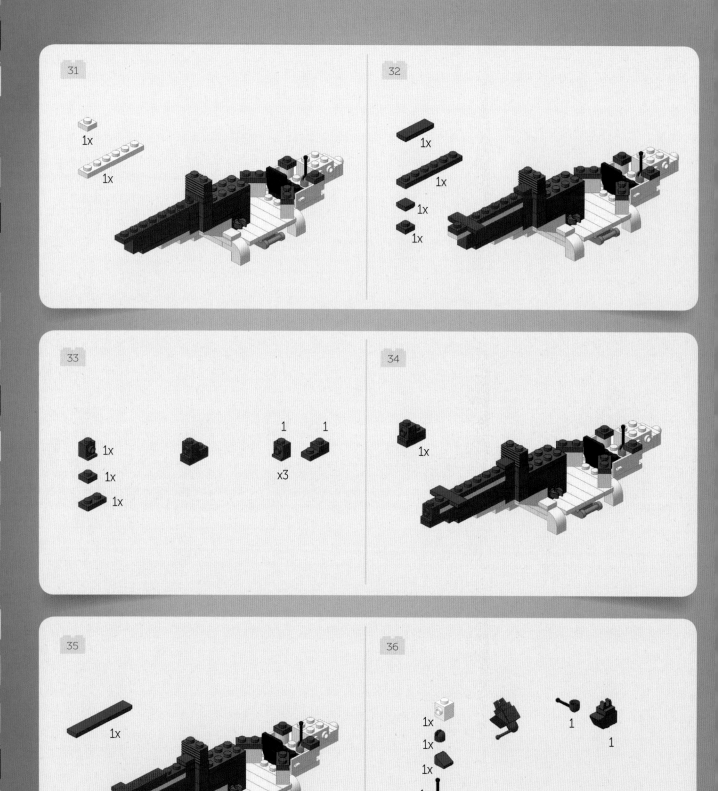

31

1x

1x

32

1x

1x

1x

1x

33

1x

1x

1x

1

1

x3

34

1x

35

1x

36

1x

1x

1x

1x

1x

1

1

37

1x

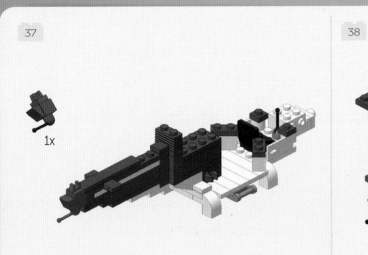

38

2x

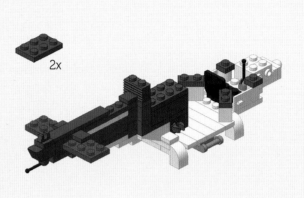

39

4x

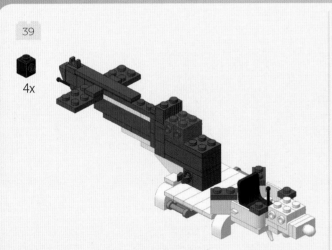

40

1x

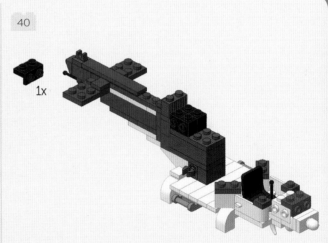

41

1x
1x
1x

1

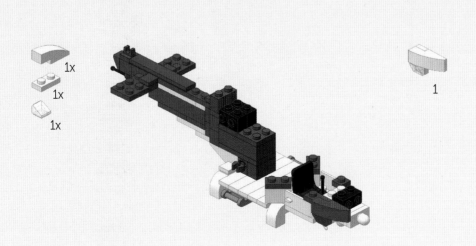

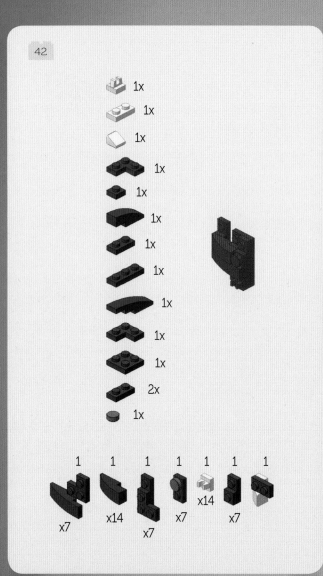

42

1x
1x
1x
1x
1x
1x
1x
1x
1x
1x
1x
2x
1x

1 1 1 1 1 1 1

x7 x14 x7 x14 x7

x7

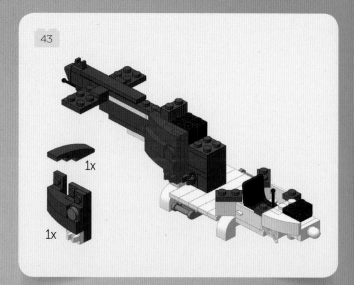

43

1x

1x

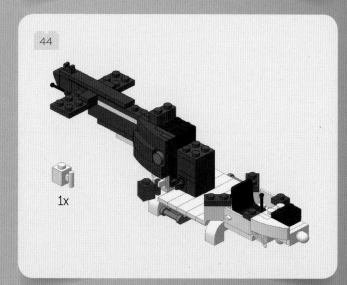

44

1x

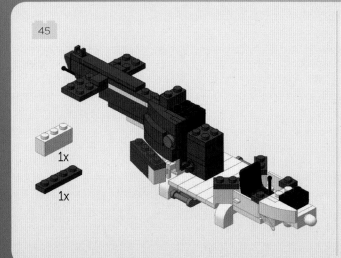

45

1x

1x

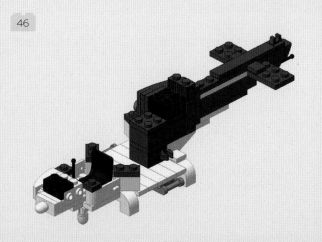

46

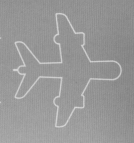

47

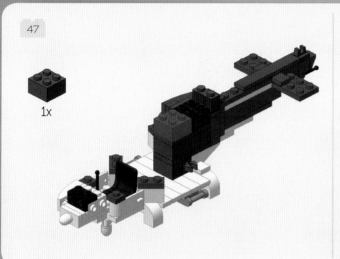

1x

48

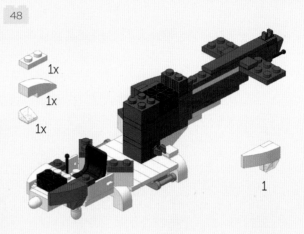

1x

1x

1x

1

49

1x

1x

1x

1x

1x

1x

3x

1x

1x

1x

2x

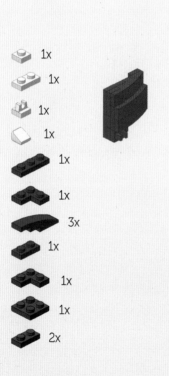

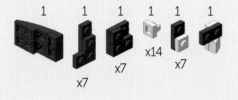

1

1

1

1

1

1

x7

x7

x14

x7

50

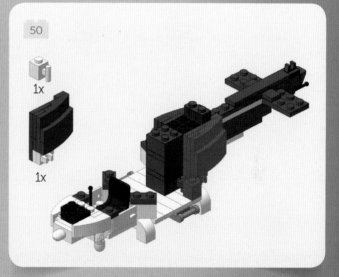

1x

1x

51

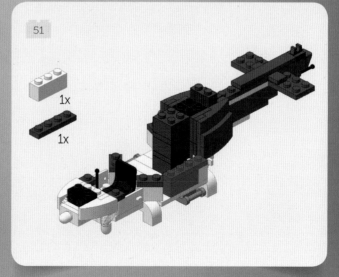

1x

1x

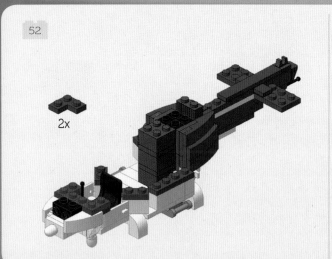

52

2x

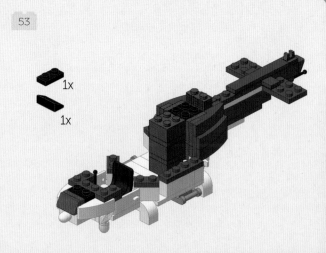

53

1x

1x

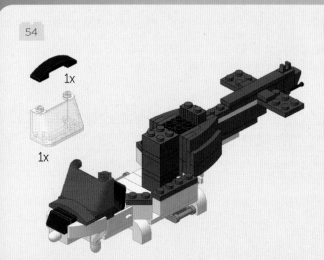

54

1x

1x

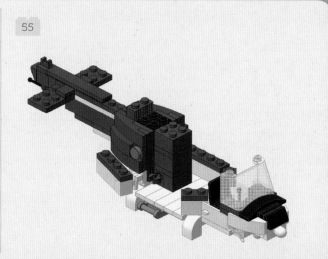

55

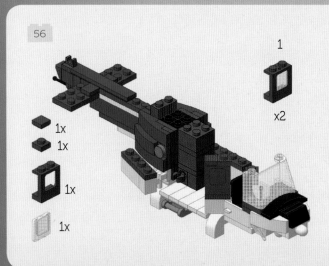

56

1x

1x

1x

1x

1

x2

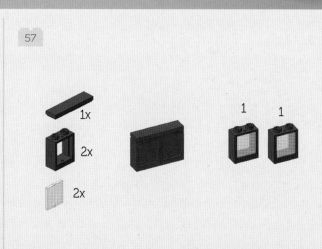

57

1x

2x

2x

1

1

58

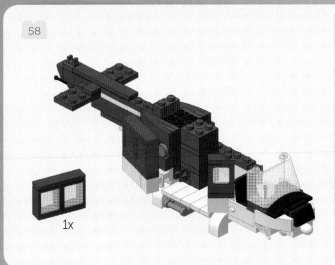

1x

59

1x
1x
1x
1x

1

x2

60

1x
2x
2x

1 1

61

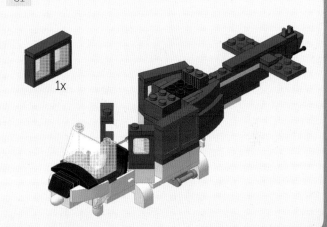

1x

62

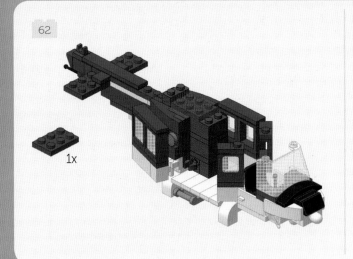

1x

63

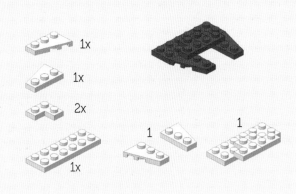

1x
1x
2x
1x

1 1

64

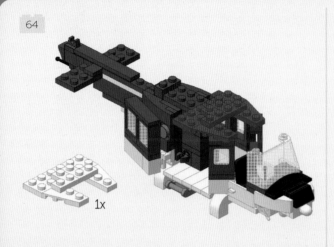

1x

65

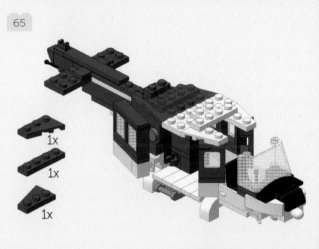

1x

1x

1x

66

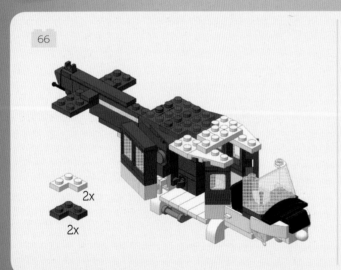

2x

2x

67

1x

1x

1x

1x

2x

1

1

x2

x2

68

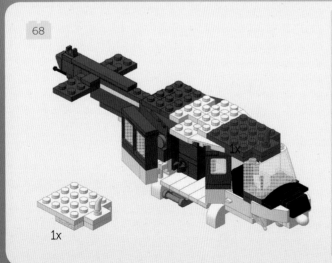

1x

1x

69

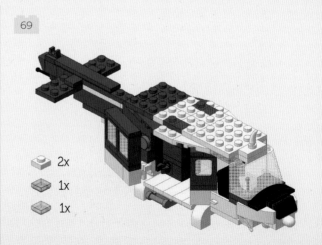

2x

1x

1x

70

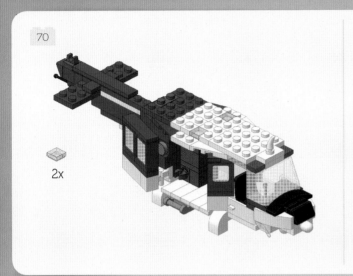

2x

71

1 1

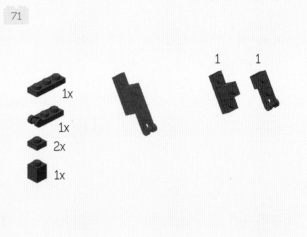

1x

1x

2x

1x

72

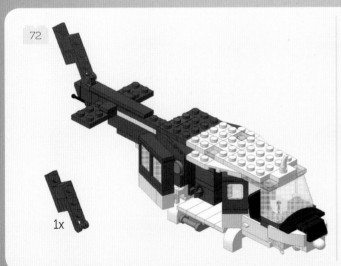

1x

73

1

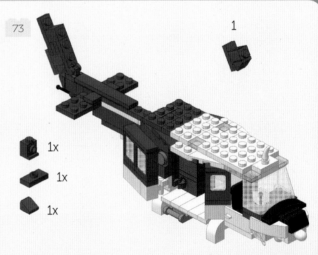

1x

1x

1x

74

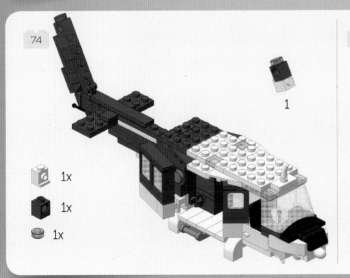

1

1x

1x

1x

75

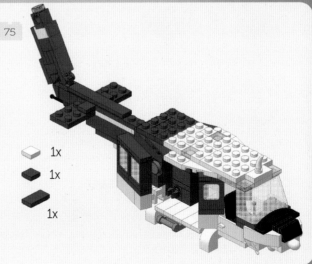

1x

1x

1x

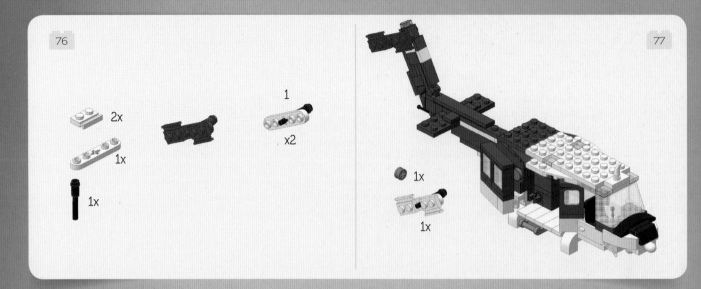

76

2x

1x

1x

1

x2

77

1x

1x

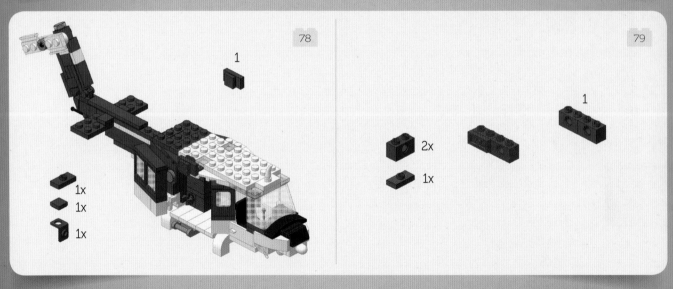

78

1x

1x

1x

1

79

2x

1x

1

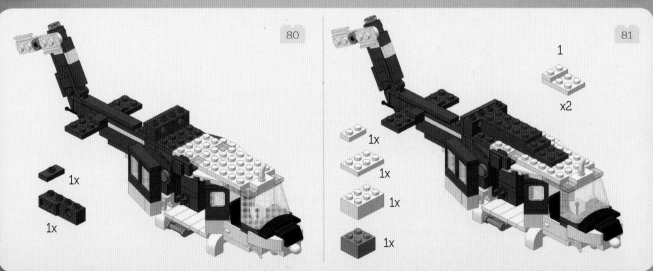

80

1x

1x

81

1

x2

1x

1x

1x

1x

82

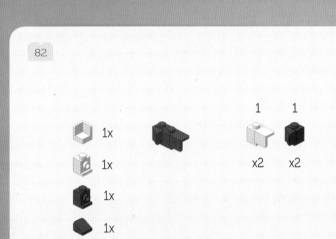

1x
1x
1x
1x

1 1
x2 x2

83

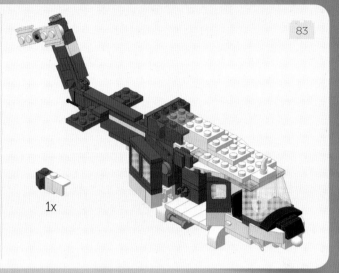

1x

84

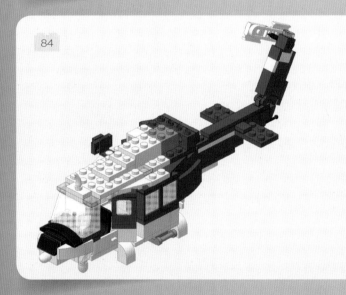

85

1x
1x
1x
1x

1 1
x2 x2

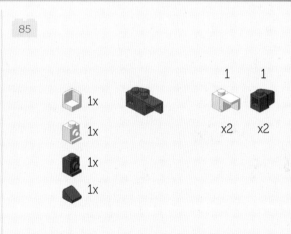

86

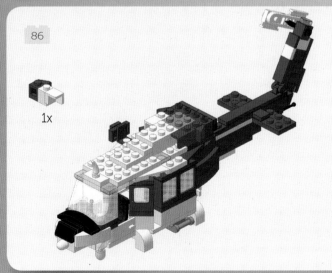

1x

87

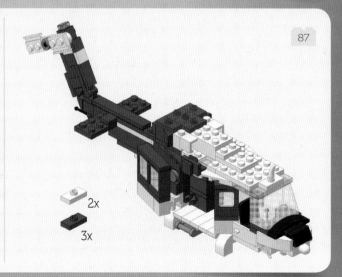

2x
3x

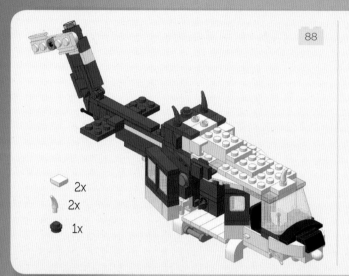

88

2x
2x
1x

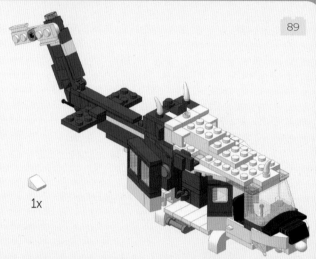

89

1x

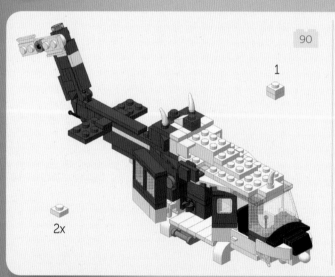

90

1

2x

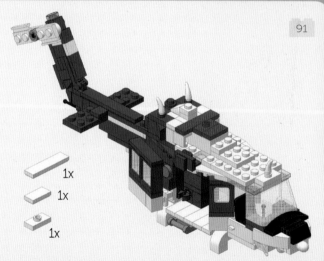

91

1x
1x
1x

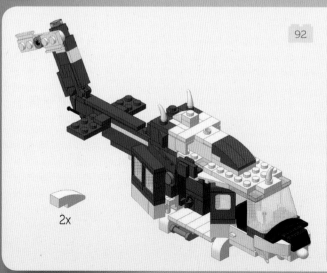

92

2x

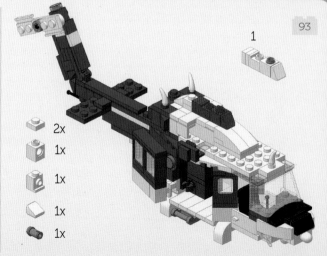

93

1

2x
1x
1x
1x
1x

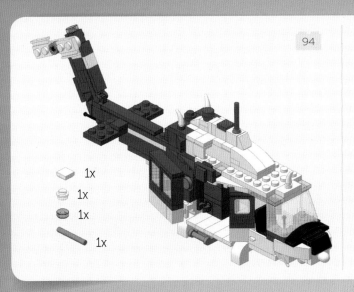

94

1x
1x
1x
1x

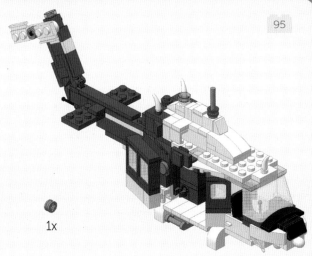

95

1x

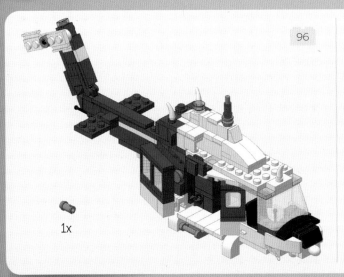

96

1x

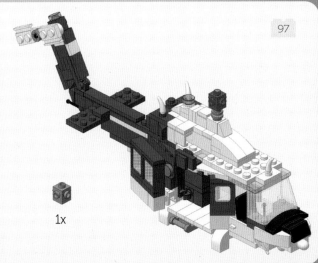

97

1x

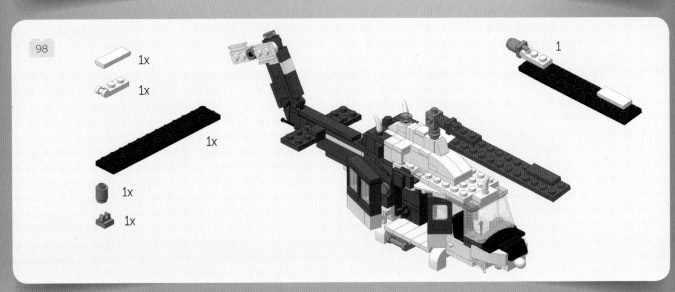

98

1x
1x
1x
1x
1x

1

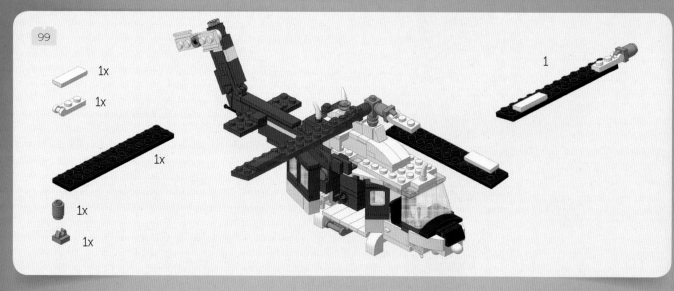

99

1x
1x
1x
1x
1x

1

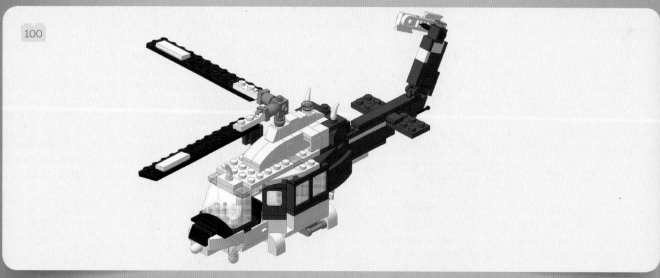

100

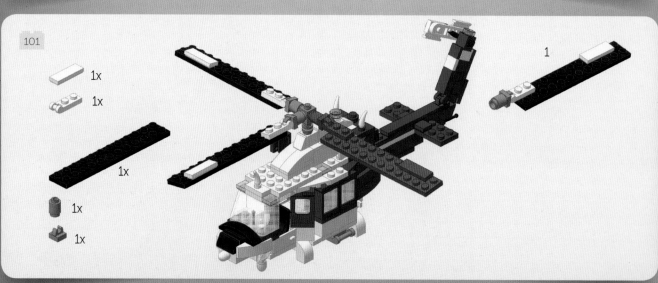

101

1x
1x
1x
1x
1x

1

102

1x
1x
1x
1x
1x

1

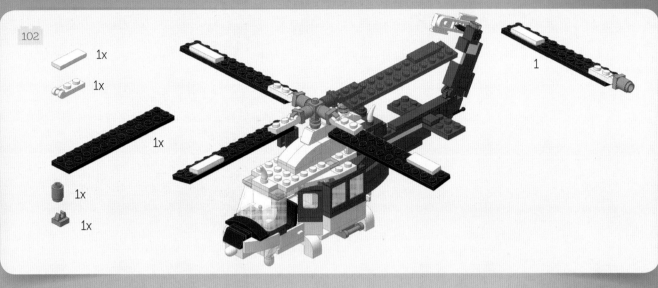

103

4x

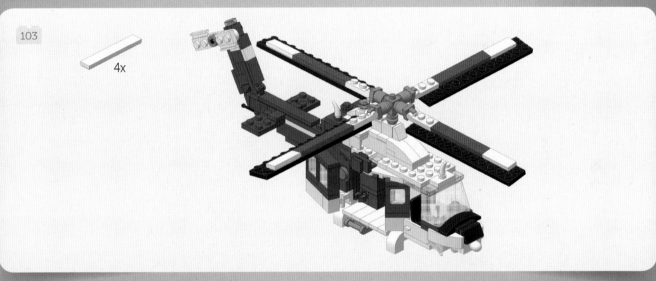

104

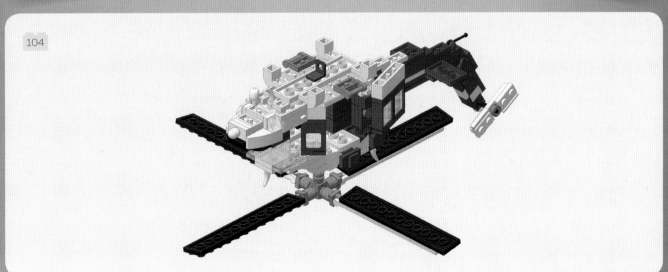

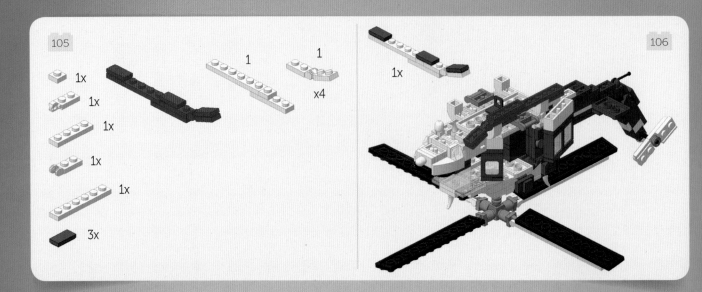

105

1x
1x
1x
1x
1x
3x

1
1
x4

106

1x

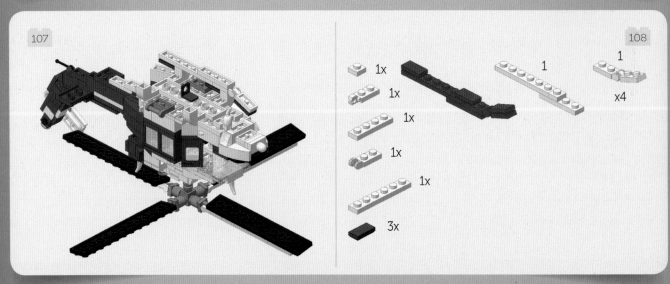

107

108

1x
1x
1x
1x
1x
3x

1
1
x4

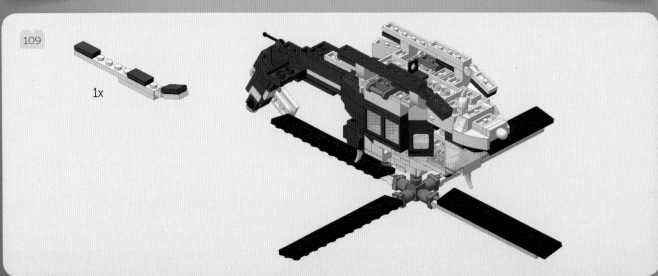

109

1x

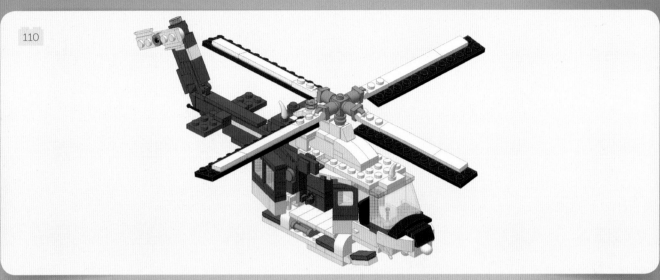

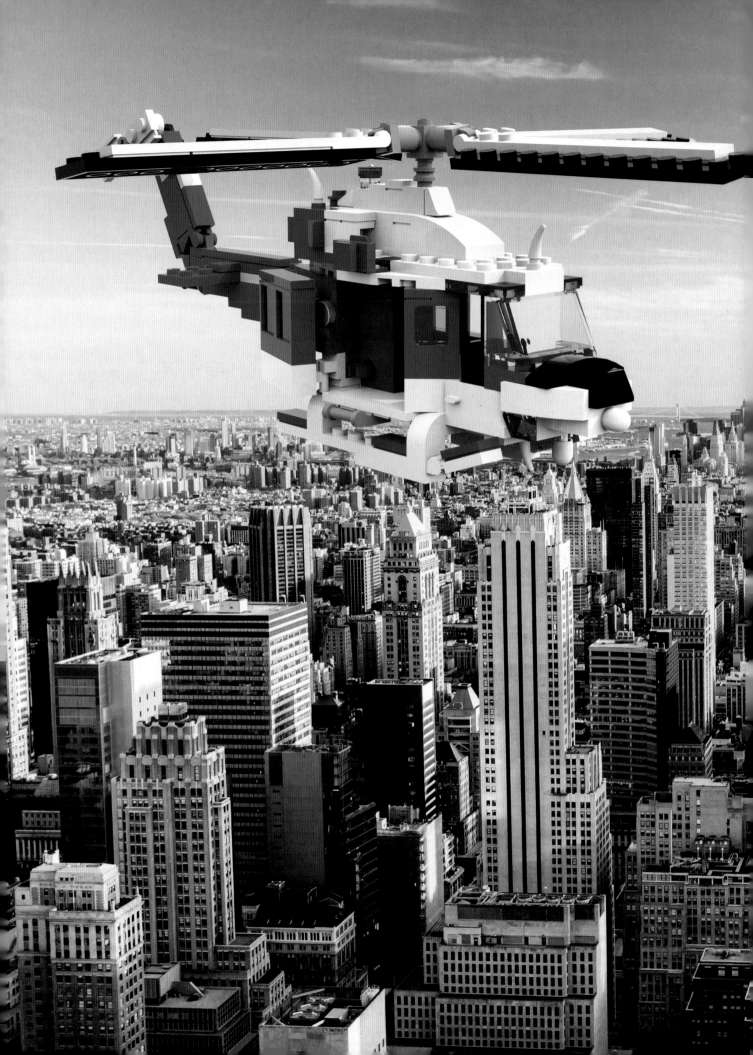

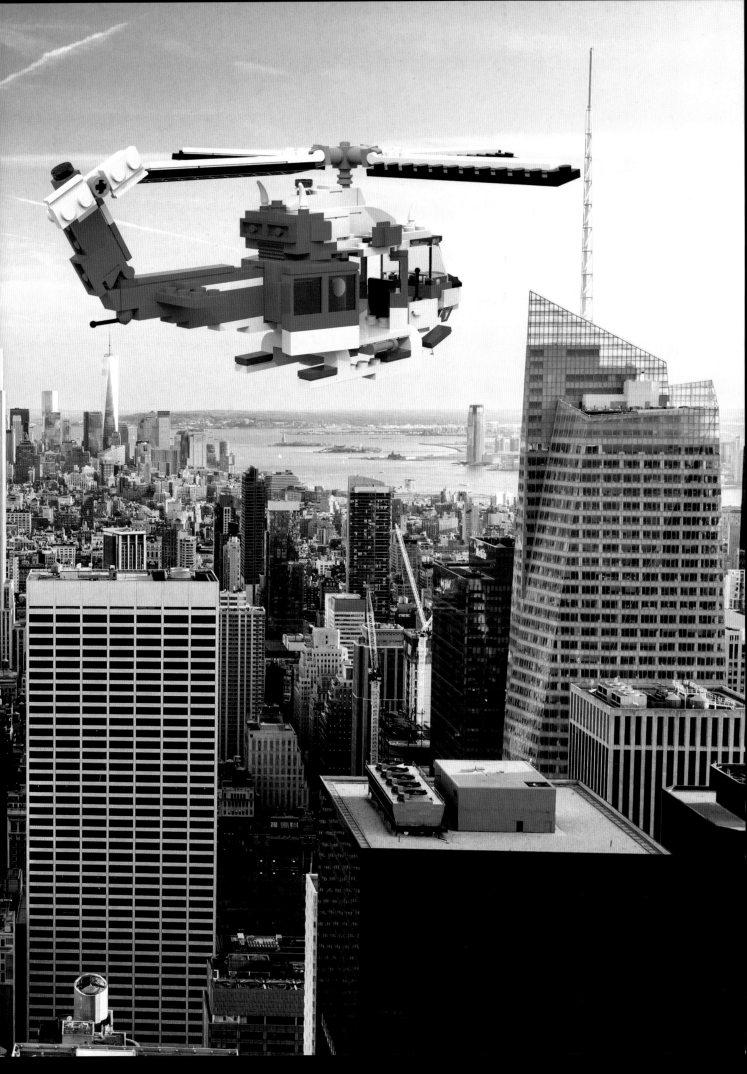

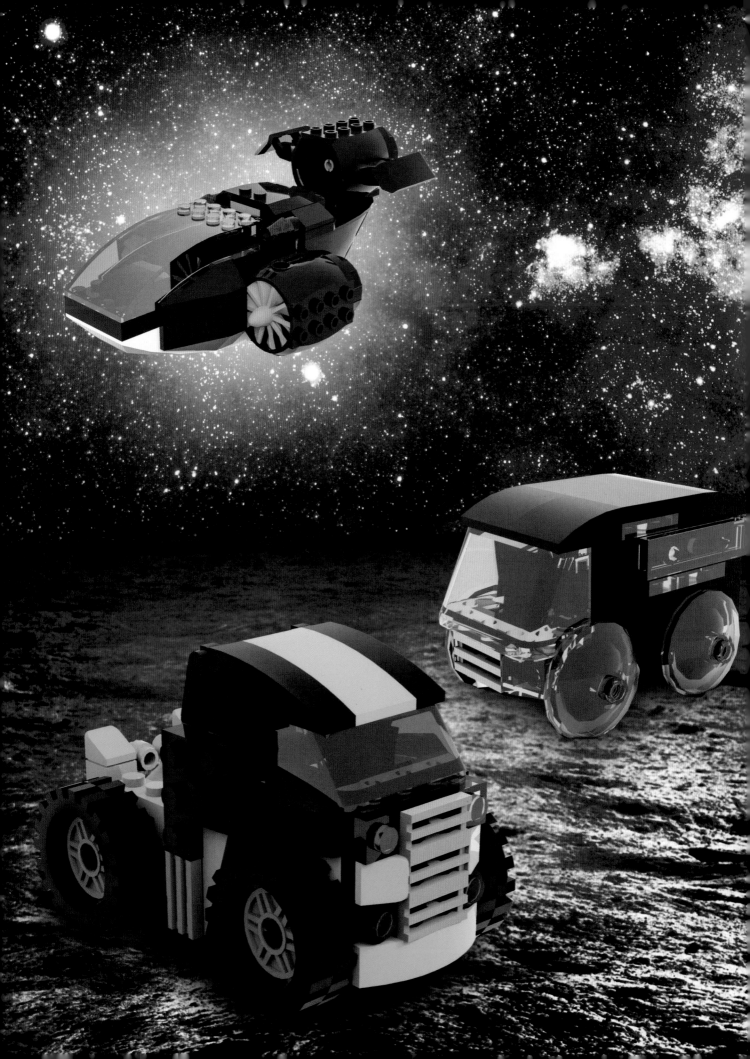

OUTER SPACE AND SCIENCE FICTION

OUTER SPACE? HERE WE COME!

The previous chapters took us on an exciting journey into the creativity of the real world: cars, trucks, boats and airplanes.

Everything that surrounds us in our daily life can be a source of inspiration, spurring us to let our imagination run wild!

Replicating real objects is, however, bound by reality itself.

Though we do have to use our wits and all our creativity to replicate the shapes of the objects we choose to reproduce, on the other hand, the result has to be as close as possible to the model we're replicating.

But there's an area unfettered by these rules, where our imagination is truly the only boundary: the world of outer space and science fiction.

In this extraordinary universe, spaceships, robots and space stations aren't subject to the laws of physics, mathematics or geometry.

It's a universe made of endless ideas, a universe of imagination and creativity... and what better "tool" to explore it with than LEGO® bricks?

And so, unlike in the previous chapters, you won't find fact sheets, news or comparisons with original models here. Just a fact sheet on the features and... some "anecdotes" concerning the model. The few words you'll find for each model are just the beginning—it's up to you to invent and create the sequel to each story!

"A long time ago in a galaxy far, far away..." and "Space: the final frontier". That's how two of the most famous science fiction sagas in the history of cinema and television start. And what about you? Are you ready to venture into boundless space?

Ladies and gentlemen, start up your engines and get ready for take-off!

The bricks that may prove useful to build robots, spaceships and space stations fall somewhere between the ones used for our vessels (we are talking about space*ships*, after all) and the ones used to build airplanes and other "flying machines" (wings, tails, jet engines and so on).

However, several elements you've already used to build some models from the previous chapters can also help you build outstanding spaceships or robots!

For example, see how the "wheel arch" used in Model 4 in the chapter on "Cars and Trucks" (**A**) can be used to create the air inlet on the jet engine of a spaceship (**B**). Or how the "shell" used in Model 6 in the chapter on "Boats and Ships" (**C**) is also perfect to create that of a "space fighter" (**D**)!

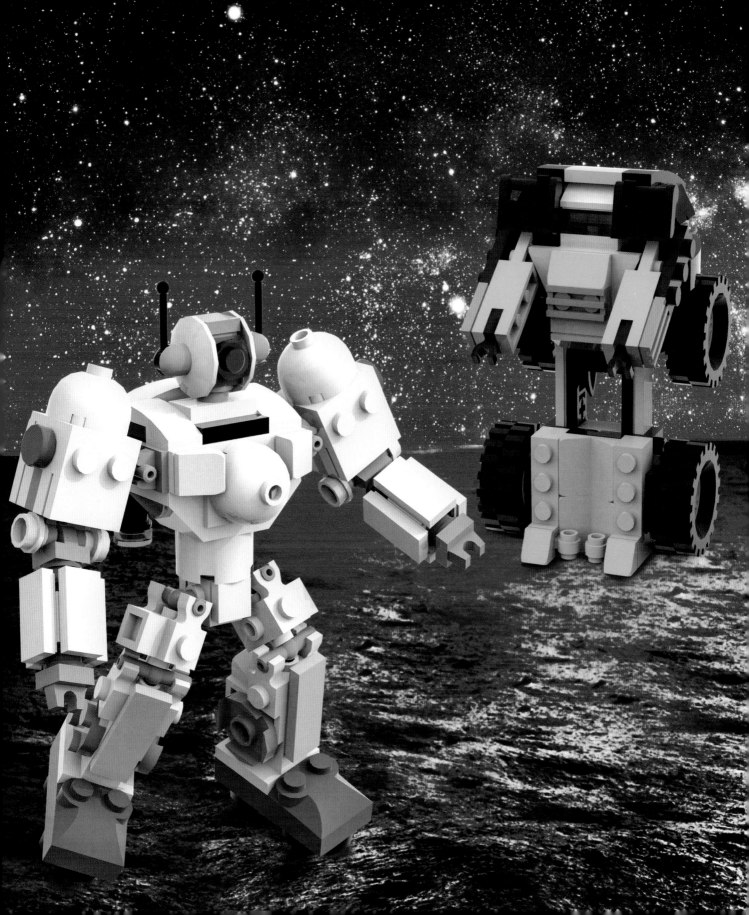

LEGO® brick version

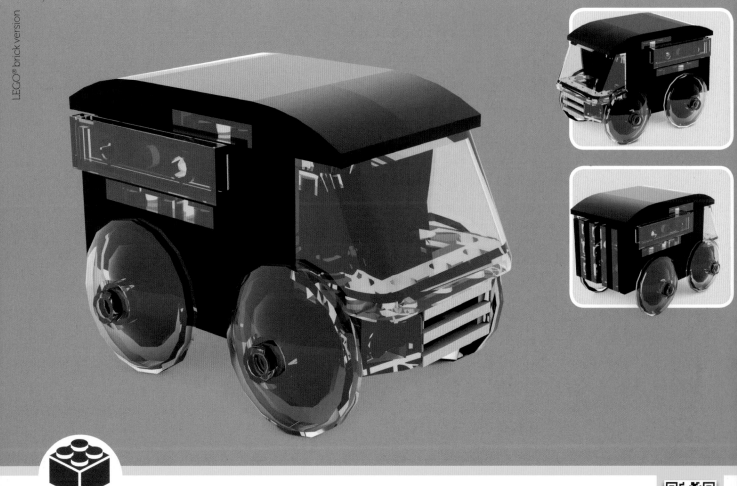

www.nuinui.ch/upload/legocreations-p134.zip

MODEL N.11

MINI "FUTURISTIC VAN"

AUTHOR/DESIGNER: UMBRA-MANIS (NICKNAME)

Since we're about to enter an unknown universe, don't you think we should start off with something small and easy? Thus, the first model in this new universe will be an awesome "futuristic van"! In the "city from the future" it comes from, it's used for... the speediest deliveries in the universe! You may not have heard, but everyone's always in a hurry in the future, so delivery vans have to be fast! Can you imagine a different version of this model? An open-body version, or one for specific hauls, or how about something for the artisans of the future? What kind of van do you think plumbers or electricians will use years from now?

UMBRA-MANIS
Known as Umbra-Manis, this highly-skilled builder and LEGO® fan prefers virtual LDD construction to "real" construction, though of course he never passes on a chance to use real bricks. He's also a great fan of all things science fiction (books, movies, comic books) and fantasy. Favorite LEGO® theme: LEGO® Ninjago®.

Features

- easy to build
- incredibly futuristic look
- "playable" model
- can be modified for a range of "professional" uses

List of bricks needed to build our Mini "Futuristic Van"

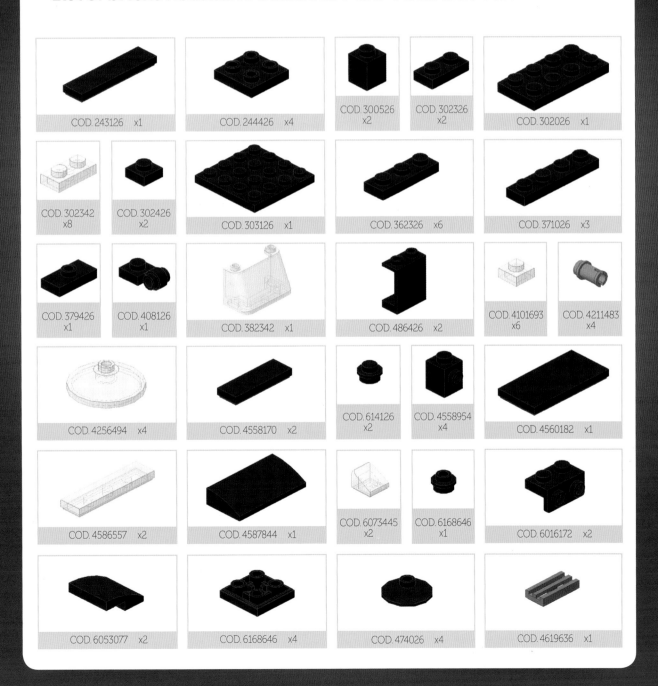

COD. 243126 x1	COD. 244426 x4	COD. 300526 x2	COD. 302326 x2	COD. 302026 x1
COD. 302342 x8	COD. 302426 x2	COD. 303126 x1	COD. 362326 x6	COD. 371026 x3
COD. 379426 x1	COD. 408126 x1	COD. 382342 x1	COD. 486426 x2	COD. 4101693 x6 / COD. 4211483 x4
COD. 4256494 x4	COD. 4558170 x2	COD. 614126 x2	COD. 4558954 x4	COD. 4560182 x1
COD. 4586557 x2	COD. 4587844 x1	COD. 6073445 x2	COD. 6168646 x1	COD. 6016172 x2
COD. 6053077 x2	COD. 6168646 x4	COD. 474026 x4	COD. 4619636 x1	

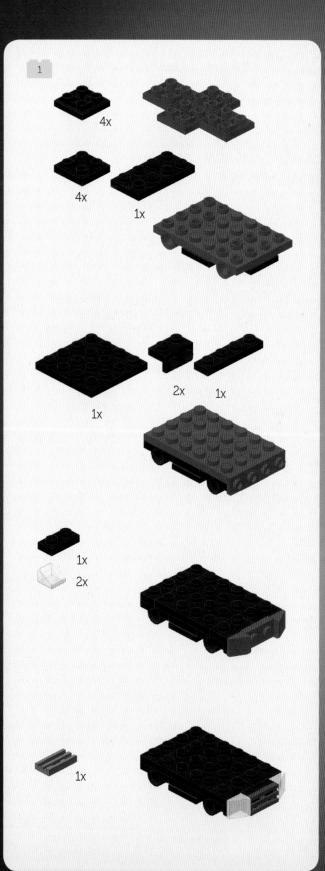

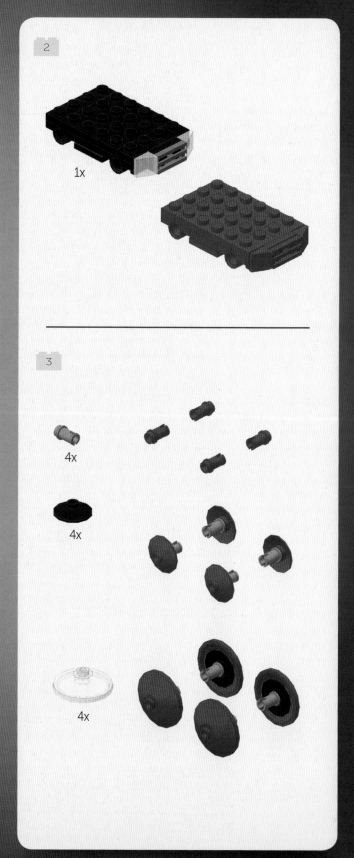

4

1x

5

2x 1x 1x

2x 1x

1x
1x
2x
2x

4x

2x

1x

2x

2x 1x

6

1x

7

1x 2x 2x

1x 1x

1x

2x

8

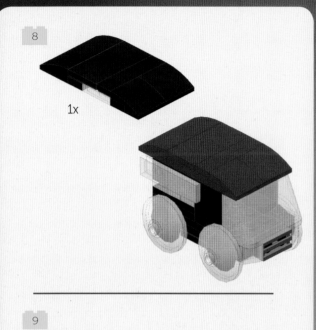

1x

9

1x 1x 1x
1x

1x 1x
1x

1x 1x
1x 1x

1x 1x
1x

10

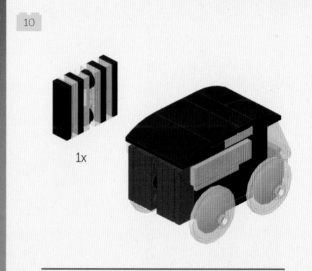

1x

11

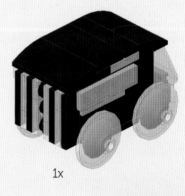

1x

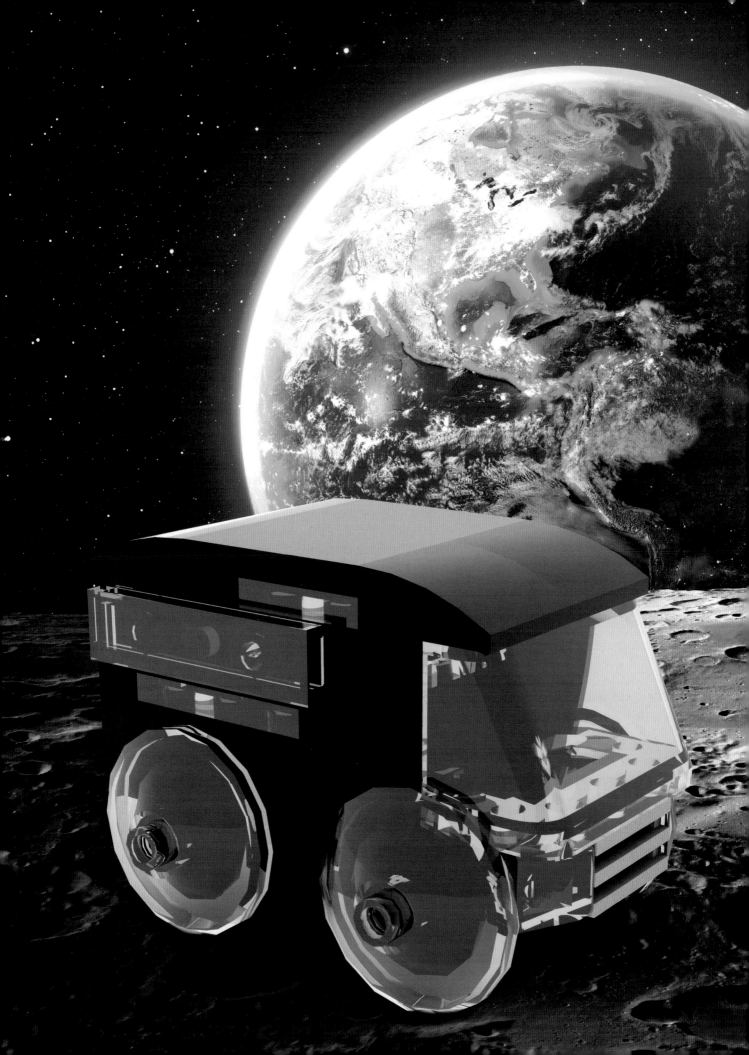

 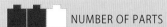
LEGO® brick version

www.nuinui.ch/upload/legocreations-p140.zip

MODEL N.12

"ORCA" SPACESHIP

AUTHOR/DESIGNER: NICOLA LUGATO (NICKNAME: MSX80)

Things are getting harder and harder! After the Mini "Futuristic Van", it's time for the speedy "travel spaceship" nicknamed the "Orca", as its shape recalls the mighty sea mammal. Fast and easy to maneuver, it's the perfect vehicle to navigate through space!

Here's your challenge: will you use a different propulsion system, or try to create a new "cargo" or two-seater version?

NICOLA LUGATO

Nicola Lugato is a truly special person: not only is he skilled at building objects with LEGO® bricks; he's an excellent software developer first and foremost. He's the author of the two software programs used to create the instructions and photorealistic renderings you find in this book: Blueprint *to generate the instructions and* Bluerender *to create the digital images.*

Features

- fun to build
- "semi-cetacean" look
- can fit a pilot at the controls
- extremely "playable" model; can be personalized

List of bricks needed to build our "space cetacean"

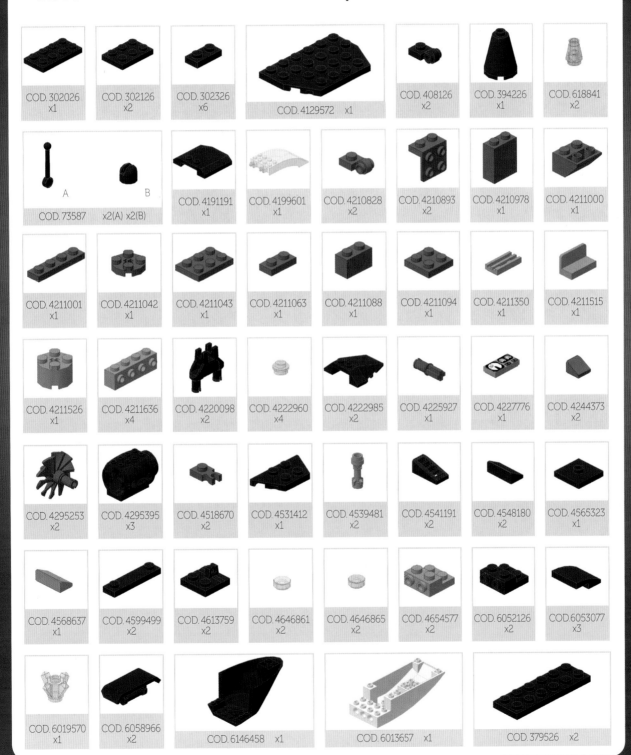

COD. 302026 x1
COD. 302126 x2
COD. 302326 x6
COD. 4129572 x1
COD. 408126 x2
COD. 394226 x1
COD. 618841 x2

COD. 73587 x2(A) x2(B)
COD. 4191191 x1
COD. 4199601 x1
COD. 4210828 x2
COD. 4210893 x2
COD. 4210978 x1
COD. 4211000 x1

COD. 4211001 x1
COD. 4211042 x1
COD. 4211043 x1
COD. 4211063 x1
COD. 4211088 x1
COD. 4211094 x1
COD. 4211350 x1
COD. 4211515 x1

COD. 4211526 x1
COD. 4211636 x4
COD. 4220098 x2
COD. 4222960 x4
COD. 4222985 x2
COD. 4225927 x1
COD. 4227776 x1
COD. 4244373 x2

COD. 4295253 x2
COD. 4295395 x3
COD. 4518670 x2
COD. 4531412 x1
COD. 4539481 x2
COD. 4541191 x2
COD. 4548180 x2
COD. 4565323 x1

COD. 4568637 x1
COD. 4599499 x2
COD. 4613759 x2
COD. 4646861 x2
COD. 4646865 x2
COD. 4654577 x2
COD. 6052126 x2
COD. 6053077 x3

COD. 6019570 x1
COD. 6058966 x2
COD. 6146458 x1
COD. 6013657 x1
COD. 379526 x2

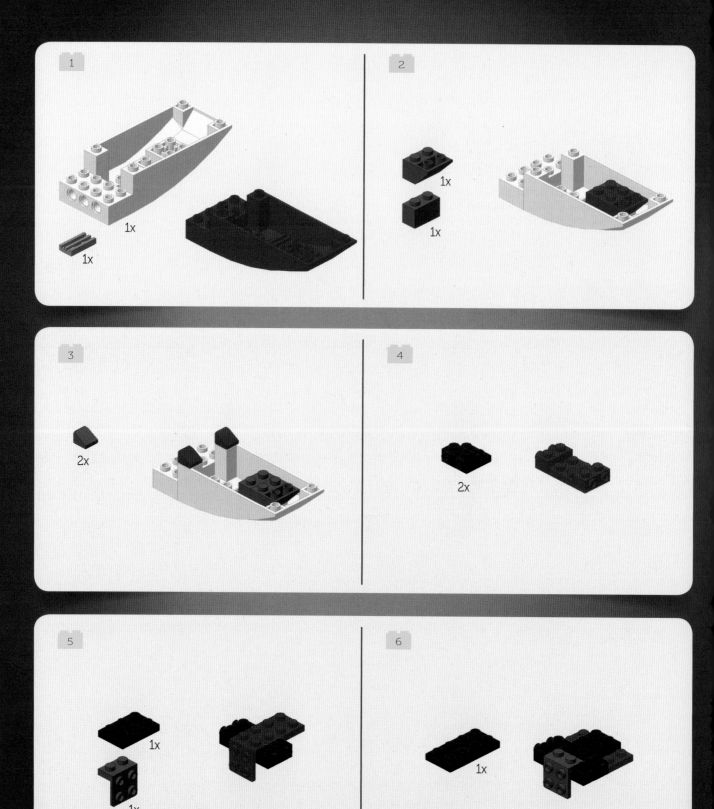

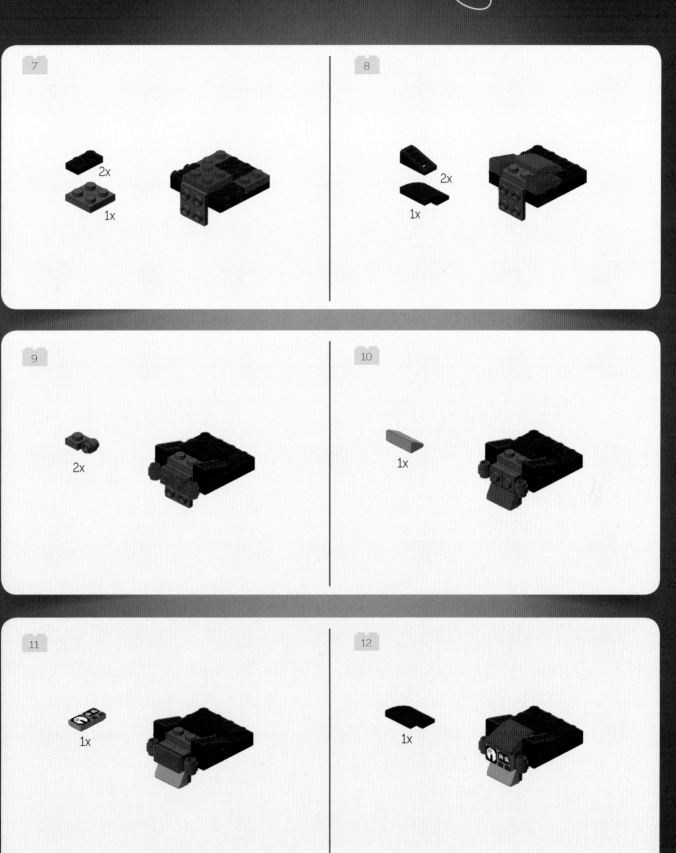

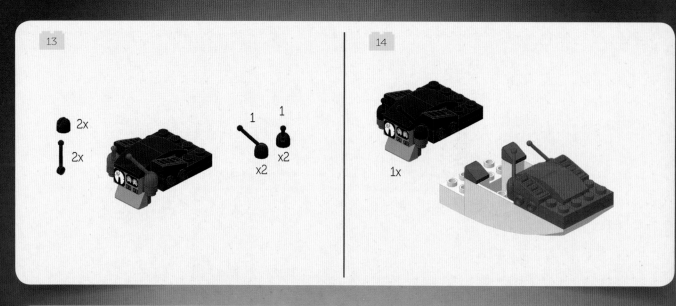

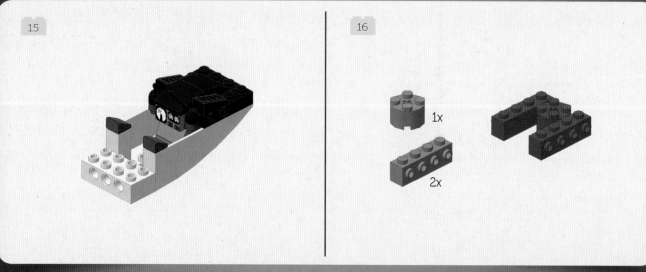

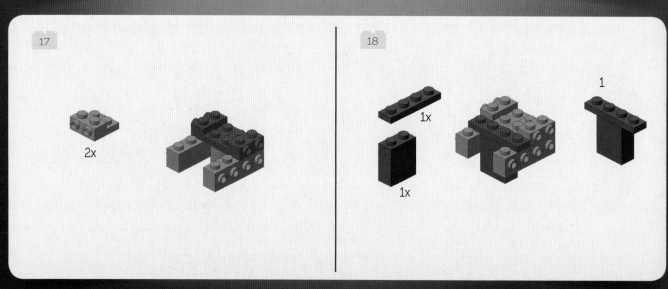

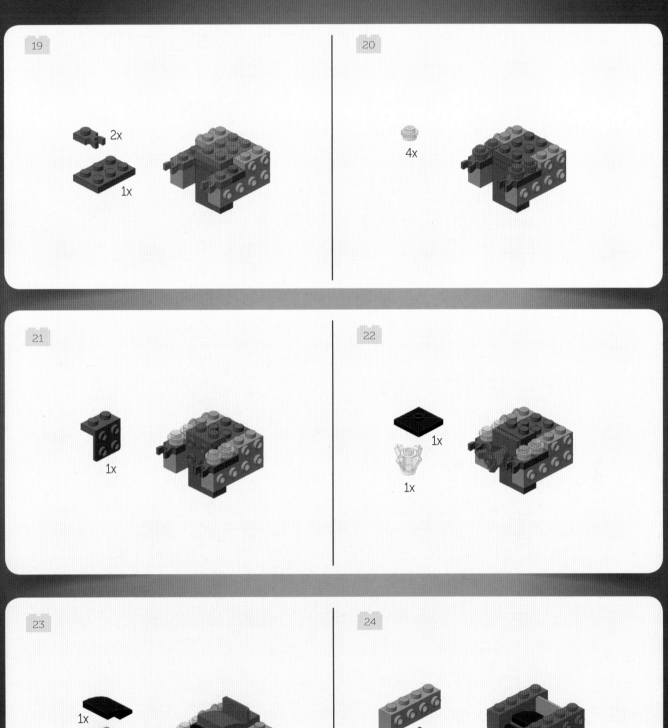

19

2x

1x

20

4x

21

1x

22

1x

1x

23

1x

1x

24

2x

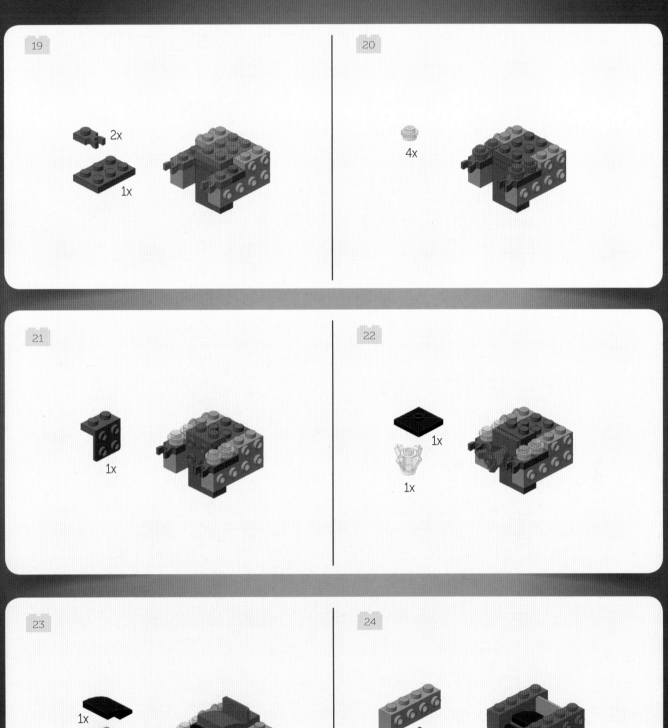

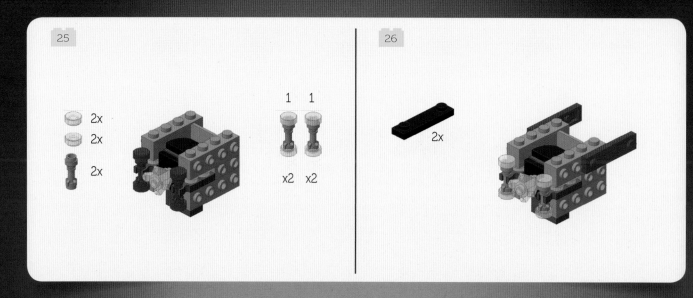

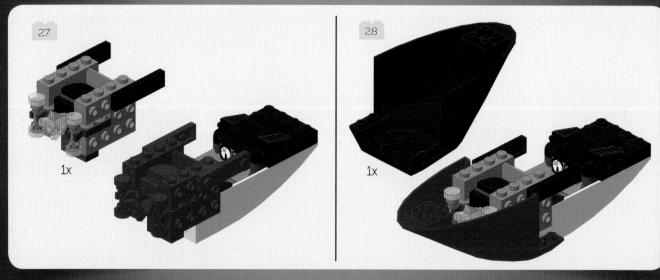

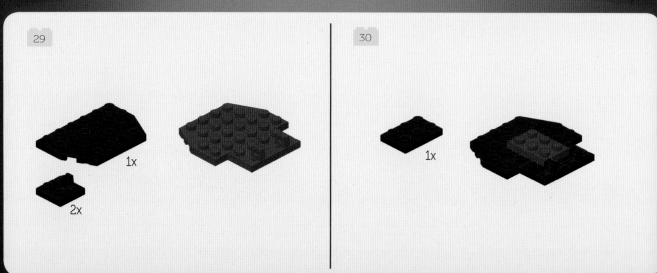

31

2x
2x

32

2x

33

1x

34

1x

35

1x
2x

36

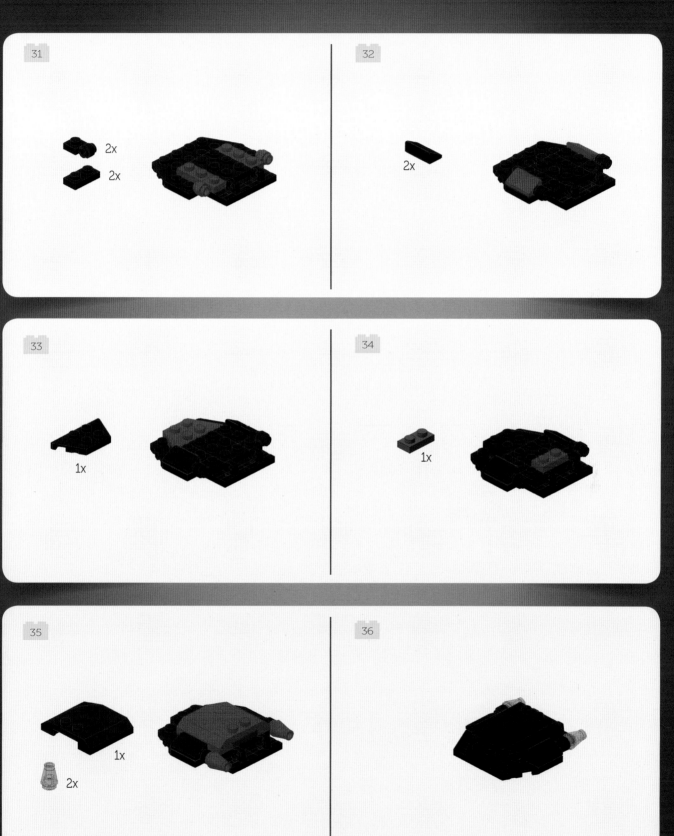

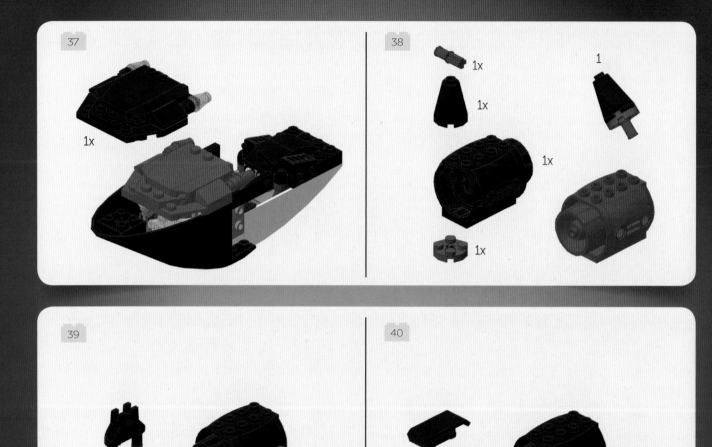

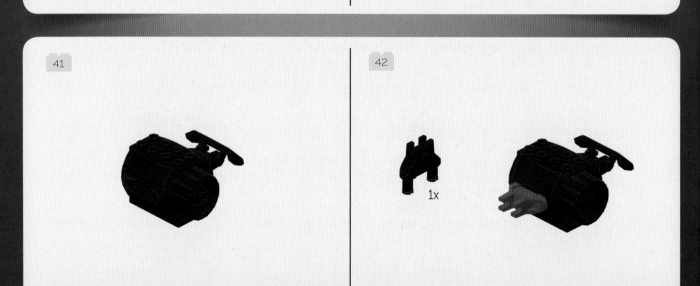

43

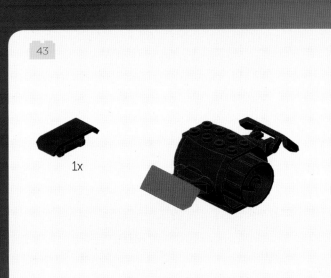

1x

44

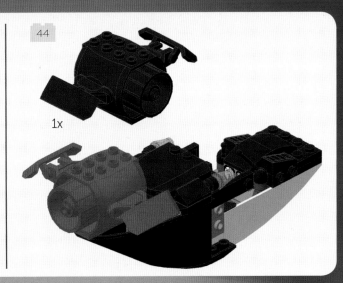

1x

45

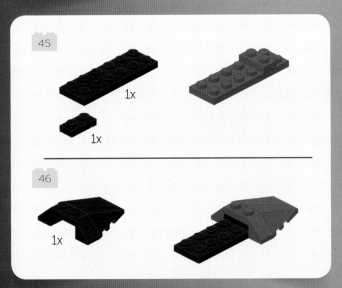

1x

1x

46

47 1

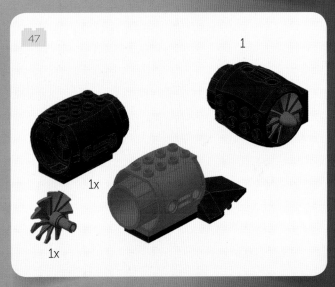

1x

1x

48

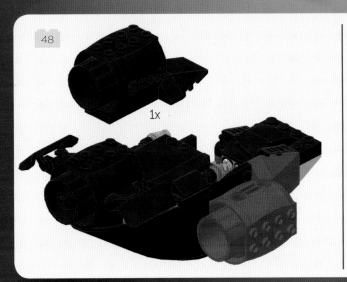

1x

49

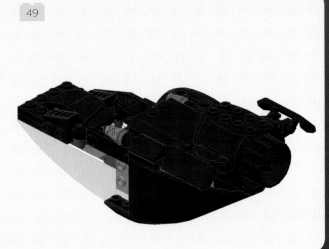

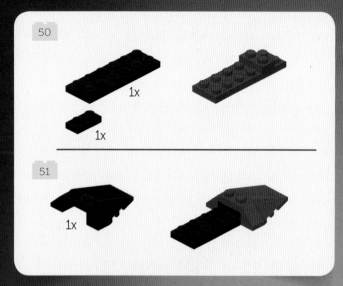

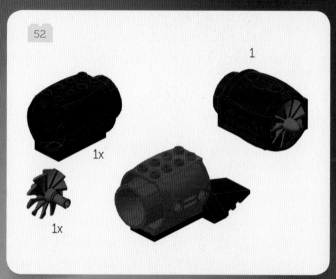

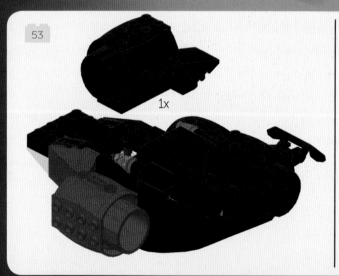

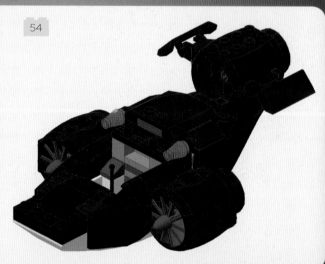

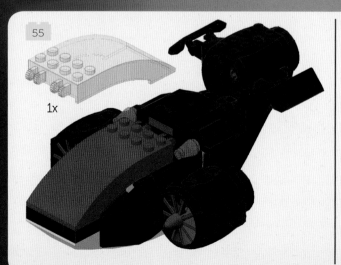

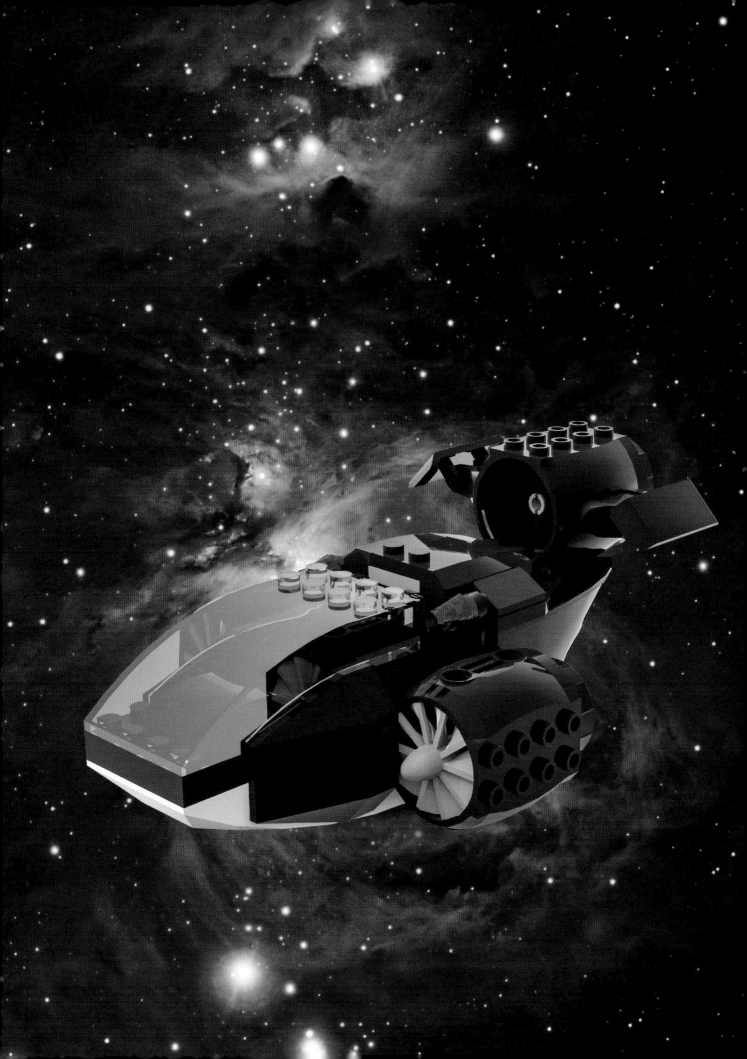

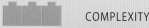 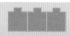
LEGO® brick version

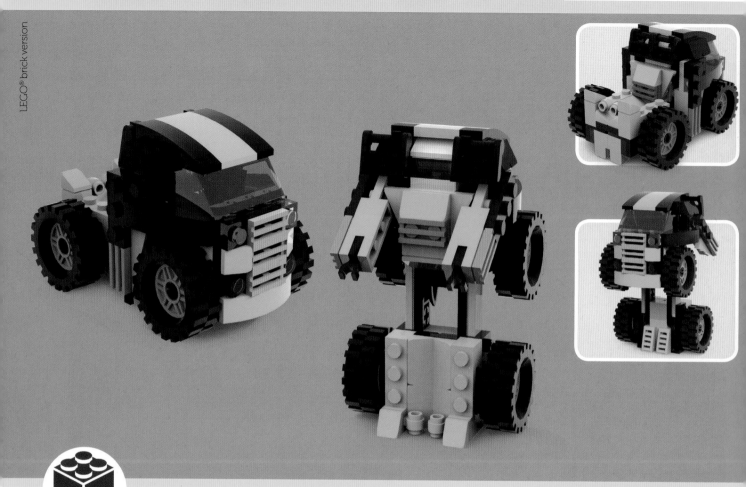

www.nuinui.ch/upload/legocreations-p152.zip

MODEL N.13

"ATTACCABRIGHE" BRICKFORMER

AUTHOR/DESIGNER: EZRA ARIELLA WIBOWO (NICKNAME: BACEM)

At this point in our book, what better challenge than to try and build a "Transformer" robot? Actually, since it will be made out of LEGO® bricks, let's call it a BRICKformer!
Is it a truck or a robot? It's a BRICKformer!

EZRA ARIELLA WIBOWO
Ezra Ariella Wibowo is a young high school student who lives in Surabaya, Indonesia. A great LEGO® enthusiast, he loves building so-called "LEGO-formers"—LEGO® brick versions of the legendary Transformers®: vehicles that turn into robots and vice versa.

Features

- "tricky" model (i.e., with several building "tricks" available)
- "tough" look
- its transformability makes it a "playable" model

List of the bricks needed to build our "Attaccabrighe" BRICKformer

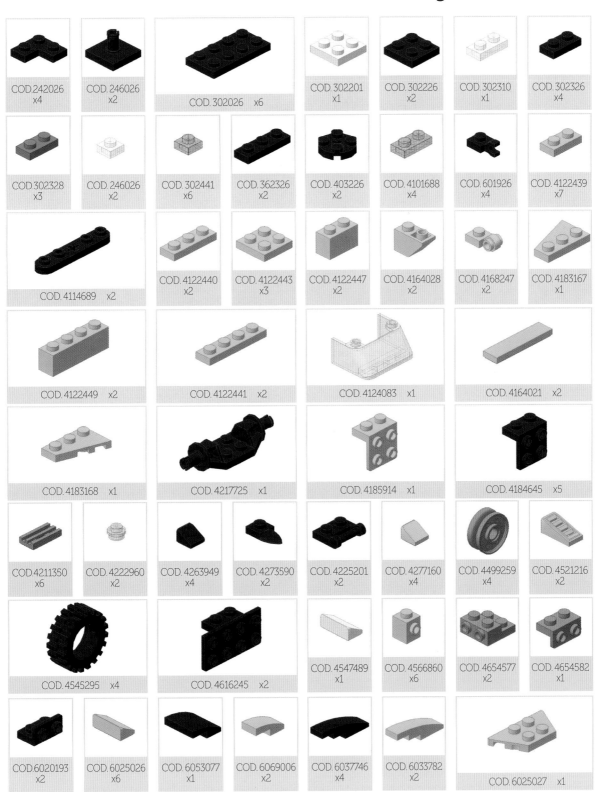

COD.242026 x4
COD.246026 x2
COD.302026 x6
COD.302201 x1
COD.302226 x2
COD.302310 x1
COD.302326 x4

COD.302328 x3
COD.246026 x2
COD.302441 x6
COD.362326 x2
COD.403226 x2
COD.4101688 x4
COD.601926 x4
COD.4122439 x7

COD.4114689 x2
COD.4122440 x2
COD.4122443 x3
COD.4122447 x2
COD.4164028 x2
COD.4168247 x2
COD.4183167 x1

COD.4122449 x2
COD.4122441 x2
COD.4124083 x1
COD.4164021 x2

COD.4183168 x1
COD.4217725 x1
COD.4185914 x1
COD.4184645 x5

COD.4211350 x6
COD.4222960 x2
COD.4263949 x4
COD.4273590 x2
COD.4225201 x2
COD.4277160 x4
COD.4499259 x4
COD.4521216 x2

COD.4545295 x4
COD.4616245 x2
COD.4547489 x1
COD.4566860 x6
COD.4654577 x2
COD.4654582 x1

COD.6020193 x2
COD.6025026 x6
COD.6053077 x1
COD.6069006 x2
COD.6037746 x4
COD.6033782 x2
COD.6025027 x1

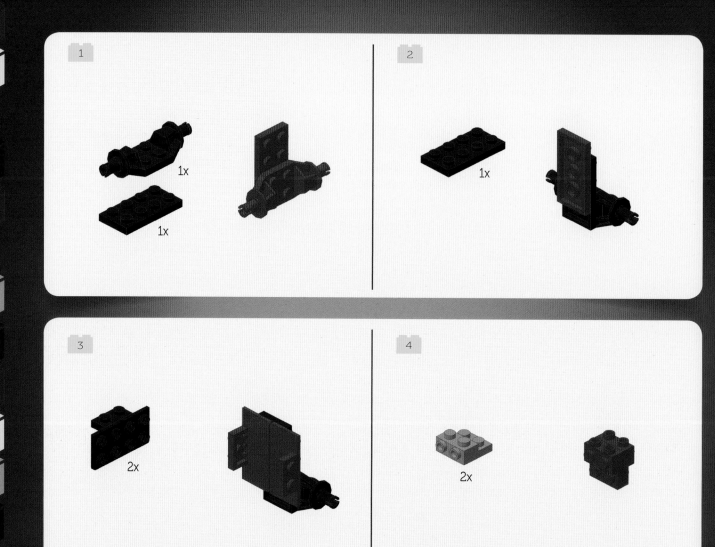

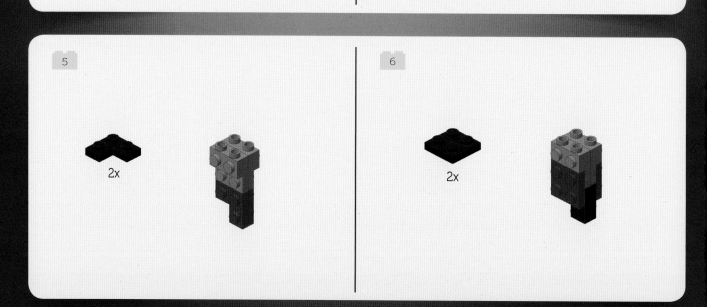

7

2x

8

1x
1x
1x
1x

9

1x
1x
1x
1x

10

1x
1x

11

1x

12

1x

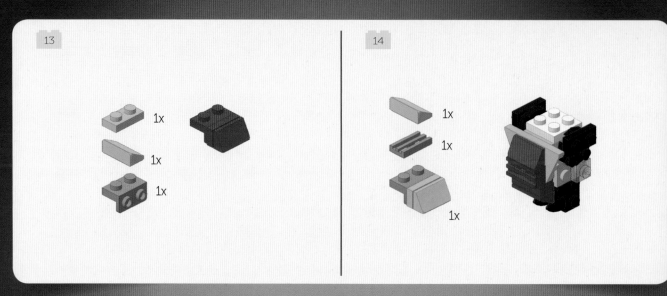

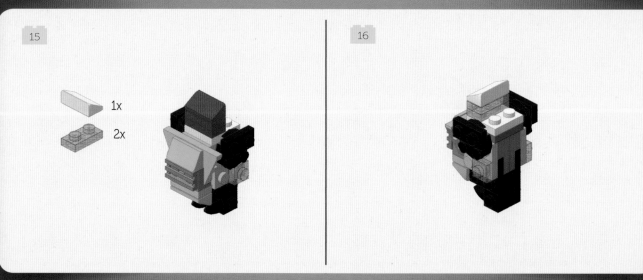

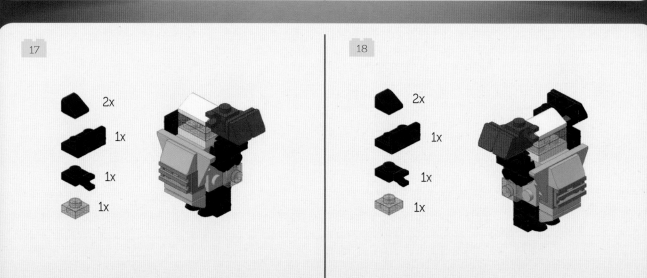

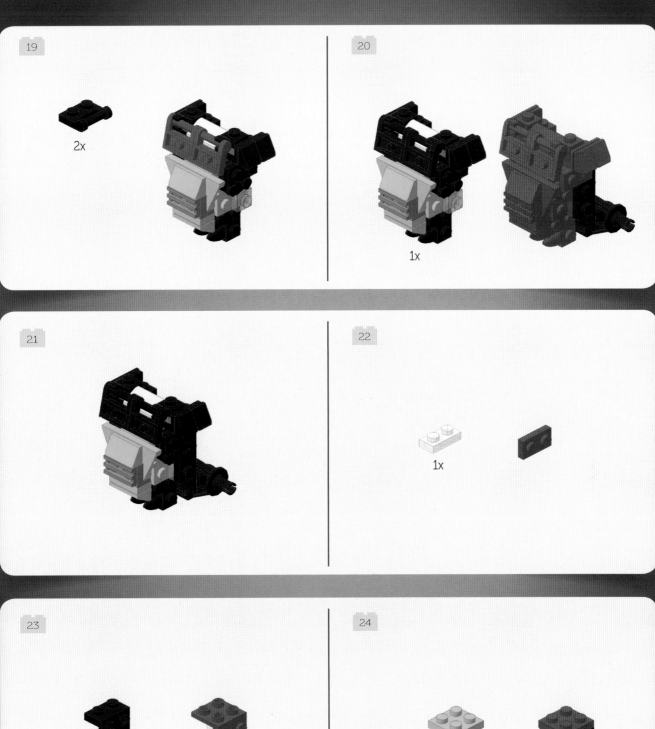

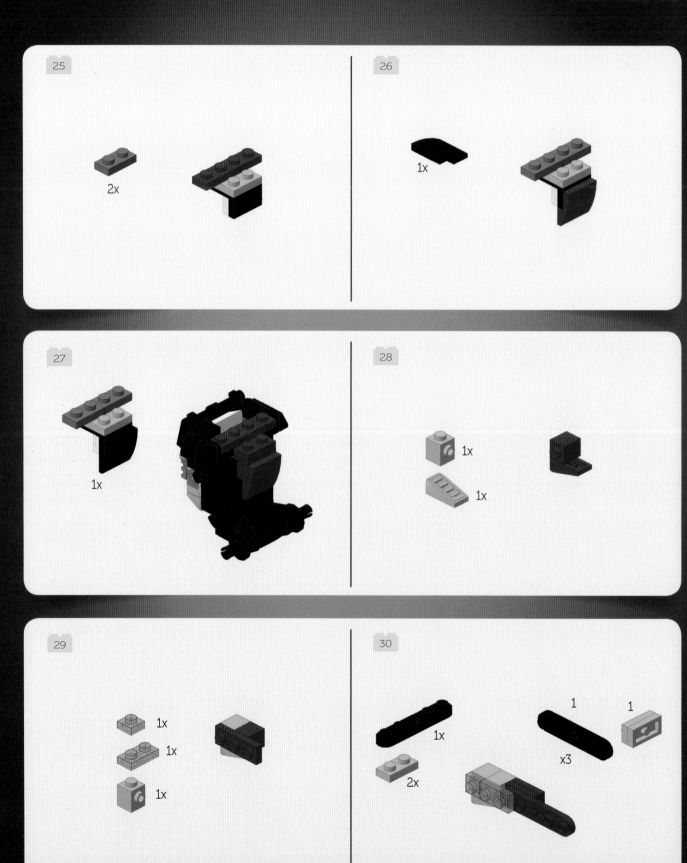

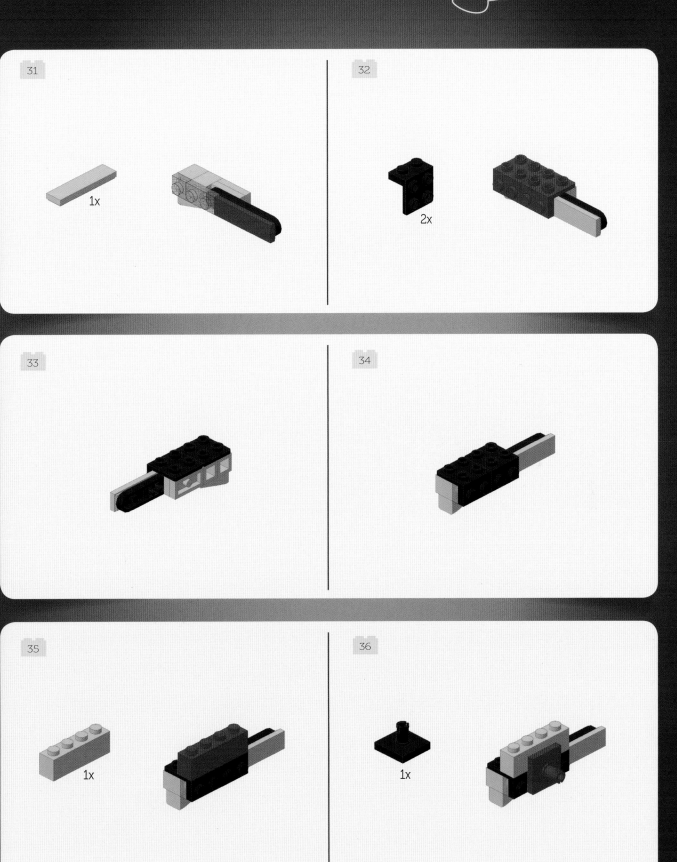

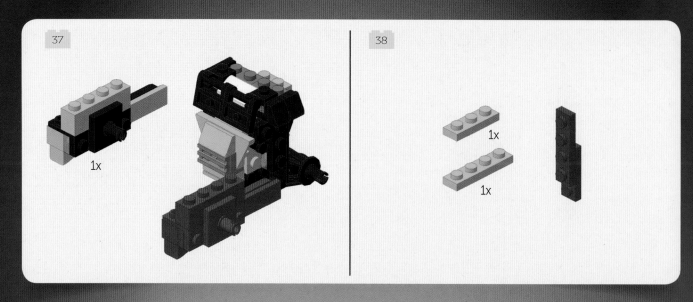

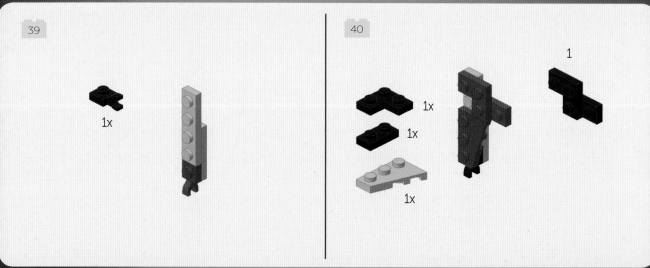

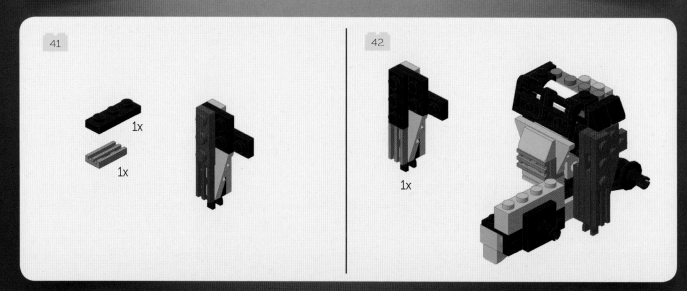

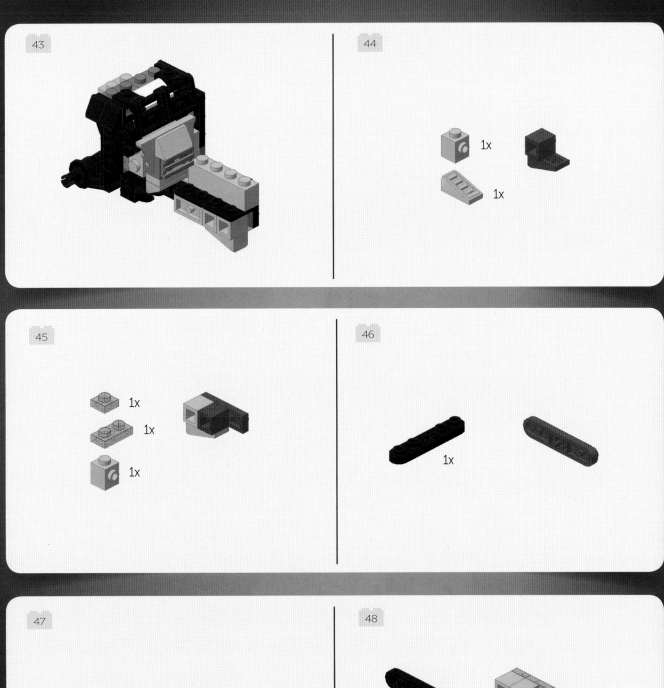

49

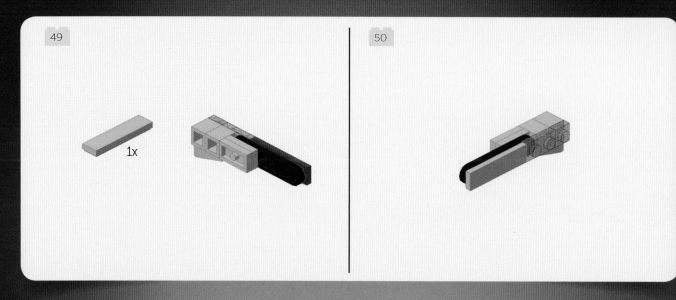

1x

50

51

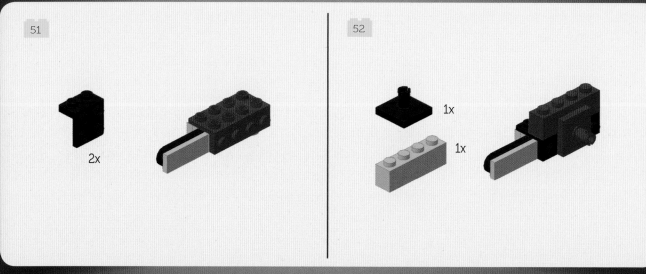

2x

52

1x

1x

53

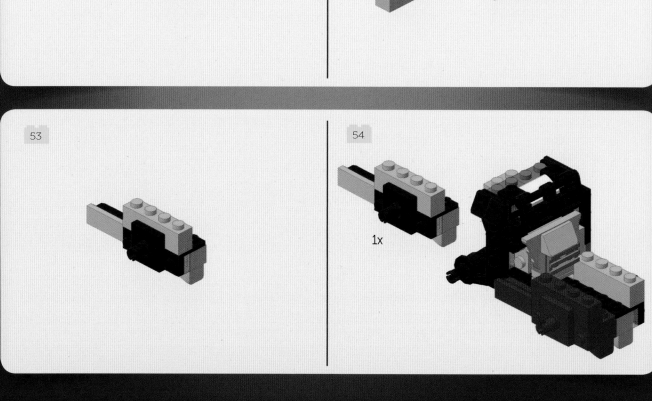

54

1x

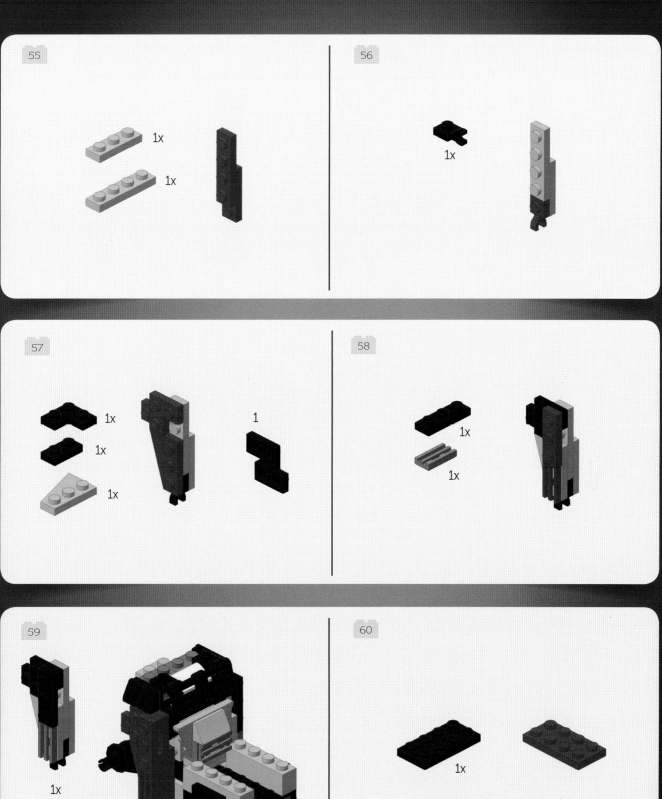

61

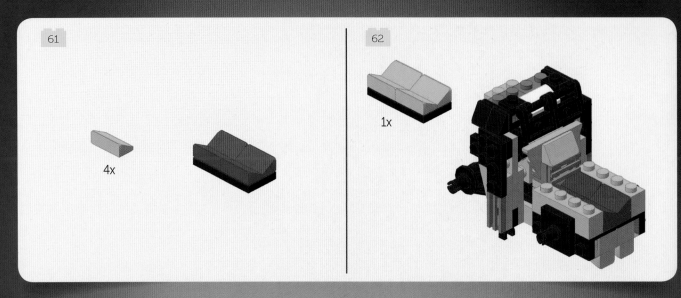

4x

62

1x

63

2x

2x

64

1x

65

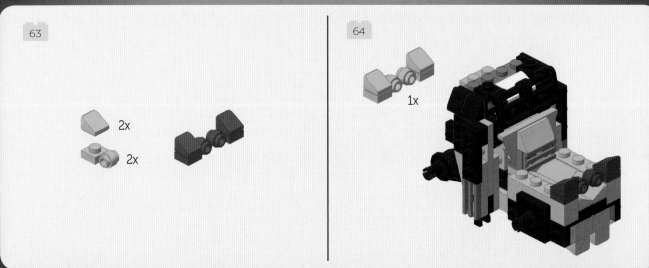

2x

66

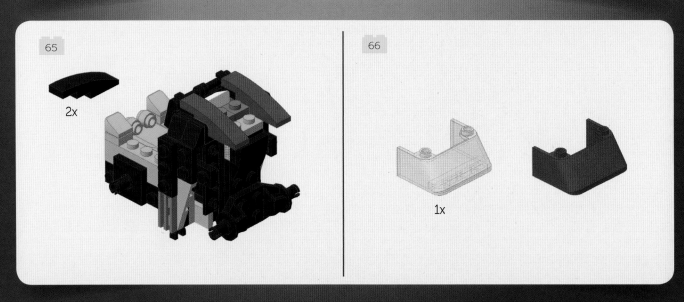

1x

67

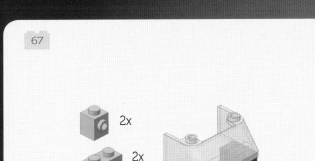

2x

2x

68

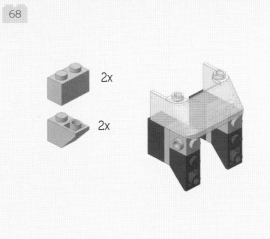

2x

2x

69

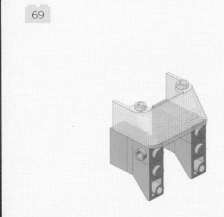

70

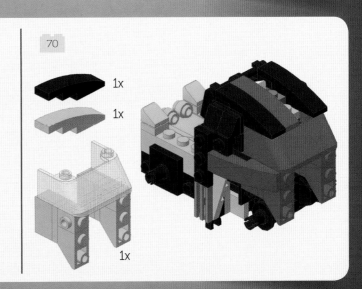

1x

1x

1x

71

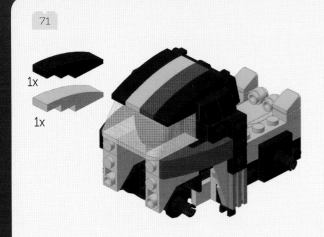

1x

1x

72

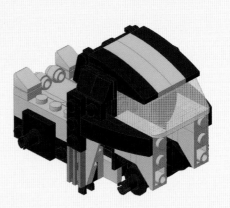

73

3x

74

2x

3x

75

2x

2x

76

2x

77

1x

78

1x

1x

79

1x

1x

80

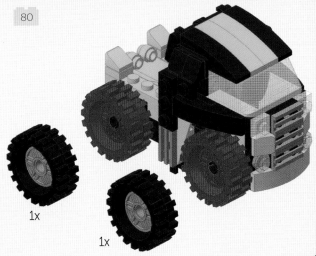

1x

1x

81

1x

1x

82

1x

1x

83

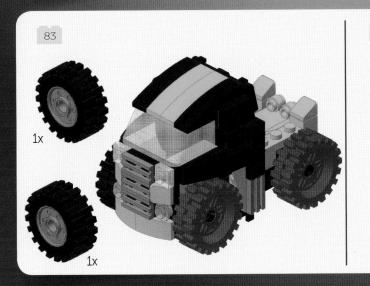

1x

1x

84

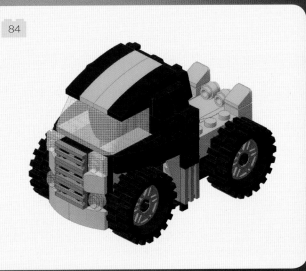

TRUCK-ROBOT CONVERSION AND VICE VERSA

Here's how you can transform your truck into a robot.
Once you've built the truck,

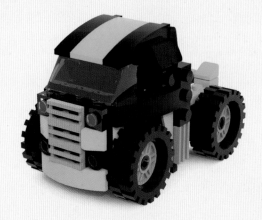

grasp the cab in one hand and the chassis/rear axle in the other, opening the hinge
between the two parts.

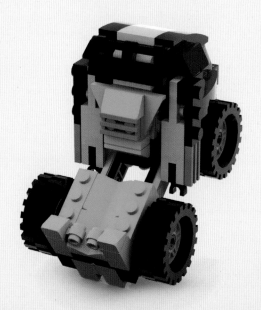

At this point, rotate the two "arms" (the cab parts directly behind the doors) forward; first the right one and then the left (or vice versa).

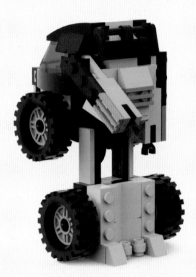 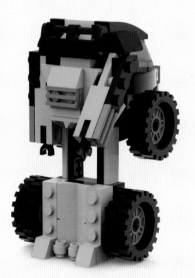

Now all you have to do is expose the robot's... head. To do this, slide the two elements that make up the "spoiler" on top (at the rear of the cabin), left and right.

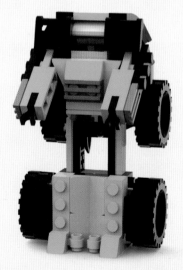

To return the robot to its original truck shape, perform the steps in reverse order: first pull together the two elements on top (at the rear of the cabin), thus hiding the robot's head; then extend the arms again. Finally, place the part representing the robot's legs and feet perpendicular to the cab.

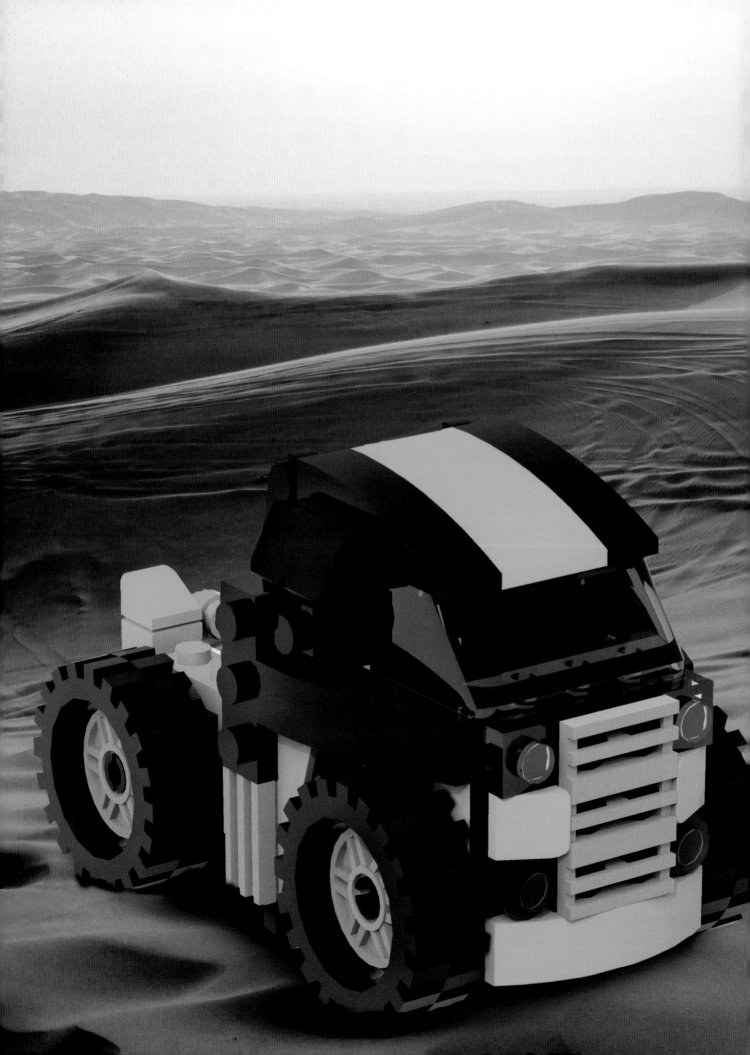

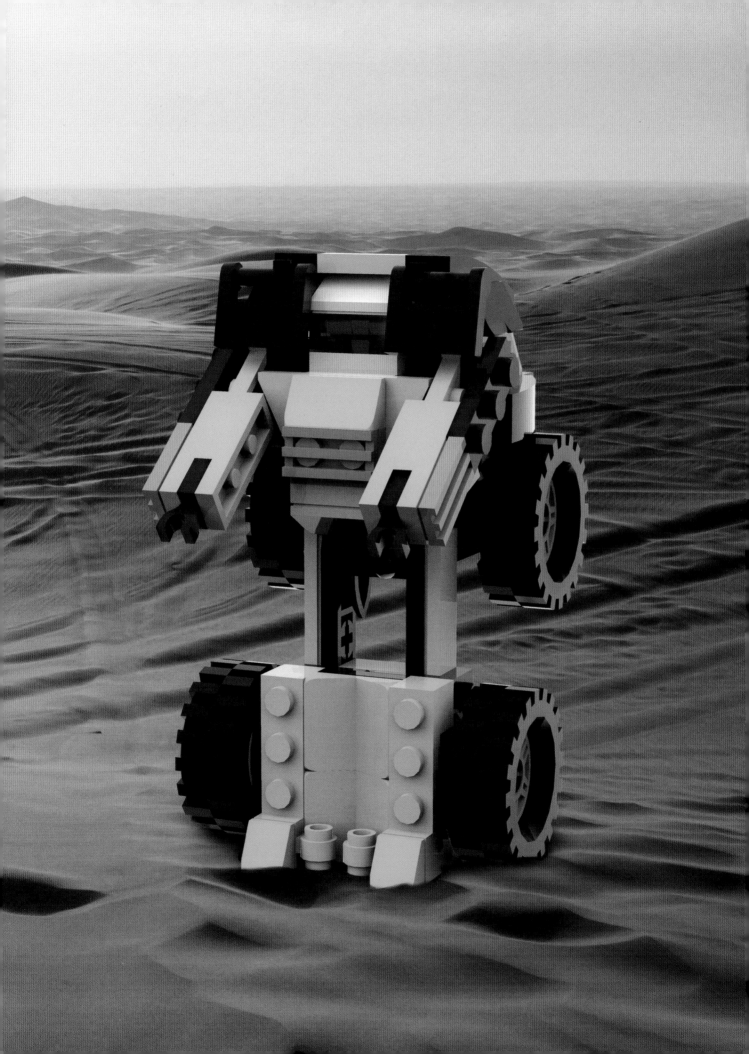

LEGO® brick version

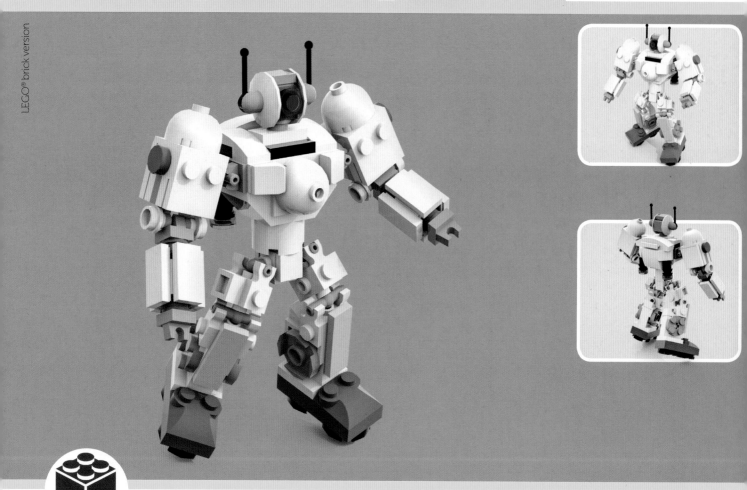

www.nuinui.ch/upload/legocreations-p172.zip

MODEL N.14

"ALPHONSE" SPACE ROBOT

AUTHOR/DESIGNER: RICARDO CHOCKEE (NICKNAME: CHOCOPOPS)

Though it was dubbed "Space Guardian" by its creator, we'll call it "Alphonse" in honor of its resemblance to the main character in one of my favorite Japanese anime series, *Patlabor*. "Alphonse" was designed to a "micro" scale, the most popular among the Japanese anime fans belonging to the community of the best builders and designers of models made with LEGO® bricks.

By now, there's a wide range of basic techniques and standard LEGO® elements we can use to create joints (knee, shoulder, etc.), such as the "T-PIECE".

Alphonse's "pelvis" and "knee" in detail

The "T-PIECE"

RICARDO CHOCKEE (CHOCOPOPS)

Richard Chockee, known as Chocopops, is a skilled builder of LEGO® brick models and creations. He lives in Panama, where he's studying to become an electromechanical engineer, and he loves to play basketball.
His "lego-ese specialty" is building robots and models to scale. His favorite LEGO® element is the red brick.

Features

- perfectly functioning "joints" (elbows, knees, etc.)
- the joints included in the "limbs" allow it to be "positioned" realistically
- the LEGO® elements that serve as hands are the same as those of normal LEGO® Minifigures, so "Alphonse" can hold any kind of tool or utensil

List of bricks needed to build our "Alphonse"

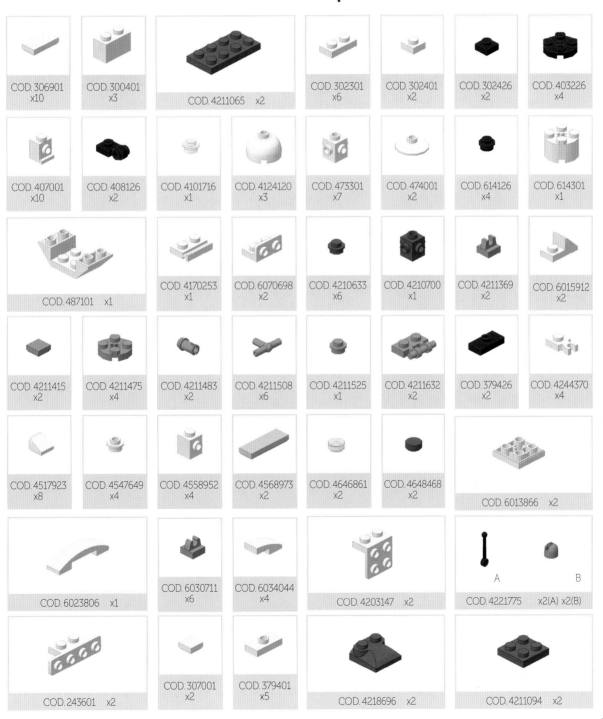

COD. 306901 x10	COD. 300401 x3
COD. 4211065 x2	
COD. 302301 x6	COD. 302401 x2
COD. 302426 x2	COD. 403226 x4
COD. 407001 x10	COD. 408126 x2
COD. 4101716 x1	COD. 4124120 x3
COD. 473301 x7	COD. 474001 x2
COD. 614126 x4	COD. 614301 x1
COD. 487101 x1	
COD. 4170253 x1	COD. 6070698 x2
COD. 4210633 x6	COD. 4210700 x1
COD. 4211369 x2	COD. 6015912 x2
COD. 4211415 x2	COD. 4211475 x4
COD. 4211483 x2	COD. 4211508 x6
COD. 4211525 x1	COD. 4211632 x2
COD. 379426 x2	COD. 4244370 x4
COD. 4517923 x8	COD. 4547649 x4
COD. 4558952 x4	COD. 4568973 x2
COD. 4646861 x2	COD. 4648468 x2
COD. 6013866 x2	
COD. 6023806 x1	COD. 6030711 x6
COD. 6034044 x4	COD. 4203147 x2
COD. 4221775 x2(A) x2(B)	A B
COD. 243601 x2	COD. 307001 x2
COD. 379401 x5	COD. 4218696 x2
COD. 4211094 x2	

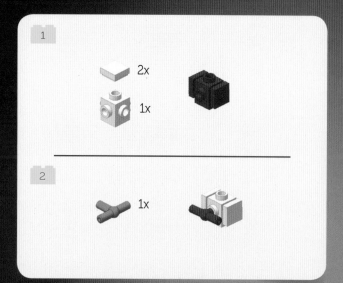

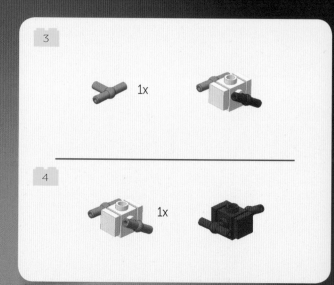

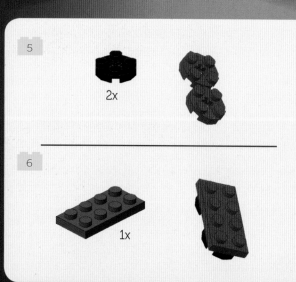

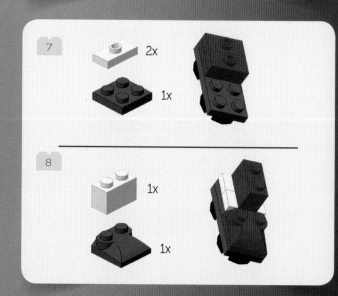

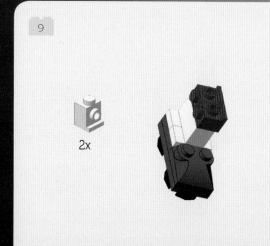

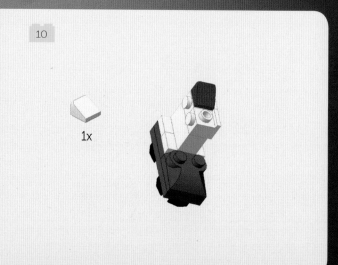

11 1x

12 1x

13 1x 2x

14 1x

15 1x

16 1x

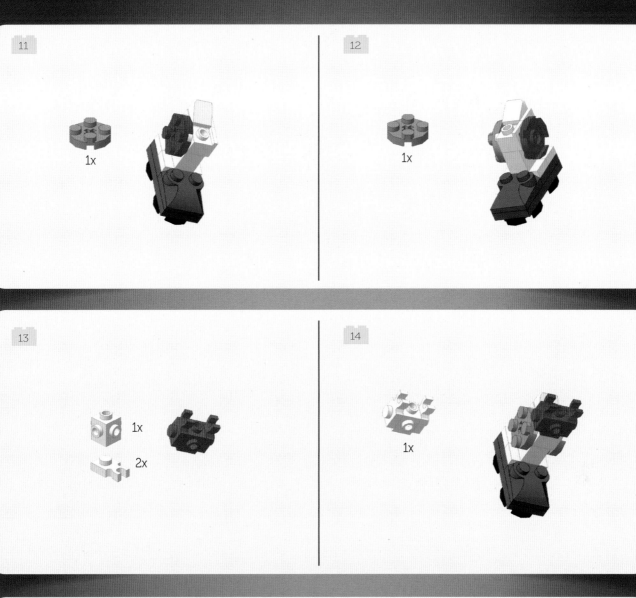

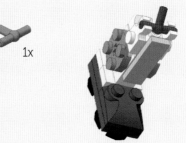

17

1x

1x

2x

1

x2

1

x2

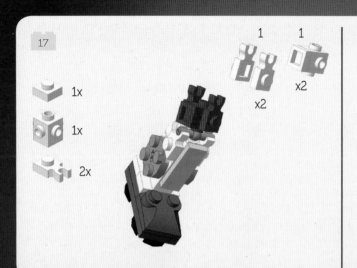

18

1x

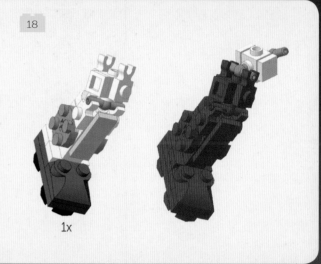

19

2x

1x

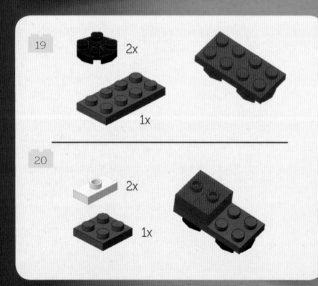

20

2x

1x

21

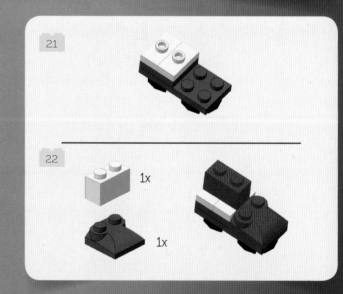

22

1x

1x

23

2x

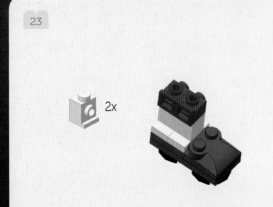

24

1x

1x

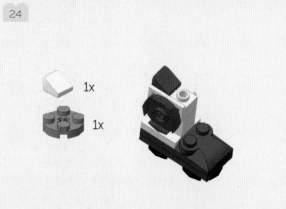

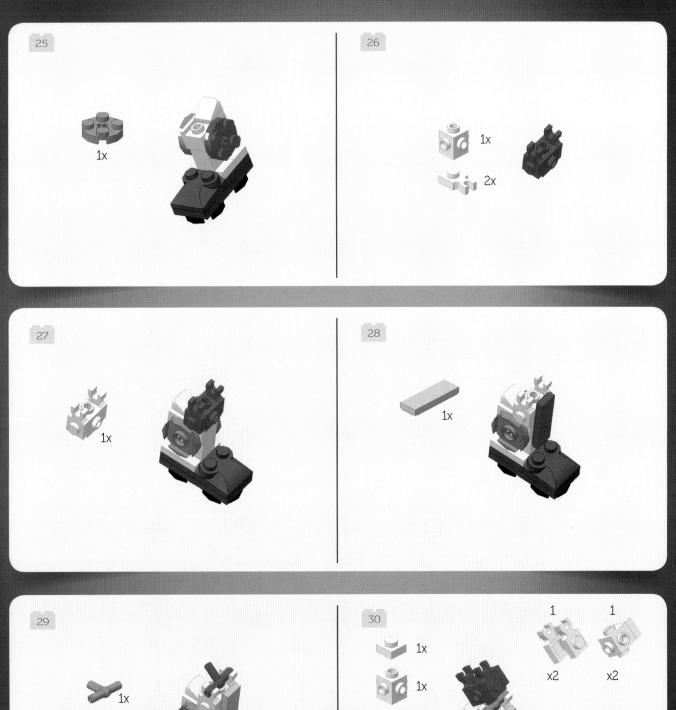

31

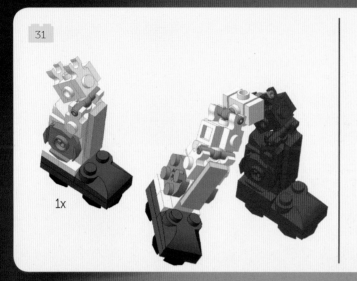

1x

32

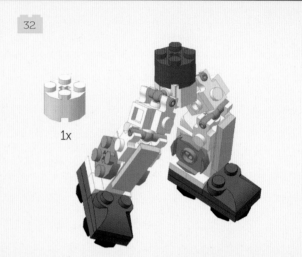

1x

33

1x

1x

34

1x

35

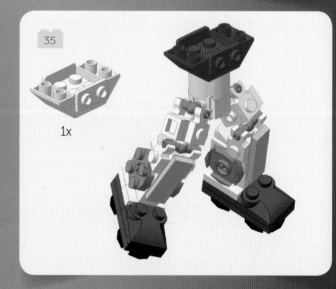

1x

36

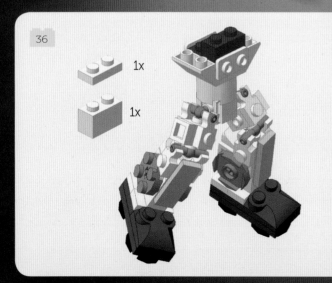

1x

1x

37

2x

38

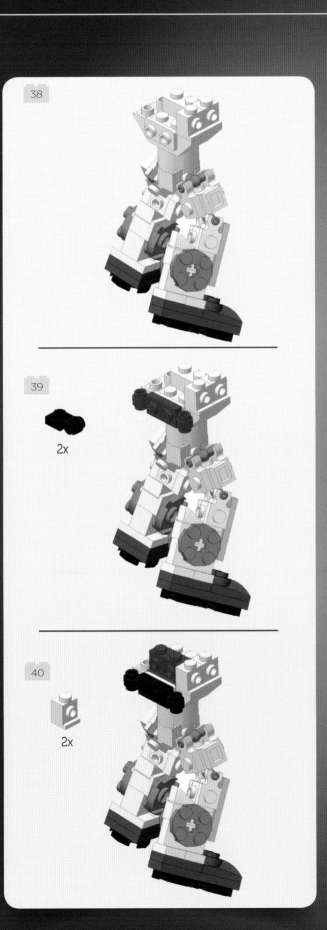

39

2x

40

2x

41

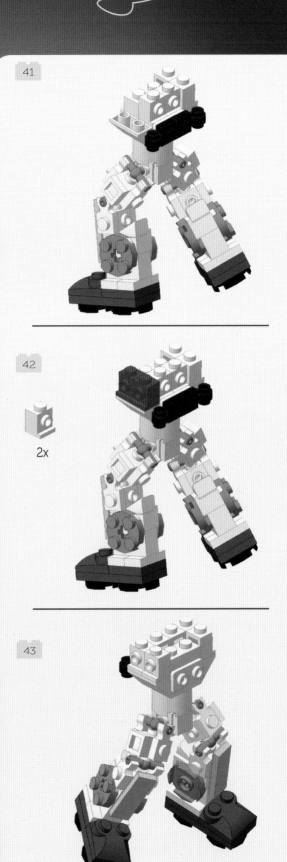

42

2x

43

44

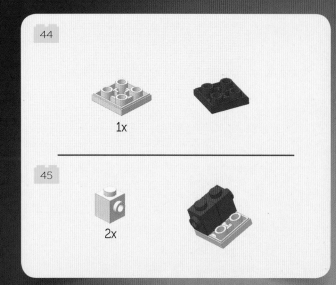

1x

45

2x

46

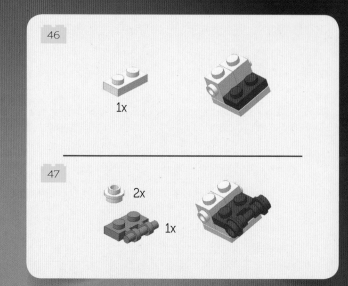

1x

47

2x

1x

48

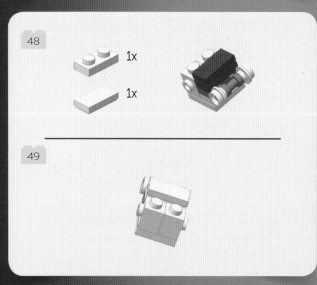

1x

1x

49

50

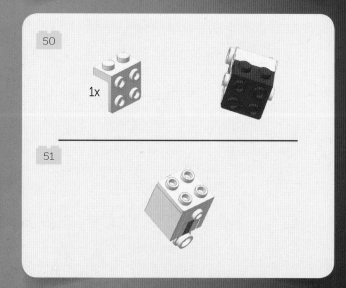

1x

51

52

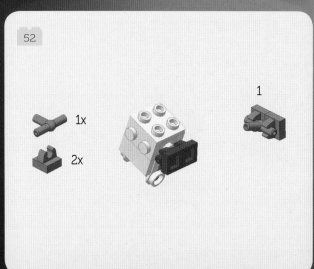

1

1x

2x

53

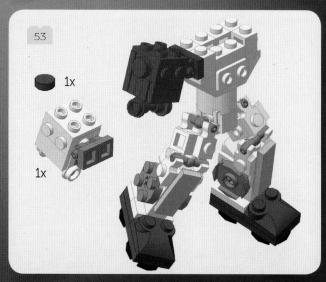

1x

1x

54

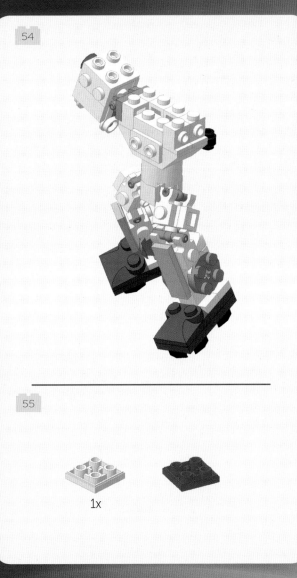

55

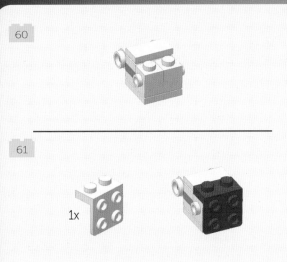

1x

56

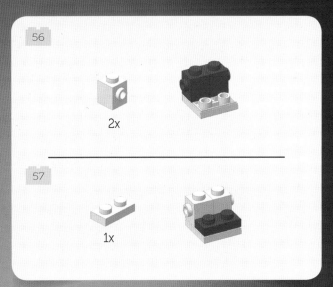

2x

57

1x

58

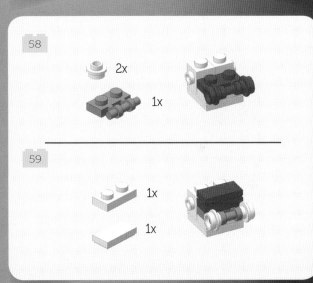

2x

1x

59

1x

1x

60

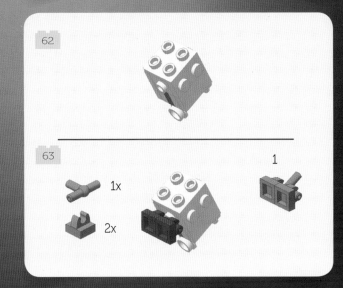

61

1x

62

63

1x

2x

1

64

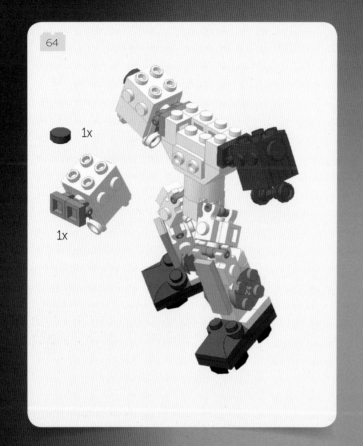

1x

1x

65

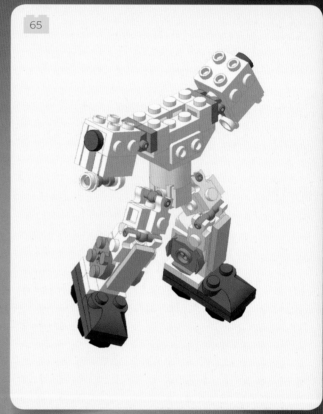

66

1x

2x

67

1

1x

1x

68

1x

1x

1

69

4x

70

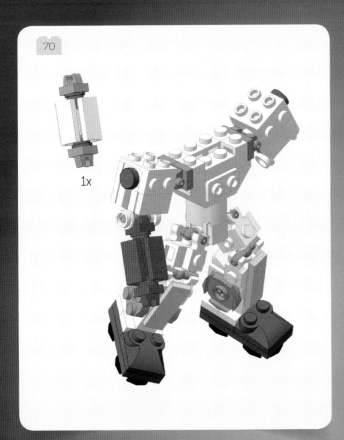

1x

71

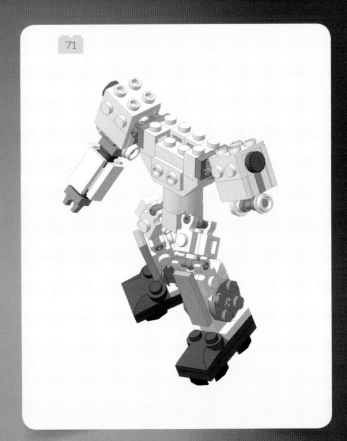

72

1x

2x

73

74

1x

1x

1

75

4x

1x

1x

1

x3

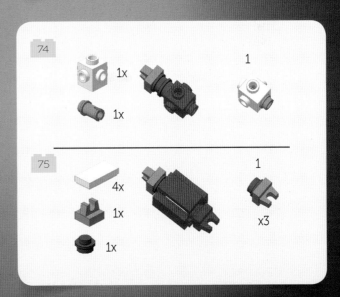

76

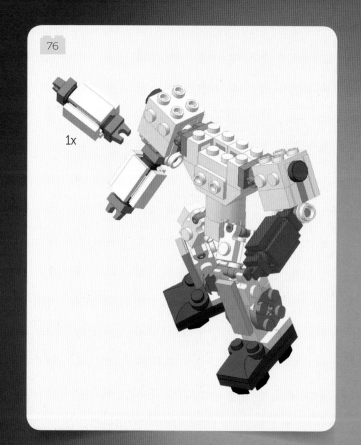

1x

77

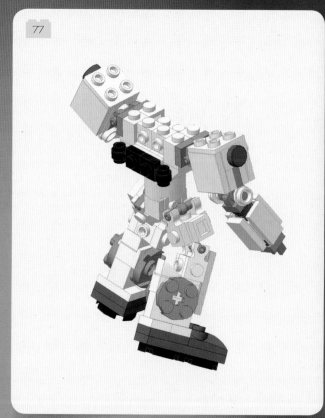

78

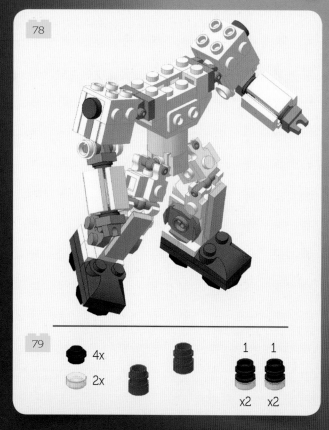

79

4x

2x

1 1

x2 x2

80

x1

x1

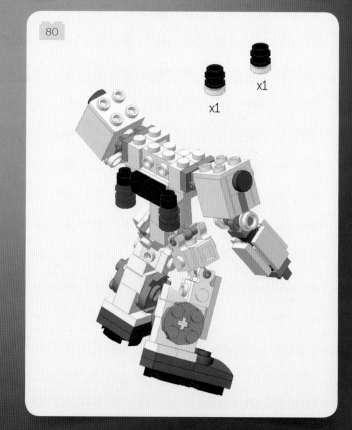

81

1x

82

2x

83

1x

84

2x

85

1x

86

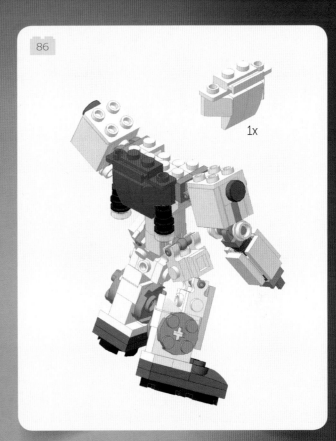

1x

87

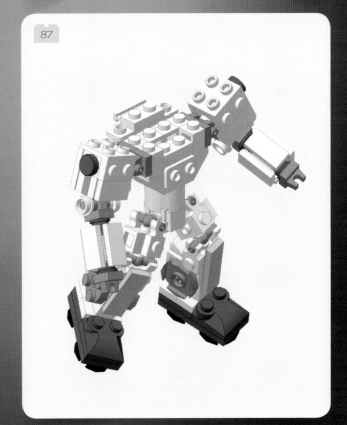

88

1x

1x

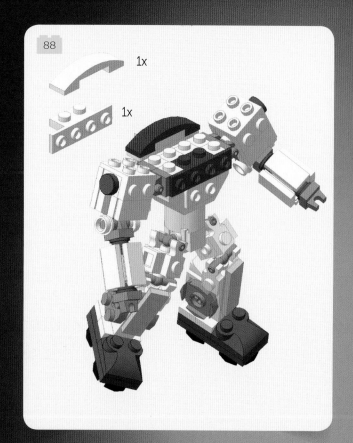

89

2x

2x

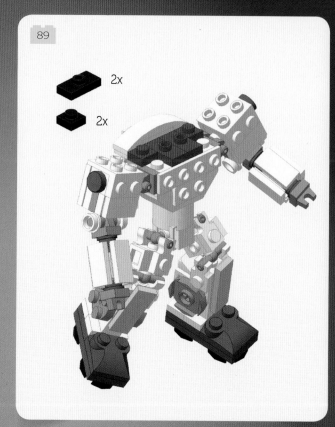

90

2x

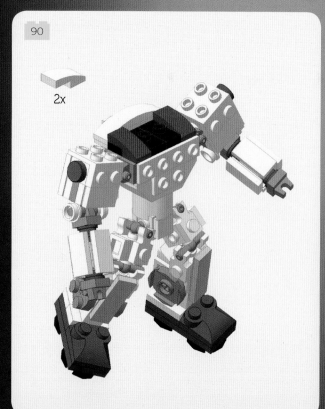

91

1x

2x

1x

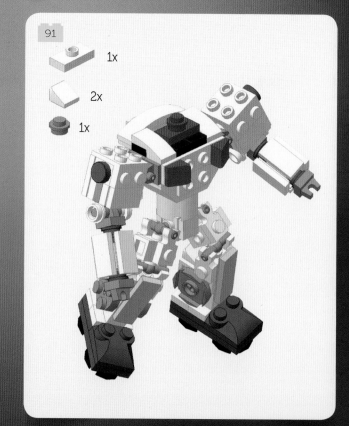

92

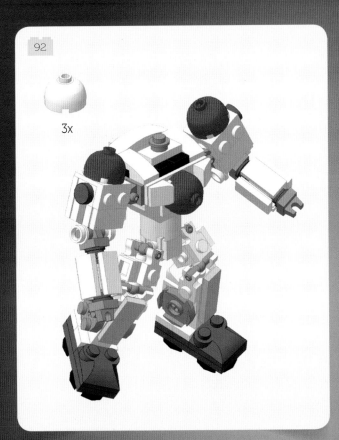

3x

93

1x

1x

94

2x

95

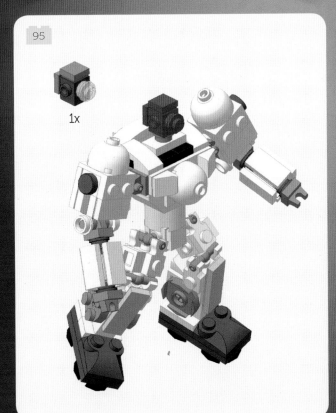

1x

96

1x

1x

1x

1

97

1x

1x

1x

1

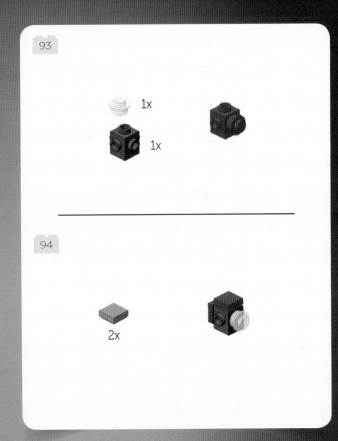

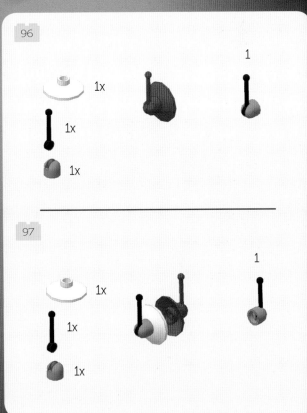

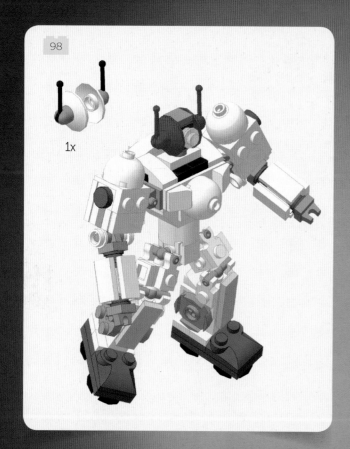

1x

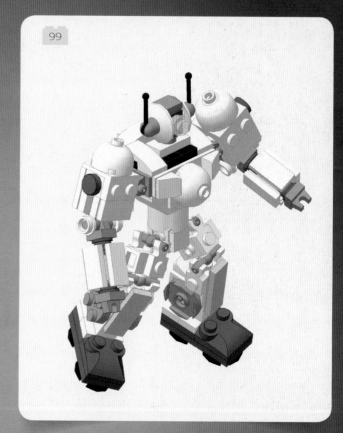

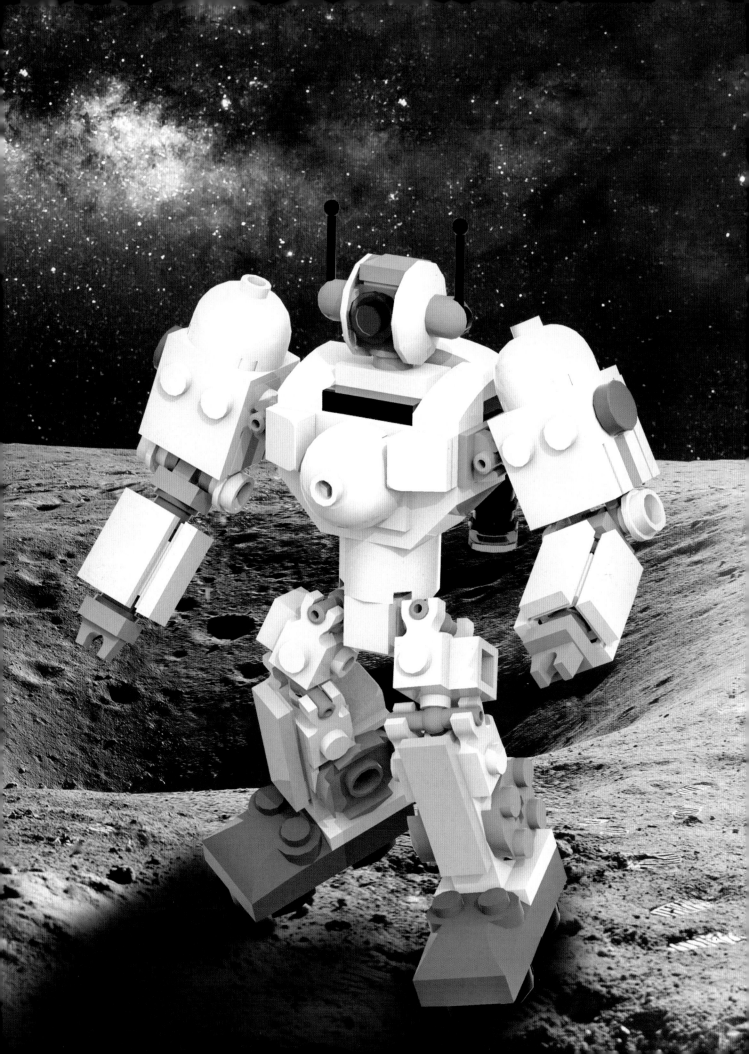

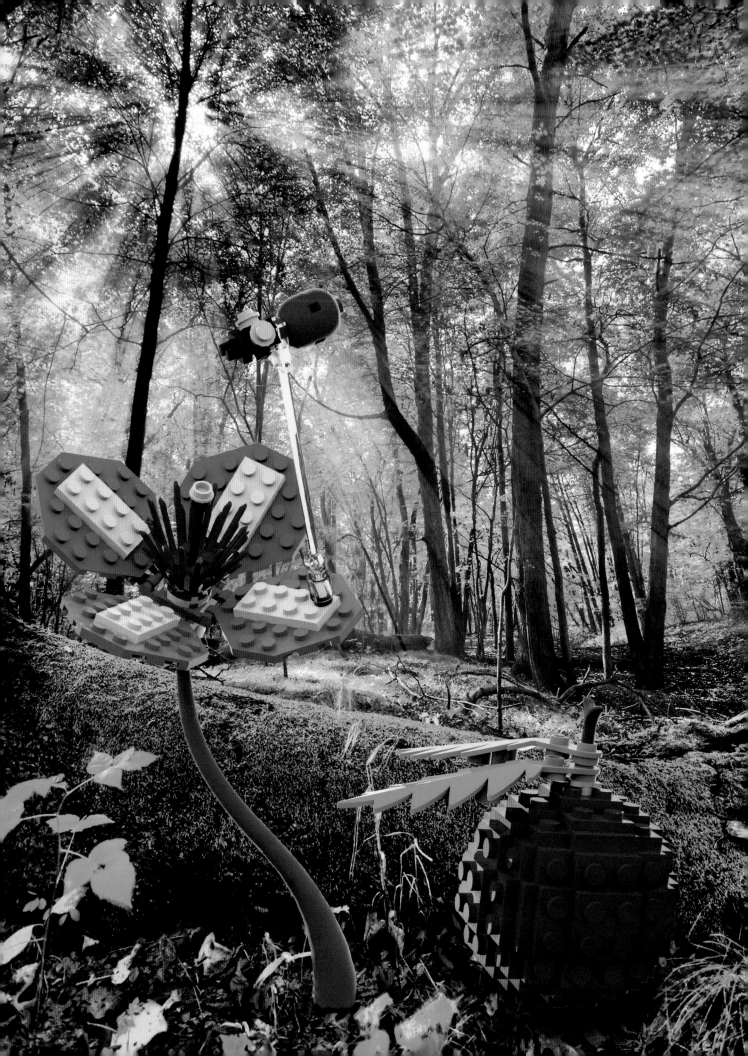

THE NATURAL WORLD

GREEN IS THE MAGIC COLOR!

In the last chapter, we dove straight into technology, but now it's time to go back to our roots, to the mother of us all—Nature, with her scents and colors.

Though it's certainly hard to imagine anything further from the world of LEGO® bricks, Master Builders have no trouble building any shape you can think of, creating natural elements very similar to the original ones.
But don't let yourself be fooled by the apple you're about to build: it looks real and perfect, red and juicy—but you'd better not take a bite if you value your teeth… and your reputation as a Master!

LEGO® has always been sensitive to the theme of Nature; indeed, you can find lots of bricks suitable for building trees, bushes, lawns and meadows. See some examples below (**A**).

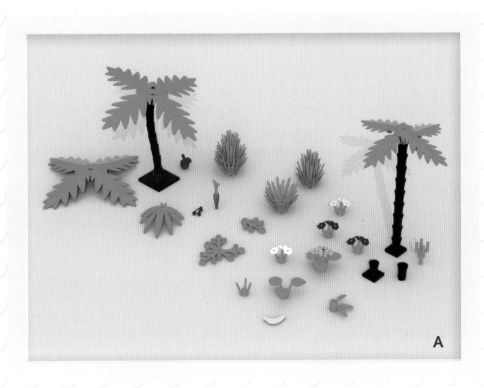

A

LEGO® brick version

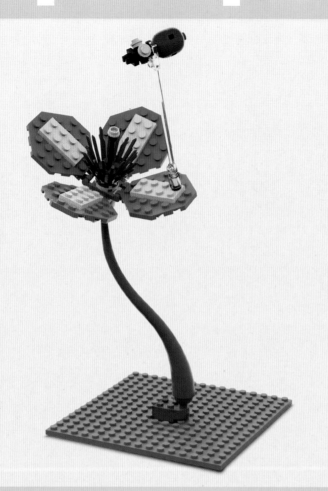

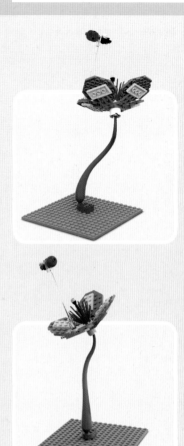

www.nuinui.ch/upload/legocreations-p192.zip

MODEL N.15

FLOWER AND LADYBUG

MODEL (FLOWER): SILVIA GRILLO - MODEL (LADYBUG): YVONNE DOYLE
CREATION: FRANCESCO FRANGIOJA

Out of all the elements we find in Nature, flowers are the ones who leave us openmouthed. Did you know there are around 391,000 plant species on Earth? And 369,000 of these are flowering plants!
Flowers are colorful and scented to attract insects that feed on their nectar, at the same time favoring the reproduction and spreading of flowers.
Albert Einstein once said that if bees disappeared off the face of the earth, the human race would only have four years left to live, so it's clear how important they are!

SILVIA GRILLO
Silvia Grillo is a cheerful university student who lives in the province of Turin with her husband Lorenzo Brovia. A lover of all things mythical and colorful, her "lego-ese specialty" is creating gorgeous scenarios filled with flowers, colorful plants and imaginary characters with LEGO® bricks.

YVONNE DOYLE
Along with her husband, Peter Reid, Yvonne Doyle is one of the most renowned builders of original works and creations with LEGO® bricks. They live in the United Kingdom, in a house filled with over 250,000 LEGO® bricks. Yvonne is a software programmer, while Peter is a mailman. They met and fell in love at a LEGO® exhibition.

Features

- easy to build
- sturdier than a normal flower
- doesn't need to be watered

List of bricks needed to build our Flower and Ladybug

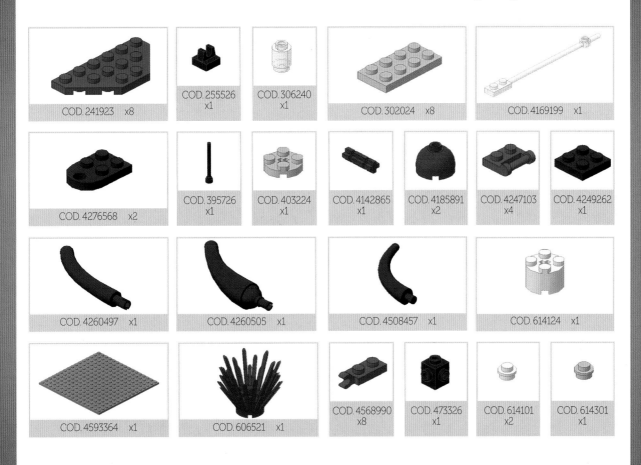

COD. 241923 x8

COD. 255526 x1

COD. 306240 x1

COD. 302024 x8

COD. 4169199 x1

COD. 4276568 x2

COD. 395726 x1

COD. 403224 x1

COD. 4142865 x1

COD. 4185891 x2

COD. 4247103 x4

COD. 4249262 x1

COD. 4260497 x1

COD. 4260505 x1

COD. 4508457 x1

COD. 614124 x1

COD. 4593364 x1

COD. 606521 x1

COD. 4568990 x8

COD. 473326 x1

COD. 614101 x2

COD. 614301 x1

1

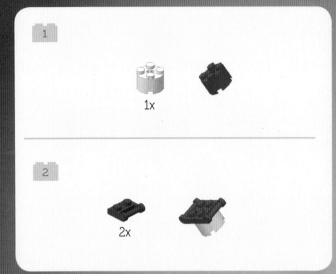

1x

2

2x

3

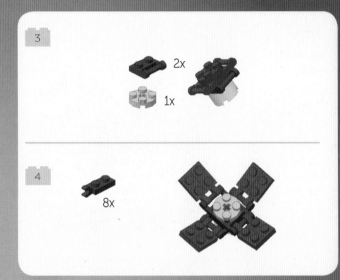

2x

1x

4

8x

5

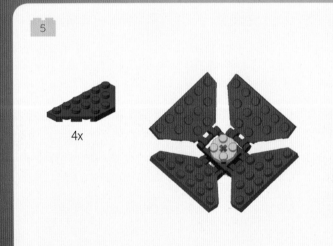

4x

6

4x

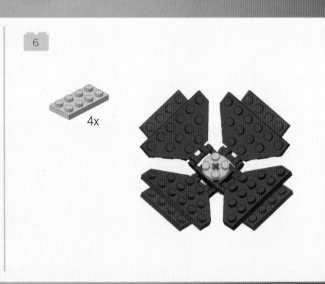

7

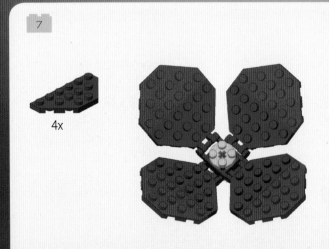

4x

8

4x

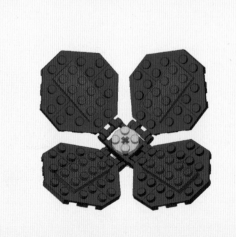

9

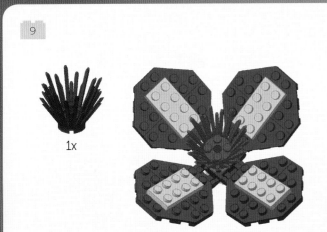

1x

10

1x

1x

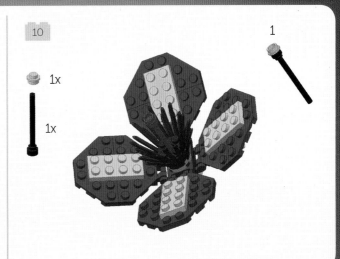

1

11

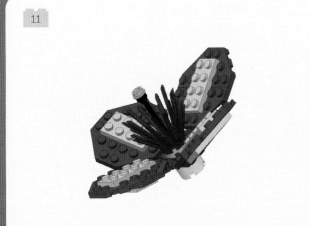

12

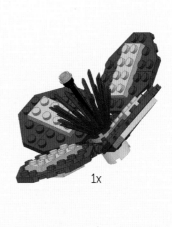

1x

13

1x

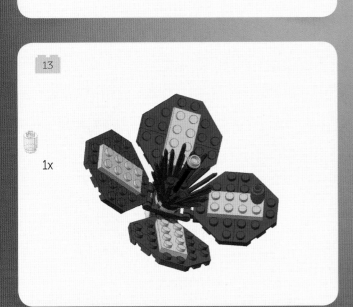

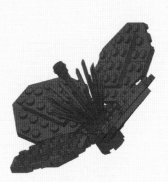

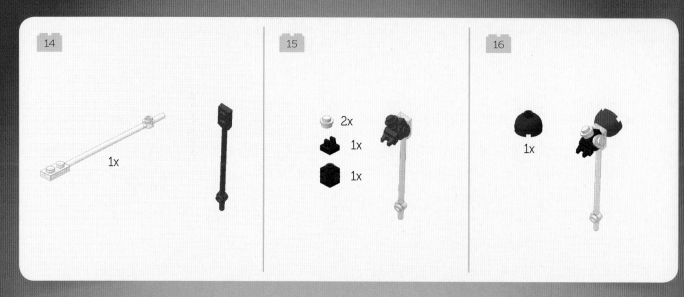

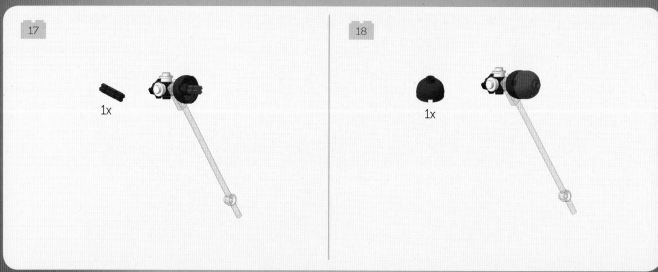

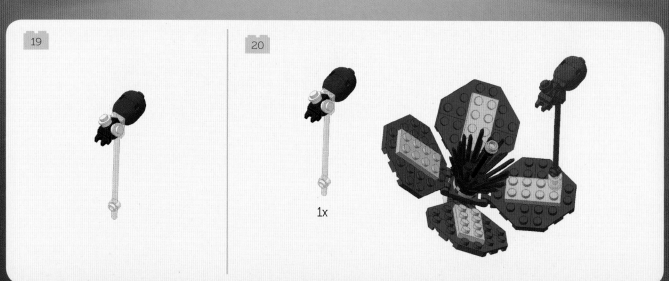

21

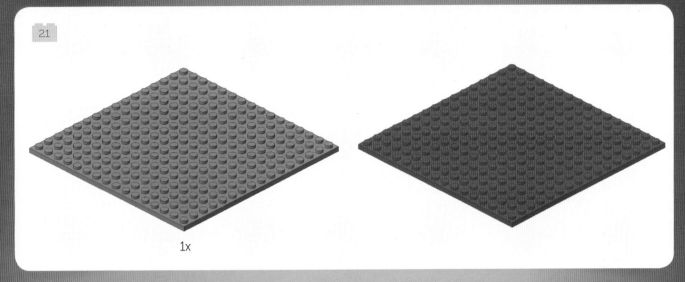

1x

22

2x

1x

23

1x

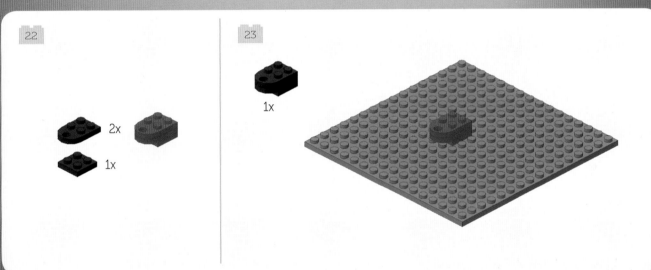

24

1x

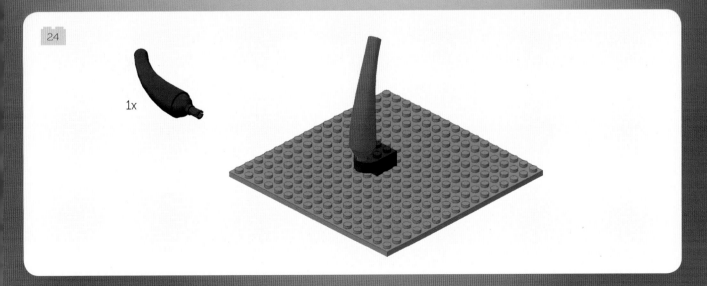

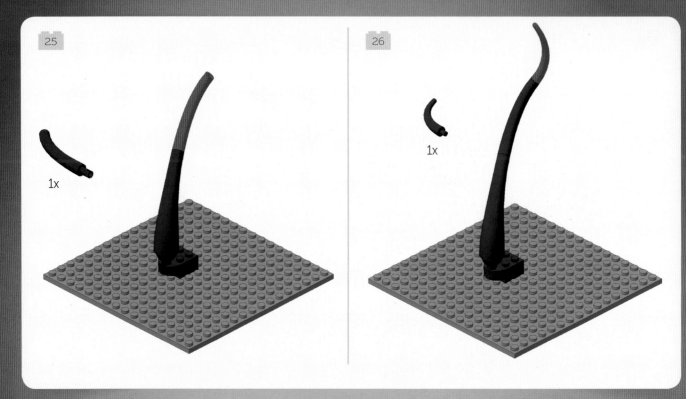

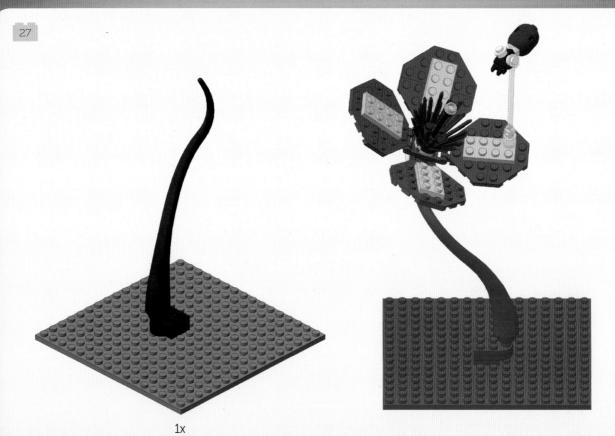

28

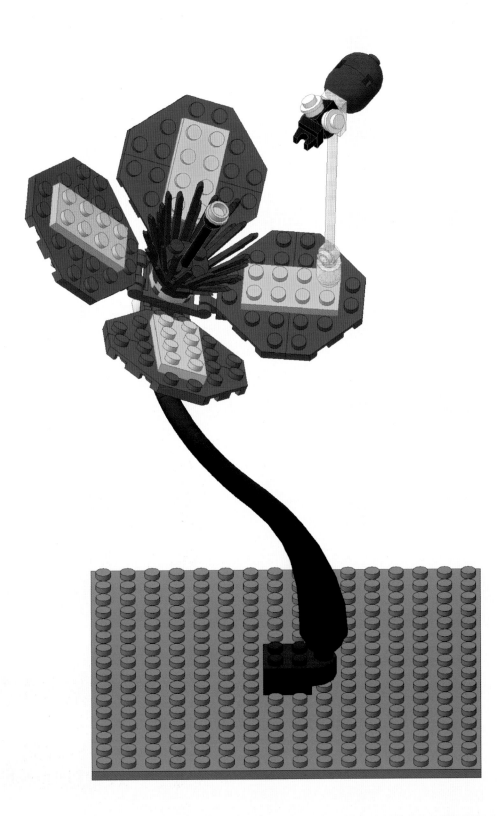

LEGO® brick reproduction of a "juicy" red apple!

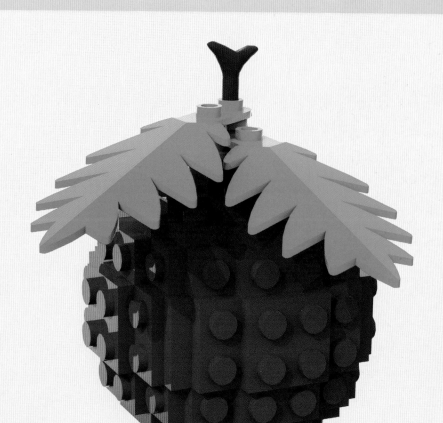
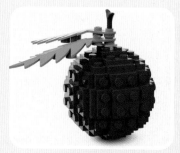
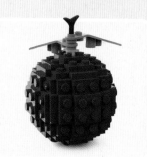

www.nuinui.ch/upload/legocreations-p200.zip

MODEL N.16

THE APPLE

AUTHOR/DESIGNER: BRUCE LOWELL

An apple a day keeps the doctor away! Why not a banana or a peach? Easy—apples are the perfect fruit! Eating any fruit gives lots of health benefits, but apples are the only ones to contain every single nourishing property.

They have few calories, prevent heart disease and tumors, lower cholesterol levels, prevent cavities, they protect your brain cells and are good for your lungs, but most of all… they're delicious!

BRUCE LOWELL

Bruce Lowell is a great LEGO® enthusiast and a skilled builder of original works and creations. He says he was building with LEGO® bricks before he could walk. When he was little, LEGO® bricks were just a game to him, but growing up he realized that they could be an amazing artistic tool.

His passion is creating curved surfaces with LEGO® bricks, which are rigid and squared in shape. This led him to create the design known as the "Lowell Sphere" to the worldwide community of LEGO® enthusiasts.

He draws inspiration from the internet and his own imagination for his creations.

Features

- easy to build
- useful to learn how to build spherical surfaces out of LEGO® bricks
- by building several copies as well as a container, you can make an amusing ornament

List of bricks needed to build our Apple

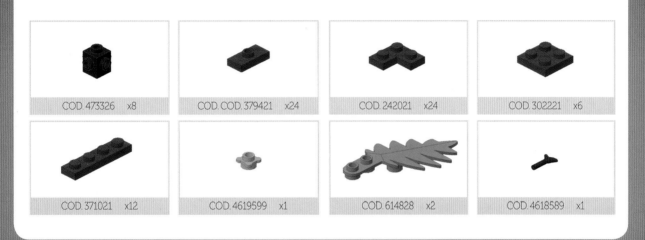

COD. 473326 x8	COD. COD. 379421 x24	COD. 242021 x24	COD. 302221 x6
COD. 371021 x12	COD. 4619599 x1	COD. 614828 x2	COD. 4618589 x1

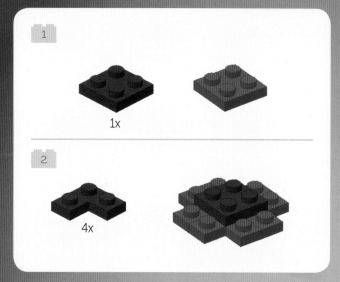

1

2

4x

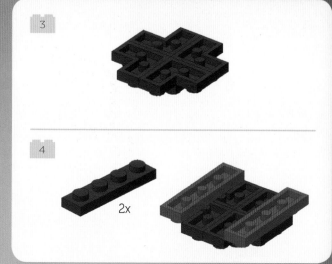

3

4

2x

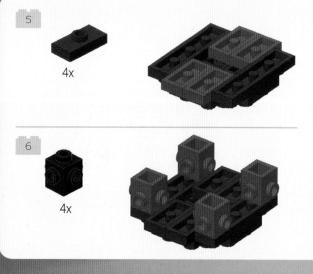

5

4x

6

4x

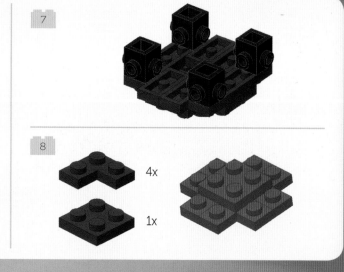

7

8

4x

1x

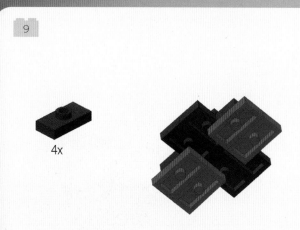

9

4x

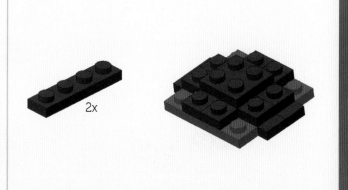

10

2x

11

1x

12

1x

13

4x

14

4x

15

2x

16

2x

17

1x

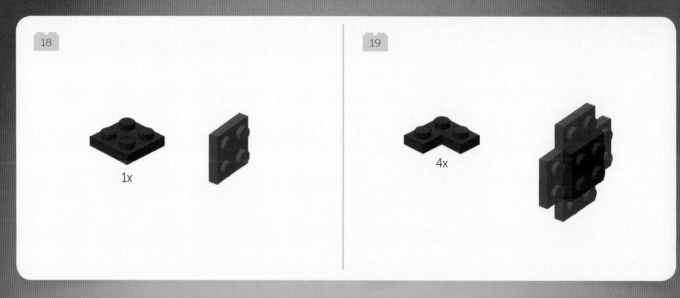

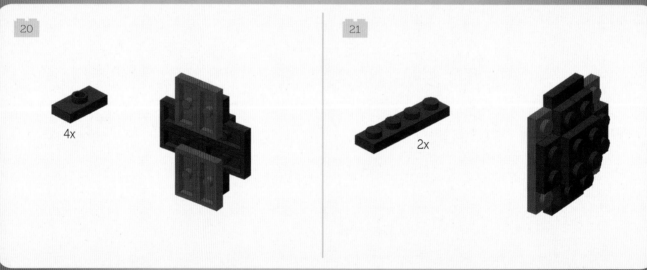

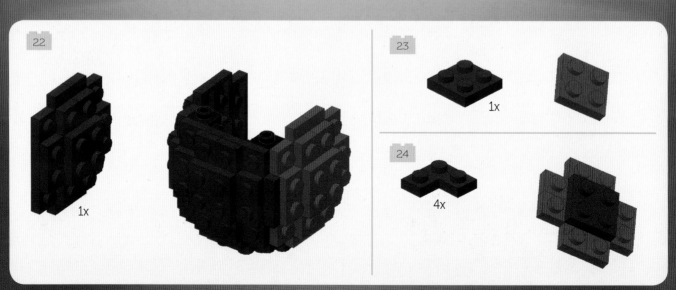

25

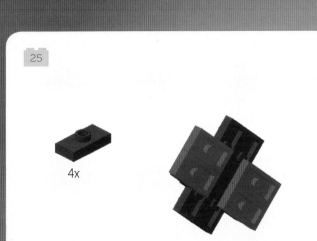

4x

26

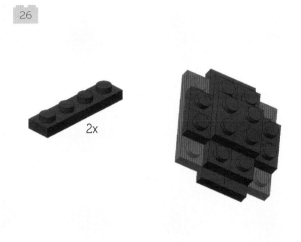

2x

27

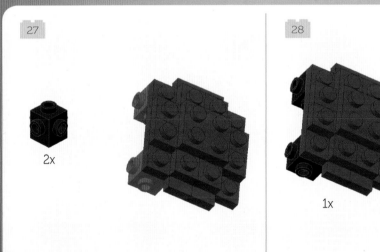

2x

28

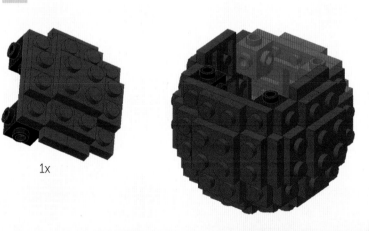

1x

29

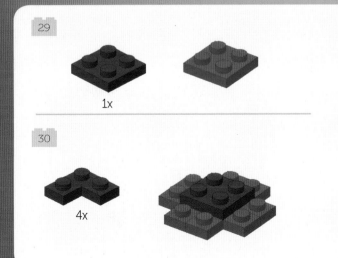

1x

30

4x

31

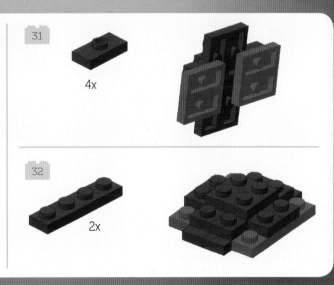

4x

32

2x

33

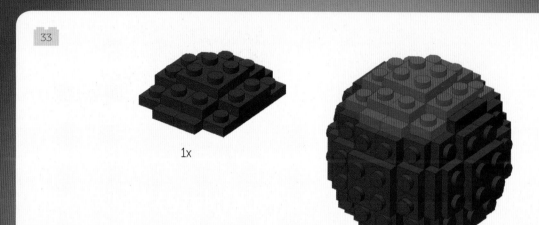

1x

34

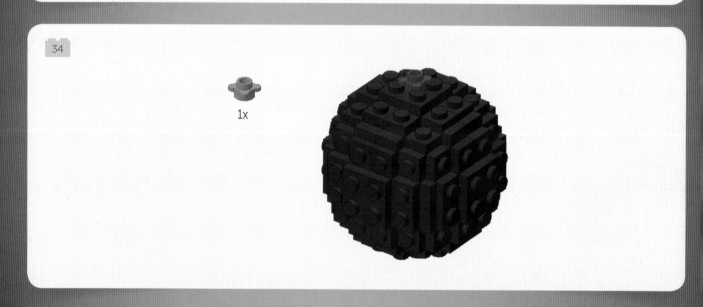

1x

35

2x

1x

36

1x

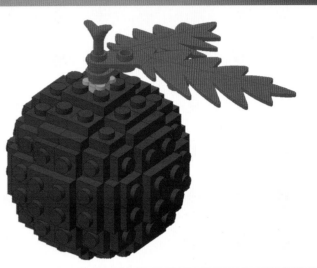

37

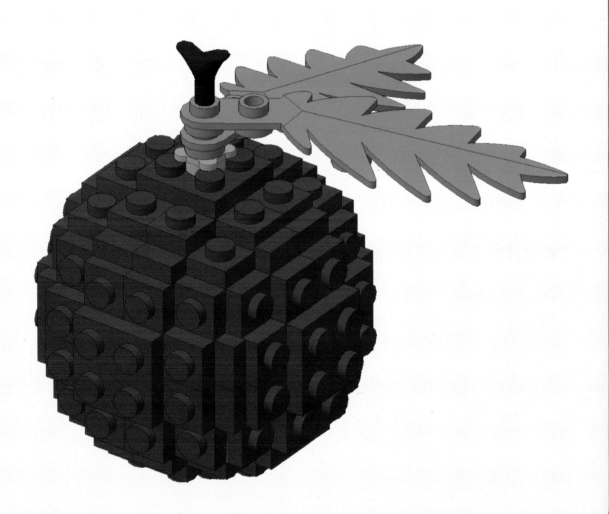

BONUS MODELS

THE FUN CONTINUES ONLINE!

Download the bonus folder, where you'll find building instructions for these three amazing models.

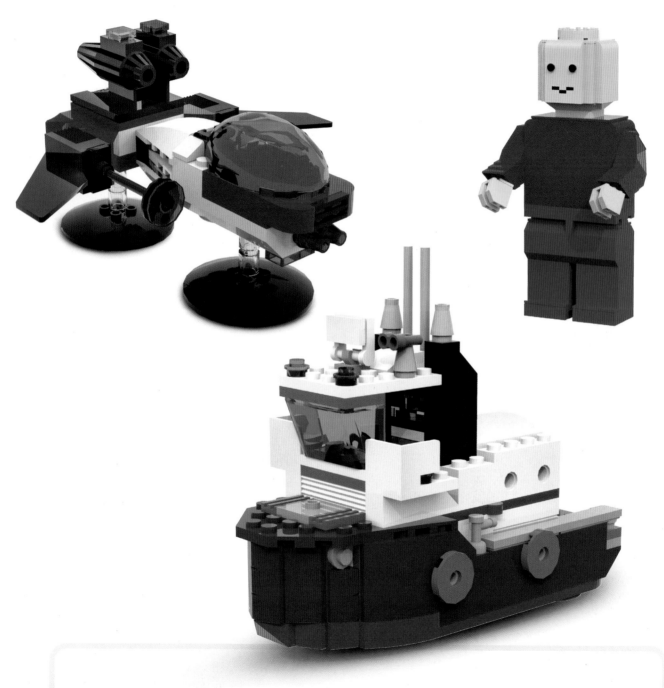

 www.nuinui.ch/upload/legocreations-p208.zip